THE WORLD OF
Trisha Romance

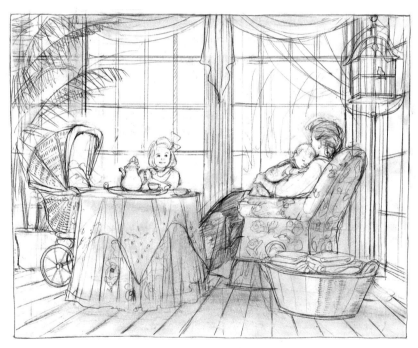

VIKING STUDIO BOOKS

To Jiep,

With warmest thanks
for everything. Here's to
the best moments in life and
to the years of treasured memories.

God Bless '93
with fine health
and contentment.

Trisha

Jan. 1993.

THE WORLD OF
Trisha Romance

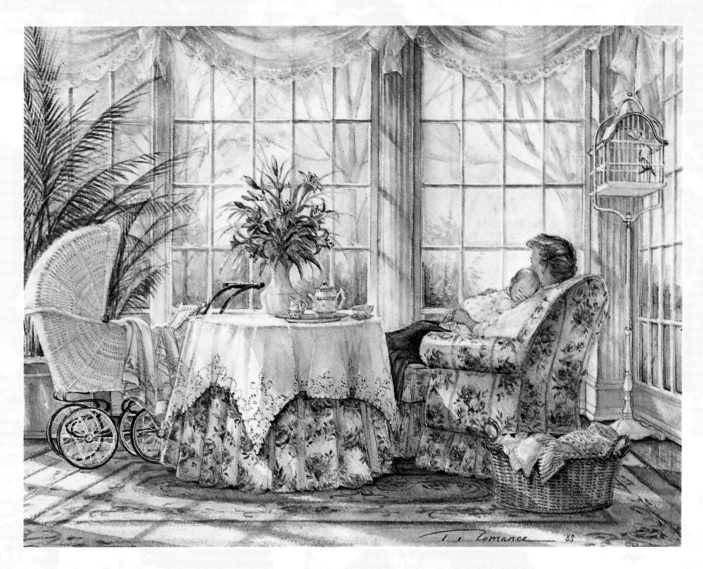

INTRODUCTION BY DAVID BURNETT

VIKING
STUDIO
BOOKS

VIKING STUDIO BOOKS
Published by the Penguin Group

Penguin Books Canada Ltd., 10 Alcorn Avenue, Toronto, Ontario, Canada M4V 3B2

Penguin Books Ltd., 27 Wrights Lane, London W8 5TZ, England

Viking Penguin, a division of Penguin Books USA Inc., 375 Hudson Street, New York, New York 10014, USA

Penguin Books Australia Ltd., Ringwood, Victoria, Australia

Penguin Books (NZ) Ltd., 182-190 Wairau Road, Auckland 10, New Zealand

Penguin Books Ltd., Registered Offices: Harmondsworth, Middlesex, England

First published 1992

10 9 8 7 6 5 4 3 2 1

Text and illustrations copyright ©The Artists' Garden Inc., 1992
Introduction copyright ©David Burnett Art Associates Limited, 1992

Canadian Cataloguing in Publication Data
Romance, Trisha, 1951-
 The world of Trisha Romance

ISBN 0-670-84201-X

1. Romance, Trisha, 1951- . I. Title.

ND249.R65A4 1992 759.11 C91-095610-3

Artist photographs on pages 25 and 27: Hugh Wesley
Artist photograph on page 157 (lower): Robert Nowell

Design and art direction by Andrew Smith
Colour separations by Colour Technologies, Toronto
Printed and bound in Italy by Arnoldo Mondadori Editore

Printed on acid-free paper ∞

Jacket front: "Bright Eyes"
Jacket back: Detail from "Winter Fantasy"
Half-title page: Working sketch for "Mother's Arms"
Title page: "Mother's Arms"
Page 6: "Winter Retreat"

Produced for Viking Studio Books by:
Lorraine Greey Publications Limited,
Suite 303,
56 The Esplanade,
Toronto, Ontario,
Canada M5E 1A7

ACKNOWLEDGEMENTS

I am forever grateful to my loving parents, who over the years have proudly saved my work, never seeing the imperfections I saw, always understanding my need to create.

Warmest thanks are also due to the many individuals who collected my work in the early years. Their support was always a great source of encouragement to Gary and me. We especially acknowledge the following for allowing my paintings to leave their collections to become an important part of this book: Ros and Ida Arnott; Donald and Marty Bagworth; Tom and Barb Barnes; Mr. and Mrs. J.D. Burke; Mr. and Mrs. James Clark; Mrs. D.B. Cowper; Thomas Dean; Mr. and Mrs. D.H. Farndale; Piep Gaudelius; Mr. and Mrs. Don Hayhoe; Eleanor and Brad Jay; Mr. and Mrs. S. Korpela; Fred and Jessie McCullough; Judy and Ross McEwen; Neil and Barbara Munro; The Mutual Group; Mr. Olanow; Mr. Ron Pearlman; Barb and John Perkins; Perth Country Gallery; Mr. and Mrs. S. Dean Peterson; The Reid Collection; Mr. and Mrs. John Romance; John and Tuula Ross; Debbie and Larry Salsberg; Deborah Shennette; Mr. and Mrs. Leon Tessler; Barrie and Nancy Usher; Mr. and Mrs. R.K. Webb; Dr. and Mrs. S. Wetmore; Nancy and Howard Wickett; Pat Yaeck.

Special thanks to David Burnett, who became the voice for my paintings, because no one is able to express the innermost part of an artist's soul quite the way he can.

In addition, I'd like to thank all my fellow perfectionists at Herzig Somerville, especially Ernie Herzig and Murray Running, who have worked closely with us for fifteen years; and Mary Black and Bob Alexander at Colour Technologies for their work on the book.

And, of course, thanks to all at Penguin Books Canada Ltd. — particularly David Kilgour, who organized, edited, graciously listened, and somehow understood me — Lorraine Greey Publications, Andrew Smith Graphics, and Garth Roberts. I shall never take any book for granted, knowing now what a true labour of love it is for all involved.

To Gary, my husband and best friend,
who has always believed in me, and to our gifts from God — Nathan, Tanya, and Whitney,
who have filled my world with special love and endless inspiration

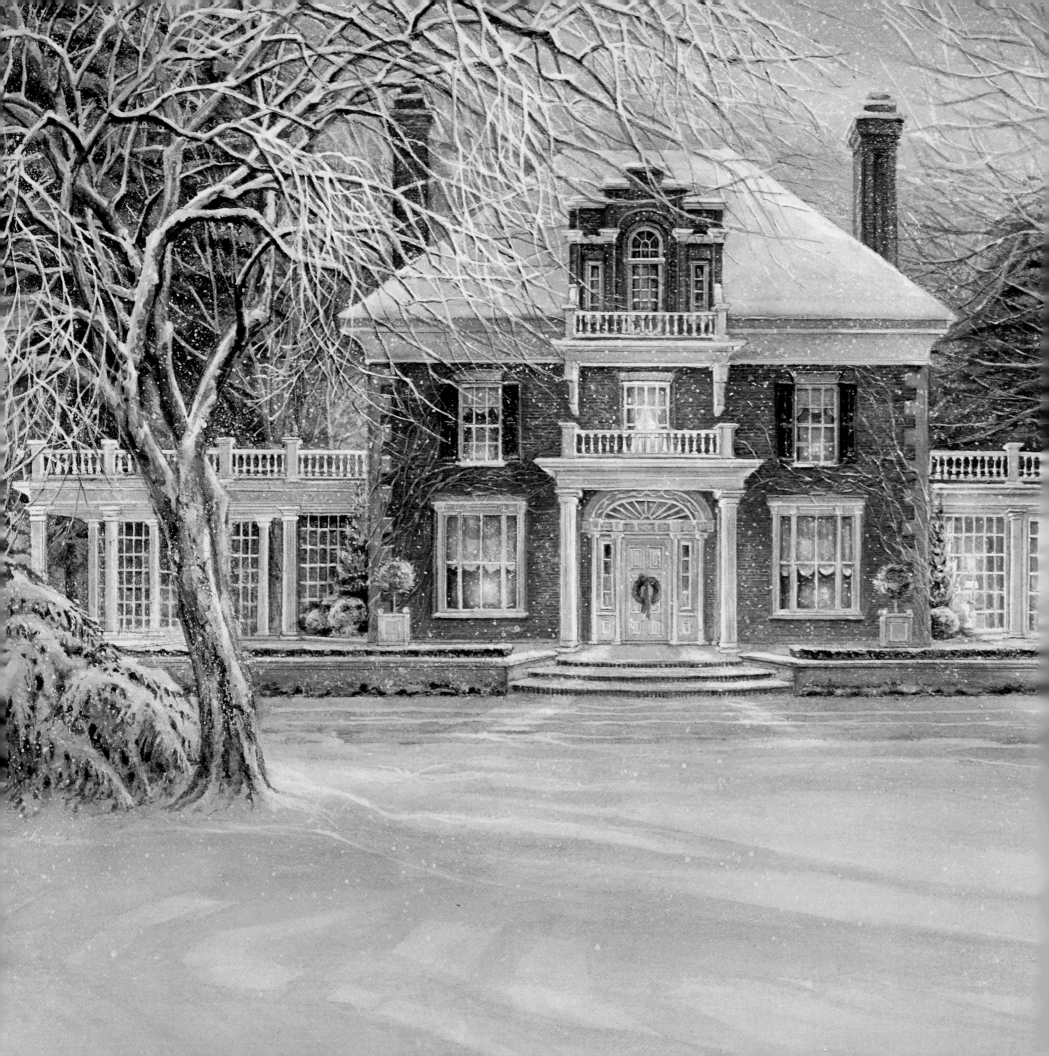

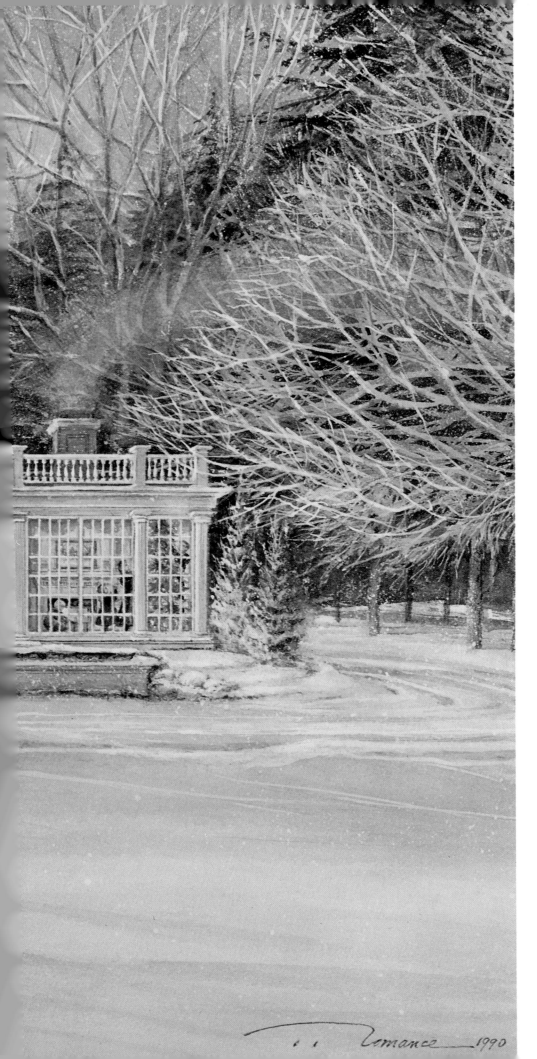

CONTENTS

INTRODUCTION

✤

*H*OW IS IT THAT AN ARTIST TRANSFORMS THE FLATNESS OF PAPER OR CANVAS INTO a compelling illusion of space? How does an artist shape the image of a room so that it appears filled with light? How is the brightness of a child's expression captured by just a few touches of a brush? How are such things achieved?

At one level, of course, such questions about our experience of painting are technical ones, conducive to rational explanation. The procedures involved can be analysed; they can be taught by description and example. But the old adage that practice makes perfect is, in this endeavour, as in many others, deceiving; the witnesses of frustrated efforts are legion. Mastery of technical skills beyond a rudimentary point is not like ascending a gradual slope, but like taking steps beyond the stride of most of us; we must recognize that the manifestation of those skills is the end point of a complex, subjective process that is beyond analysis. What we come to understand is that the question "How?" is not really the one we want to ask. Or, rather, it may be the question, but only when it is given a much broader sense in which, like an alchemist's magic, the base materials of watercolour or oil paint are transmuted into a pictorial world.

The drive behind that magic is the artist's vision, that special capacity of the artist for physical and psychological perceptions of the world that are given truth by being given form through the technical skills that express those perceptions by the conventions of drawing and painting. The technical skills can be learned, with a greater or lesser degree of success, but without that drive, without that vision, they remain merely clever exercises.

We lack the ability — to my mind happily — to determine why this or that individual develops the special capacities of the artist. We can say, however, that it is unusual for an artist voluntarily to stop working (imagine the poverty of the arts if artists were forced to retire at sixty-five). And it is in general true that the desire for artistic creation is formed at an early age. This does not mean that a child expresses or recognizes a specific ambition, but, later, the roots of the interest will be traceable to those early years. More difficult still to understand, but a curious fact that recurs with uncanny frequency, is how often a serious childhood illness marks a pivotal point in the origins of an artist's career. Young children have a natural urge to draw, but few carry that through into maturity. In most children, even well before puberty, the interest wanes, the imaginative pleasure they once derived from drawing loses its power under a growing impatience with their own efforts and a frustration at recognizing the limitations of their ability to express themselves. It is as if a critical wedge were driven between the unity of

perception and technical skills. But for a few the urge to maintain that unity remains necessary, even though the development of the technical skills takes many years to perfect; artists can be well into their thirties before it is possible to look at their work and say with confidence that they possess a personal style.

Trisha Romance was one of those children whose fascination with making art was always present; she can barely recall a time when she was not making images. She was also, as a very young child, seriously ill and, as with other children whose artistic interests continue into adulthood, her recovery from the trauma fueled her creative life. As she describes in her own story later in this book, the illness she suffered threatened her eyesight; for a time she lay isolated in hospital with bandages over her eyes. But when she recovered she began to live, as she says, with "a new appreciation of sight" that left her with a desire "to capture everything I saw" by drawing. Being so young, there was no question of her having any sense of being an artist, nor of understanding what it meant to develop an artistic technique. But she was moved to feel that the ability to see was a special gift and this demanded of her a need to hold closely and permanently to the scenes and events around her.

There is still, however, a deep chasm to be bridged between the ability to see the world in terms of the desire to draw and the determination to spend one's life as a visual artist, a fine art professional. In part that chasm exists because ours is a culture in which making art is an unbidden activity — not forbidden, as it is and has been in other places and at other times, for the choice is open, but the choice of an individual to make art is set at the margins of our social and professional structures.

The situation is different for the applied arts and commercial art. There is a demonstrable need for designers of many types, for commercial artists, for draughtsmen, and so on, a need that is reflected in the paths that exist for a young person to receive training for a career. The paths for a fine artist are ill-defined and the prospects limited.

When she moved from high school to college, Trisha made the decision to pursue a career in fashion design and illustration. She went to Sheridan College in Oakville, just to the west of Toronto, and on graduating in 1971 began work as a fashion illustrator. But she knew that her real interests were elsewhere, that they were in her independent artistic work. She realized that before she became too settled into her illustration work she had to allow herself, at the least, the opportunity to test those other creative interests.

The requirement in art schools and colleges that art students should take a survey

of art history courses has had, over the years, a turbulent ride. Many students in North America came to art history all but unprepared by their public and high school years' experience and were then expected to come to terms with the art of the past largely through books and slides. The distance they so often felt from the subject can, perhaps, be correlated to their distance from the experience of the works of art themselves. Trisha felt herself fortunate in finding at Sheridan, as she says, a "charismatic art history instructor". She came to realize that she could not settle into her career in the applied arts until she had experienced for herself something of the artistic heritage that she had been introduced to in her art history studies. The only way, she felt, was to spend some time in Europe.

The six-month trip she had allowed herself turned into two years and she would have stayed away longer but for a disagreement with Swedish officialdom. She travelled widely in those years, from Greece and Italy through France and Germany and the Netherlands to Scandinavia, settling for a winter in Lapland. At one level, through her previous studies and her sense of anticipation, she was ready for the experience, and yet she was wholly unprepared for the intensity of her reaction to what she saw. If her childhood experience of illness and the rediscovery of sight had given her a special desire to hold what she saw, the time she spent in Europe and the example of all the art she saw revealed the means and the structure to transform what she saw into an expression of her own. It was not that she was seeking a particular style to follow; rather that she wanted to absorb everything she could, whether in architecture or in painting or in sculpture.

Her European experience had vital effects on Trisha in several ways. Some were immediate and powerful in their impact — the Acropolis at midnight, Michelangelo's "David", the paintings of Monet and van Gogh — others developed more gradually. In the long term, perhaps, the most significant effect was that she came to recognize how the works of art she admired in the museums were truly expressions of the cultures from which they had arisen and that they remained, in complex ways, part of the present. This is something that must be felt rather than learned. The realization of this was for her as significant as the opportunity to come face to face with great individual works of art; it came to be an affirmation of the direction she was to give her own art.

In certain respects, the aspect of her stay that had the most direct and lasting effect on her own work was the time she spent in Scandinavia. The opportunity to live and

work in relative isolation, the attraction she felt for the snow-filled northern landscape, the relationship she experienced between the harsh beauty of the outside world and the enclosure of warmth and security in the home seem to have formed a link with her own experience of growing up and laid the foundations for the work she would do on her return to Canada.

There was a major tradition in European painting that, in contrast to those dealing with religious, mythological, and historical subjects, concentrated on the facts and the virtues of everyday life. It was a tradition whose roots are to be found in the emerging independence of the Netherlands at the beginning of the seventeenth century and whose fullest expression can be found in the work of Johannes Vermeer, Pieter de Hooch, Nicolas Maes, and Gerard Ter Borch. The work of these artists and their contemporaries had a profound effect on subsequent art, particularly in northern Europe, with their subjects drawn from the values of home life, from the activities of work and play, from the events of the daily lives most people led. The tradition strengthened and grew in extent through the nineteenth century and into the twentieth. Immigrant artists brought it across the Atlantic in the nineteenth century — in Canada, the work of Cornelius Krieghof comes to mind. In the early twentieth century in Sweden one of the leading figures in this genre of painting was Carl Larsson, an artist whose work Trisha sought out in Stockholm; she found, as she says, "in his vision a kindred spirit".

One result of her European experience was that when she started working again back in Canada, Trisha felt compelled to give expression to her sense of place, both in a personal way and in terms of a broader appreciation of her surroundings. On her return home she settled in Toronto and sought out subjects in her immediate environment. She began to paint scenes in and around where she lived, following a direction that had been established in Toronto by the painter Albert Franck who, through the 1950s and 1960s, took as his subject the laneways of the older Toronto neighbourhoods — Franck, as Harold Town described him in his book on the artist, was "Keeper of the Laneways".

Trisha's own childhood, however, had been spent in rural New York State, and it was in reconnecting with these roots that she found the purpose she sought for her own painting. The inexorable expansion of the city was in the most direct way changing the appearance of the countryside: farmland was being paved over and serviced for subdivisions, the old farmhouses and their outbuildings were being destroyed. Trisha

began to seek out these places as the subjects for her work and, starting in the mid-1970s, produced an extensive series of paintings and drawings on this theme. To begin with, her approach was to concentrate on the buildings themselves. Sometimes she would include figures, not as the focus of the paintings but, rather, as references to the successive generations of people who had occupied these houses and worked the land. What she sought through the character of her painting itself was to give a pictorial interpretation to the houses that distanced them from a specific time and convinced the spectator of their extended existence as they stood out against the change and repetition of the seasons.

It was inevitable that when the circumstances permitted, Trisha should move out of the city. She and Gary Peterson were married in 1977, and two years after that, when she was expecting her first child, they moved to a farm near Milton, Ontario. She continued to make paintings of the old buildings in the area, but gradually a new emphasis began to develop in her work as the centre of her life increasingly revolved around her family. Her artistic training and her own studies in Europe had been much concerned with drawing the human figure. Her early independent work, as I have described, in concentrating on architecture and landscape, tended to exclude this aspect. But with a change of emphasis in her life came a change of emphasis in her art, and the two aspects of her work that, up until then, had been developed more or less independently were now, increasingly, brought together. Her purpose in the farmhouse paintings had been to find a way to preserve them. Now it was as if she came to see them not as gradually fading monuments to a lost past, but as centres of activity, as centres of renewal expressed through the life of the family.

The realization of this new vision did not mean that she had to turn her back on what she had done before; rather, the focus of her work became different, but the changes, often quite subtle, resulted in totally new meanings in the work. For instance, she began to approach a view more closely, limiting the breadth of her scan, so that the façade of a house, as we see in "Gone to the Store" and "Best Friend", now more than fills the whole plane of the picture. Even where the whole of a house is the subject of the picture, it is presented as though enclosed by its surroundings rather than standing out against them. What I mean is shown very clearly by comparing the 1977 picture "Country Castle" with "Victorian Majesty", painted four years later. In "Country Castle" the house stands high above us, frontal and imposing. The barns on the property and the surrounding forest, shrouded in mist, seem incidental to the

character of the house. In composition, "Victorian Majesty" is quite similar, but in every other way our response to the world of the picture is different. Rather than the mound of rough, open ground that separates us from "Country Castle", our approach to the house in "Victorian Majesty" is made a welcome one as we walk or drive up the curving roadway. And though we must still climb a rise to reach the house, it seems to anticipate our arrival, drawing the barn and trees around it like a cloak, assuring us of a secure haven and warm protection, even in the midst of winter.

This change of character — accompanied as it is by a change in style — is, perhaps, most fully developed in the painting "Warmth of Winter". As with "Victorian Majesty", the perspective is such as to set our viewpoint off to the left with the house slightly elevated above us at the end of a curving driveway. But from here Trisha develops a complex balance between the notion of inside and outside with layers of meaning contrasting warmth and winter. The lights from the house reach across the snow towards us, signals of a warm refuge. But the landscape, too, is lit by the setting sun, which repeats the glow from within the house. The disc of the sun is echoed by the tire that is strung up to a branch of the tree, and this subtle reprise both evokes memories of children's games in the summer past and anticipates the return of the season. Here, although the painting includes no figures, the artist's way of building the picture strongly suggests human presence; life within the house is as much the subject of the picture as the house itself.

At the same time that she made these changes in her paintings of buildings, Trisha also began to broaden the range of her subjects, in particular to include interior scenes and themes of family life which responded to her personal experience as the mother of a growing family of a boy and two girls. Such subjects have been the dominant feature of her work over the past ten years. The notion of a close focus becomes stronger still as Trisha concentrates on observing and recording the small events of everyday life: a mother's sympathy for her son's injured thumb in "The Little Carpenter", the inexhaustible attraction of water for play in "Bathtime". The subjects for paintings invariably arise out of events in Trisha's life, and although she may alter the particular details of an incident in the course of working on a picture, the essential character of the experience remains substantially present.

The appeal of Trisha's work in its subject matter arises from her ability — which means, in fact, from her particular vision — to transform the truth of her own experience in such a way that the images she creates appear immediately addressed to the

spectator; specific in locale and detail and yet, somehow, timeless. From her earliest independent work, expressing a sense of place has always had special significance for her. And this has been as true for deciding where to live as it has been for the settings of her work. With their growing family and the development of their gallery, Trisha and Gary needed to move to an urban setting. Niagara-on-the-Lake, with its special charm, its parklands, and a determination to preserve its architectural heritage, was their immediate choice. They purchased one of the fine old homes close to the town centre and began renovations. To begin with they combined home and business, with their home above the gallery and Trisha setting up a studio that overlooked the garden. They soon found, however, that they needed more space for the gallery and for their own living and Trisha a more isolated place in which to work. They were able to acquire a beautiful old home on the outskirts of the town, the core of the house built in 1829 and then extended over the years. Trisha moved her studio into the house immediately and then began supervising its restoration, taking every advantage of the elegantly shaped and well-proportioned spaces of the building.

It is a telling factor in the purpose of her work that the house that is now home for her, Gary, and their family should have been, to begin with, her studio; that not only is the house the centre of her life, but she was first at the centre of the place towards which her family life was drawn.

The shift of emphasis and focus in her subjects that I have described as coming at the beginning of the 1980s involved also, as I have mentioned, a shift in style. The change is distinct, responsive to a different way of thinking about the depiction of light and the relationship between colour and drawing. In her earlier work, following an approach that was well established in watercolour painting, Trisha used the soft and fluid character of watercolour in such a way that the medium itself comprised the unity of the picture, modified here to form a building or figures, there to represent trees or sky. The range of colours was used as tonal modulations with stronger accents for emphasis, but with the local colour of objects subordinate to the overall character of the light.

In her more recent work, and certainly fully developed by the mid-1980s, it seems that light, rather than the painting medium, is the vital, unifying source, light that is intense and revealing. It is as if rather than seeking to represent light as a sort of substance enclosing objects, Trisha accepts light as a searching energy, responding in complex and infinitely variable ways as it interacts with a multitude of shapes and

colours, textures, and reflections of three-dimensional bodies and objects. The result is one that brings a new clarity and openness to the paintings, while at the same time allowing her the freedom to use colour in as bright and high-key a way as she wishes. How complex this can become — and how adeptly accomplished — can be seen, for example, in "The Kitchen Elf", where there are four different sources of light, each distinct in colour and intensity and yet blending their different effects on the surfaces that they illuminate. Look, for instance, at the two paintings "Bathtime" and "The Christmas Story"; none of the local colour of objects in either picture is lost or compromised, yet the first is filled with strongly reflective surfaces and the latter with soft and absorbent ones.

This control over the depiction of light and its range is accompanied by the strong and clear assertion of Trisha's drawing. She is able to give close attention to detail without jeopardizing the wholeness of the surface, without having it break up into a multitude of points of attention. What she has come to combine in her paintings of recent years is, in a way, a contradiction — that is, holding the fleeting and continually changing character of light to reveal the solid and permanent forms of figures and objects. To achieve this, to make the contradiction work, demands a sure but light touch. Watercolour is a relatively swift-drying medium; the artist must take advantage of its fluidity and the transparency of its colours. But the advantages of the medium are exacted at a price: watercolour does not tolerate change or reworking, the transparency of its colours is easily lost to become muddy and opaque pools. The secret is to hold the unity of the surface with the whiteness of the paper, which reflects light beneath the films of paint.

Without going beyond the range of themes that has occupied her for the past decade, Trisha finds and will continue to find in her surroundings and in the events of her life and that of her family the subjects for her work. The possibilities are inexhaustible. In her work of the past year or so, she has broadened that range again with a number of open-air subjects, such as "Sea Treasures", "First Mate", and "To the Beach". She has met the challenge of these subjects with a heightened confidence, certain in the unique personality of her style and looking forward to the challenges with which her work will always present her.

David Burnett
Toronto, January 1992

AN ARTIST'S LIFE

"*I*F I DIE THIS NIGHT, I WILL DIE A TOTALLY CONTENTED HUMAN BEING." I WHISPERED these words at the end of an unbelievable day in Lautenheim, a remote village in France where, for the first time, I had met my relatives in the old world.

In the middle of a long trip to Europe, I had been drawn there, not knowing what to expect but eager to see the home of my ancestors.

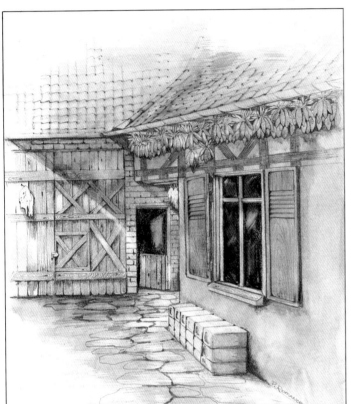

Entrance to great-great-grandfather's workshop

Before I knew it, surrounded by loving relations who a moment before had been perfect strangers, I was entering the house that my great-great-grandfather had built. As my cousins proudly took me on a tour, I couldn't help but become a tangle of emotion and inspiration. When they opened the door to my great-great-grandfather's workshop, I felt close to him, just as I had felt when I spent hours in my grandfather's workshop, catching curled wood-shavings as they flowed from his plane.

It was a moment of contentment never to be forgotten, and in an attempt to capture it, I sketched the doorway that had welcomed me into the house. Looking back, I think this moment crystallizes my experience as an artist, combining my love of family and surroundings with my need to record them in my painting.

This need and desire to capture such moments has been part of me for as long as I can remember. So when people ask, "When did you become an artist?" I answer that I believe it isn't a case of becoming as much as it is a state of being.

While the simple desire to understand shape and colour is very natural to any child, it is the artist in you that never lets you outgrow that desire. In my case, the wonderful release of expression that art offers took many forms, but it always seemed to be influenced by my surroundings and the things that were important to me.

Ours was a simple, cozy home, yet rich in love and faith. We were always encouraged to do the best we could do, whatever that might be. As the second in a family of four daughters, in my early years I shared many moments that nurtured the feelings and values implicit in my work today. Those moments formed a cohesive memory, a bond that can never be broken, and for that reason understanding them is important in understanding my art.

I had a typical country childhood. Summer days were filled with catching butterflies and frogs, building forts in the woods, and fishing for sunfish in the creek. Winter was

Artist (centre) with father and sister Nanette

magical, with deep, billowing drifts of snow, thrilling toboggan runs, and a pond where we would skate by the light of the moon.

In our basement my mother set up an exciting, creative space. While the wood stove kept us warm, the work table and chalkboard kept my sisters and me busy for hours. We were allowed to paste anything we wanted on the wall with our homemade glue. True freedom of expression!

My early years were not, however, without pain. When I was four years old, I developed an ulcer on the cornea of my right eye, which eventually threatened my sight and had to be cauterized. My eyes were bandaged and I was put in isolation at the hospital. It was a traumatic experience, but I knew that I was not being abandoned; I had my favourite doll, and somehow I knew that God was always there.

I believe it was a miracle that saved my sight. When the bandages were removed for good, I felt an indescribable sense of light, freedom, and happiness. This experience was the beginning of my deep faith, which has remained firmly grounded ever since.

It was also another beginning, a new appreciation of sight. In my attempt to capture everything I saw, I began to draw. At first I drew what I knew well at the time — hospital rooms and nurses. When that subject had been exhausted I moved on to the things around me that I loved — horses and barns. And I have never stopped drawing what I see around me.

Crayon drawing of uncle's barn, done at age six

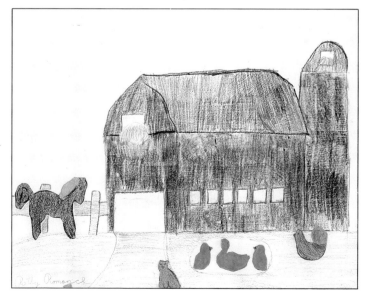

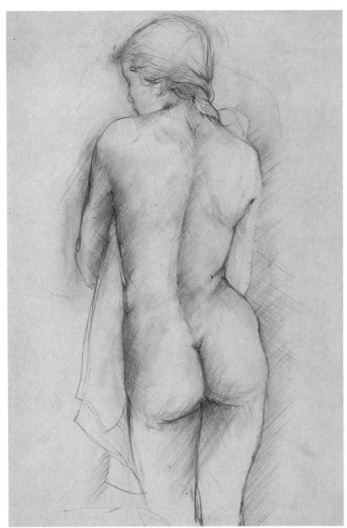
Nude study done at Sheridan College

Working on a project at Sheridan, fall 1969

Every young artist needs reassurance, and when I was in the first grade it came to me in the form of a first prize in a small school art competition. However insignificant it may seem, this small taste of recognition was a great source of encouragement to me. In the years that followed, as County Fair time drew near, I would prepare pieces for entry in the various categories of art competition. This was never an easy thing to do because the perfectionist in me was never satisfied, so pieces never seemed finished. Needless to say, I was always amazed when I saw a first- or second-prize ribbon on my work.

When I entered junior high school, not only did I find diverse and exciting art materials, but the well-stocked art room won my undivided attention. While other subjects were work for me, art became a passion. I was soon involved in every aspect of art activity in the school. Requests came to me for signs, brochures, floats for parades, and murals for proms. While my sisters were busy joining the cheerleading squad, I spent my hours after school busy in the art room.

In all of this I was greatly influenced by a superb art teacher, Mrs. Collins. Although at first she seemed severe, she was able to make the discipline of art a source of tremendous energy. I sensed that she believed in me, and thus I believed in my own possibilities. When she chose me as art editor of the school year book, I feared it but also welcomed it.

By the end of my senior year, I had developed a healthy portfolio, and with that I managed to win a scholarship to a respected school, but I decided after one visit that I did not feel comfortable in or inspired by its setting.

Even though it meant a move from my home in the United States, I found my answer in Canada, at Sheridan College in Oakville, Ontario. Surrounded by fields, forests, and farms like those of my home, I knew that it was a place where I could nurture my art.

Although I became particularly engrossed in life drawing and fashion illustration at Sheridan, I found my charismatic art history instructor captivating. He instilled in me a desire to know the masters of the past, to see face to face works I had only known in art books and slides. With that, the seeds were sown for my eventual trip to Europe.

When I graduated from Sheridan in 1971, I had to make a decision about a career.

Much depended on my portfolio, which featured mostly fashion illustration.

It was a brave art director at a department store in Buffalo who took me on, and my first published work appeared in the *Buffalo Evening News*. It was the chance of a lifetime that any fresh graduate would envy. But within six months I was requesting a leave of absence. With deadlines and prescribed illustrations, I felt that I was losing sight of my own creativity, the very thing that energized me. I needed to travel, and most of all I needed to see with my own eyes the masterpieces of the great artists of the past.

Leaving America, I criss-crossed Europe, following instinct and good weather, seeking out the work of the masters everywhere I went. I will never forget the first time I set foot in the Van Gogh Museum in Amsterdam — and surrendered to tears. A guard came over and asked me if I was alright, and I had to explain to him that I was just overcome with the power of it all.

And so it went with every "meeting" I had with the great art of Europe. When I arrived in Florence, I quickly made my way to the Accademia, where I knew Michelangelo's "David" lived. He caught me totally by surprise. As I rounded a corner, there he was under a skylit dome, standing powerful, beautiful, ready to sling the waiting stone at Goliath. I slumped to the floor, pulled out my journal, and sketched him, never to forget him.

Statues of every sort, both whimsical and religious, began to fill the pages of my sketchbook, in order to satisfy my craving for life drawing. Statues were a superb substitute for human figures: I could choose any angle and sketch away.

Italy inspired me to continue my study of the human form, but my passion for architecture was kindled in Athens. I had arrived in the middle of the night and found a rooftop on which to sleep. But when I looked up and saw the Acropolis lit by the light of a full moon, I was unable to sleep. I was drawn to it like the tide to the shore.

Creeping past guards, I climbed to the top and wandered among the Parthenon, the Erechtheion, and the Temple of Nike Aptera. Totally alone throughout the night, I was moved beyond inspiration, something I had never experienced. I was humbled. The perfection

Fashion illustration project, 1970

Journal sketch of Michelangelo's "David", 1973

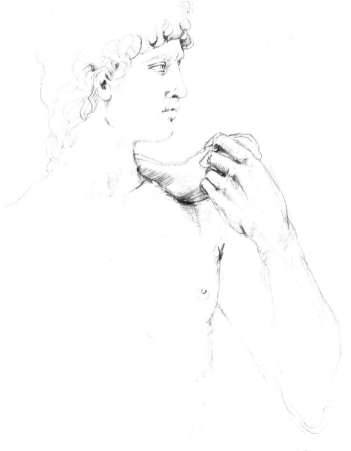

of the place seemed so complete that I could never duplicate it on paper. I didn't even try.

It wasn't just the art of Europe that inspired me — it was also the people I met. One was a woman in Munich who left a lifelong impression on me. She was not an artist in the literal sense of the word, but she had an artist's heart. She would gather people up and whisk them away, on foot, to the Deutsch Museum or the opera. Off she would float, steps ahead of you, her cape flying. Her energy and love of the arts were absolutely infectious. She felt what I felt when viewing the works of Monet, and it was through her that I located a painting I had been looking for by Carl Spitzvig, called "The Poet". Uncannily, it was also a favourite of hers. In her company I felt as though I was in a storybook, and so I named her "Mother Goose".

There seemed to be no limits to the inspiration Europe had to offer me, and what was to have been a six-month trip stretched to two years. In my second year there I headed northward to Sweden, in search of snow for my favourite season, Christmas.

I stayed with a couple I had met that summer who were planning a move to the mountains in Lapland. When they asked me to go with

"Mother Goose"

them as nanny to their little son, I accepted the chance to settle for a while. After a few weeks with the family, I retreated to a solitary cabin of my own and began to paint in earnest.

In the long hours of darkness of a Swedish winter, I was very productive. I would work tirelessly into the wee hours of the morning. Surrounded by Swedish folklore and sculptures of gnomes of every sort, my drawings reflected this storybook setting. Greatly influenced by the keen Swedish sense of design and cleanliness of line, I also began to create paintings of the landscape using only shape and bold planes of colour.

It was the local Laplanders themselves, however, who affected me the most. As they would pass by my cabin with their herd of reindeer, I couldn't help but think that these were true artists, so full of colour, creative resourcefulness, and energy. In spite of their constant migrations they were beautifully content. I had much to learn from them.

Their works of art and handcrafts always had a symbolic nature, giving me new

Figure from Roman fountain

Maple key fairy, sketchbook study, Europe, 1973

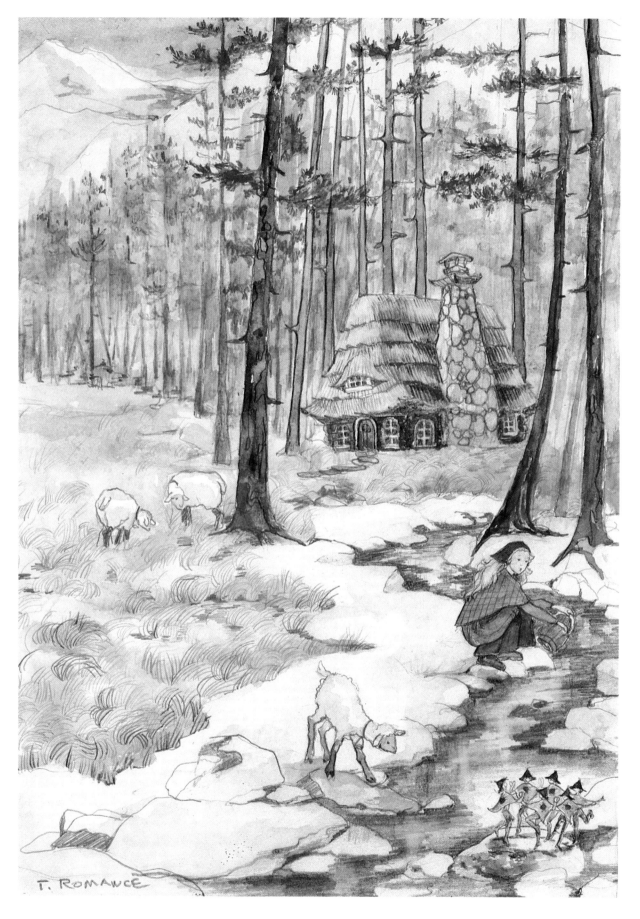

T. ROMANCE

Dancing fairies, watercolour sketch, Sweden, 1973

Landscape in acrylic, Sweden, 1974

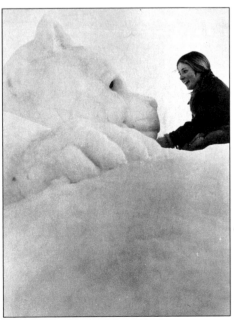

Artist with ice bear

inspiration. When they discovered that I was a fellow artisan, I discovered how generous they could be. All of their jewelry and crafts were a beautiful reflection of what nature had given to them, and they freely shared them with me.

I might have stayed in Sweden forever if I hadn't attracted attention from an unexpected source. It seems that a picture of a twenty-foot-long bear that I carved in ice not only made local news, but reached Stockholm. Or perhaps I shouldn't have allowed my picture to be taken and used in a tourist brochure. Whatever the reason, one day two immigration officials appeared at my door and served me with deportation papers.

Under a midnight sun, I said goodbye to Lapland. But there was one more revelation in store for me in Sweden. I had been told that I must go to Stockholm and see the works of Carl Larsson. Somehow my work had reminded my Swedish friends of his art. Before I left, I did just that, and found in him a kindred spirit. With definite intentions of returning to Sweden as soon as I could afford to, I ended up in Toronto and began to make plans ... but God had other things in store for me.

My first pressing need was to earn money. After renting an apartment, I found a job selling other artists' paintings door to door. It wasn't easy, and was certainly not what I had imagined myself doing, but at least I had managed to avoid the proverbial nine-to-five routine.

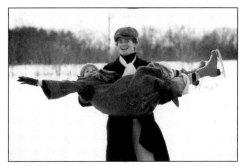

With Gary about the time we met

In the meantime I had received a phone call from a friend I'd met in Germany. He had just returned to Toronto and wanted to share the trauma of culture shock with me. On our way to dinner, we passed the family home of an old friend of his, Gary Peterson. It had been years since they had seen each other, but my friend was curious to see if Gary still lived there.

Since I was now used to going up to strange doors unannounced, I quickly agreed. Little did I know that when this door opened, my life was about to change forever. Gary answered the bell.

The two friends instantly recognized each other, and briefly spoke of the good old days. Although I certainly had no intention of staying long, I managed to talk a blue streak. When I finally gave Gary a word in edgewise, he went on to say that he was an actor "between pictures".

"Perfect", I said. "You can come and work with me. You'll be on stage every time a door opens!"

He arrived at work the following Monday, and we quickly became friends. Every

Early watercolour of Ontario barn, 1975

time we were together, we would talk about anything and everything. Without realizing it, we were on our way to becoming a team.

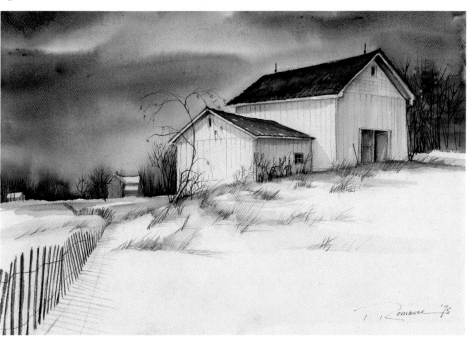

Gary quickly became the top salesman of the crew, and I decided that it was time to step down. I was anxious to get back to my own painting. Offhandedly, I mentioned to Gary that maybe he could sell my work. "I didn't know you were an artist!" I can remember him saying.

"Of course you wouldn't know. Everything is still packed away under my bed and in my closet!"

As I showed Gary my work, we talked late into the night. The next day, out came the watercolours and other supplies as I organized a primitive studio. As always, I painted what I saw around me, and the work

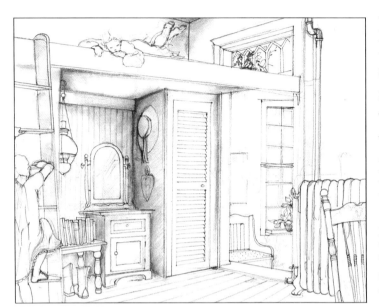

Study sketch for "The Loft"

I started to do now was completely different from what I'd done in Europe. While on trips to the countryside around Toronto in search of subjects, I noticed beautiful homes and farms that lay in the path of future development. The contrast to what I had seen and felt in Europe was astonishing. There, homes were often hundreds of years old. Why would we allow our heritage here to be torn down in the name of progress? My new mission became preservation, and one way to accomplish it was to paint these places before they disappeared.

In need of proper studio space, I rented a very reasonable apartment in the Annex area of Toronto, neglecting to notice that it didn't have a kitchen sink or a sleeping space. But it had a quaint fireplace and, best of all, great light! Eventually I designed a loft area, which Gary built. The result seemed to have the makings of a fun painting, and it did indeed become one of my first paintings in Canada with people in it, "The Loft".

To make ends meet, I began painting for my former employer — seven to ten paintings a week! When Gary found out how little I was getting for them, the arrangement was short-lived.

With Gary helping me, I soon realized that every artist needs a good manager. But Gary was to become much more than my manager. About this time, our friendship became love. In 1977, two years after our chance meeting, we were married and went on a three-month honeymoon trip across Canada and the United States.

Feeling newly focused, we returned home to Ontario and I continued showing my work at outdoor art shows and juried exhibitions.

Demand for my work was growing steadily. Seeing the frustration I faced in trying to keep up with it, Gary explored the idea of limited-edition prints. In order to maintain quality, I needed to spend more time with each painting, and producing prints now allowed me that luxury.

While this was going on, we were about to undergo a monumental change. I was pregnant, and we decided that it was time to move to the country, where we rented a farm, a quiet place to raise our child.

While our friends thought we were making a radical move, I knew that we would not miss the city. After all, I was a country mouse. We would have a garden, a scarecrow, and a clothesline, and in my country kitchen I could make jams and preserves, capturing summer in a jar.

At one of many outdoor art shows, 1976

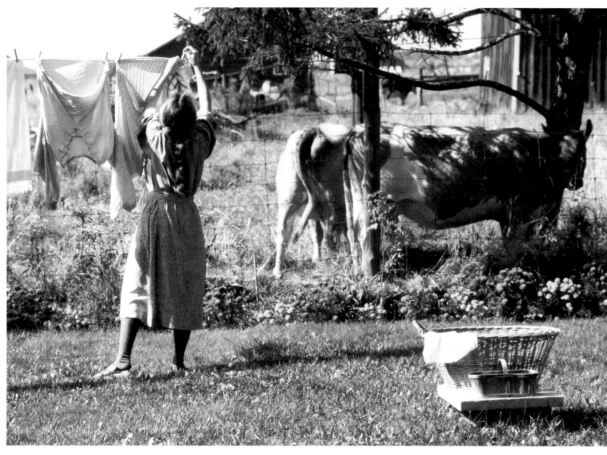

Hanging laundry at the farm

"When the chestnuts are ripe, our child will be born," I wrote in my journal. Months later, on a glorious Sunday afternoon, our beautiful son was born. We named him Nathan, which means "Gift from God". There was a carpet of chestnuts on the ground the day we brought him home from the hospital. I took him into every room of the house, introducing him to his new world. When I finally settled him into the waiting cradle, I couldn't help but think he truly was a gift. How, after experiencing this new life, could I paint only "empty" homes and barns?

The maternal instinct is among the strongest in nature, and for centuries it has inspired the work of many artists, from religious depictions of the Madonna and child to Mary Cassatt's paintings of mothers and children. With the birth of Nathan, an old passion was revived in me. I slowly began to put people and small children back into my work again, with Nathan as my special subject.

I felt that it was very important to make our home the base for our business. I couldn't imagine myself going from gallery to gallery while Nathan was young.

With Nathan in the studio at the farm

At the same time, it also seemed important that the people who bought my work have an opportunity to experience the environment out of which my paintings came. For these reasons, we decided to try having an art show at the farm.

I will never forget the first one, in the fall of 1981. Our application for a grant to cover the framing costs had been declined, and putting together a one-woman show seemed financially almost impossible. We employed the assistance of anyone willing to bake goodies for the three-day ordeal, while Gary framed madly and installed the necessary lighting system. In the nick of time I finished wallpapering, painting, spring cleaning — and my paintings.

We had mowed the front field to make a parking lot. While my father stood waiting to direct drivers with his trusty flashlight, all was more or less ready for "Opening Night".

Financially strapped, emotionally drained, and physically exhausted, we began the wait. In the gabled window upstairs, I stood, insides in knots, watching for any light other than my father's flashlight.

Then, as if all my anxiety had been in vain, a pair of headlights came down the long lane ... followed by another, and another. Soon the farmhouse was spilling over with people. It was a sellout show, as were all the others that followed.

The thought of leaving the farm we loved was very distressing, and yet we knew that we could not stay there forever: we were only renting it, and the area was threatened by development. We began to look for a home to raise a family in and further develop our fast-growing business.

Our search ended abruptly in spring 1985, as soon as I saw the town of Niagara-on-the-Lake, nestled quaintly on Lake Ontario at the mouth of the Niagara River. It was a town like no other I had seen in the United States or Canada. As we came upon the main street, a boulevard made for parades, my eyes went to the clock tower. Like many towns I had loved in Europe, this one had a heart that ticked! The fact that it was a place steeped in history was a pleasant bonus. Around every corner, another subject for a painting appeared.

Here was enough magic to keep me inspired for the rest of my life. After another successful show at the farm, we were able to buy the historic home we had seen earlier in the spring.

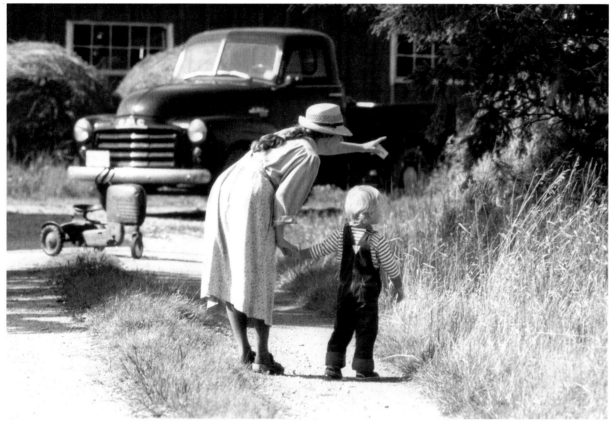

A walk down the farm lane with Nathan

It wasn't easy leaving the farm, which had nurtured us so much. I was pregnant with our second child when I took Nathan for our last walk out to the barn and the fields beyond. We said goodbye to the cows that had calmed us, to the picnic rock that had warmed us, to the old tractor that had always welcomed us, to the barn ramp that had given us a view, to the orchard and fields that had given us space. For five years this place had been my inspiration and delight. As the view became blurred with tears, I thought to myself, thank goodness for paintings: they make a great place for memories.

Although we would miss the farm, we had a lot to look forward to, and a lot to do. It took long months of work on our new home in Niagara-on-the-Lake to get it ready, just in time, for the birth of our daughter, Tanya.

As I've often said, there is only one thing better than having a child — and that's having two! Foolishly, I feared that somehow there wouldn't be enough love to go around. Miraculously, it multiplied.

Feeling as I did that we were really a family now, paintings were also multiplying

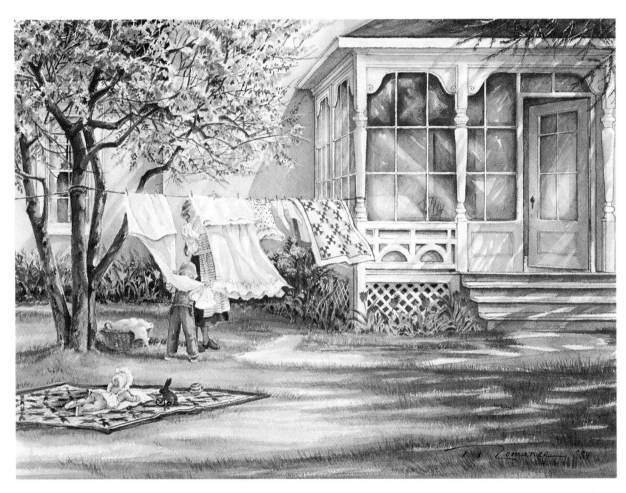

My old sun-porch studio, as it appears in
"The Entertainer"

in my head with each passing day. The interactions of Nathan and Tanya at play, as well as our daily outings, became the subjects of my sketching and my now precious painting time. I sometimes felt that there weren't enough years in life to paint all that was being imprinted in my brain. Somehow, if I could get it down on paper, even in the form of a thumbnail sketch, then I was at least temporarily satisfied.

Unfortunately, the best moments in life are often fleeting. My camera is a useless tool when it comes to capturing spontaneity — the roll of film always seems to be on its last exposure, with no replacement film on hand. Since having children I've become a resourceful artist out of necessity. I make "imprints" visually, mentally, and emotionally. Additional, less important details I can retrieve later when my camera decides to co-operate. The moment of a painting's conception coincides with this mental etching process.

The sun porch at the back of our new house became my studio, the place where all of these imprints eventually became paintings. But as the gallery we opened at the front of the house became increasingly busy, I found that I was missing my quiet life on the farm terribly.

And so our search for a farm began. Doors closed on every plan until one day we heard that a house I had longed to paint was for sale. It was a home well beyond our means, but we somehow put together enough money to buy it. Initially blind to the tender loving care the house would need, we have made it the home and working space of my dreams.

Before it even had furniture in it, I saw each room in a painting. All that was needed was for a fleeting moment to happen there, and my inspiration would be complete. Sometimes in my anxious desire to see my vision of a room become a reality, I would finish a painting before the carpenter finished his work, as was the case in "The Christmas Story".

We had just come in from a winter walk and decided to have a fire in the family room. As we snuggled up to read our favourite Christmas book, I couldn't help thinking what a perfect library this room would make. I painted "The Christmas Story" so that the carpenter would know just how the bookshelves were to look. We now have a library created from the painting.

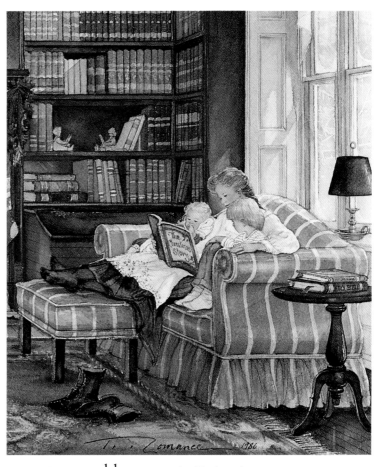

Detail of "The Christmas Story"

Although I've been accused of being obsessed with restoring this house, I like to think of it as giving back all that it has given me. After all, every artist thrives on obsessions and passions. I can fully understand Monet's obsession with his gardens at Giverny, which consumed him emotionally and financially. Similarly, I can relate to Van Gogh's drive to paint sunflowers. I have managed to surround myself with reminders of these on my own property.

Viewers often wonder where ideas for paintings come from. Every artist has his or her own reasons for painting a subject. In my case, certain "cornerstones" must be in place. The first is inspiration: does the subject leave me spellbound, or in awe, causing me to return to it time and time again? The second is truth: does it have meaning, does it speak of values I believe in? The next is love: will the love I feel for it be strong

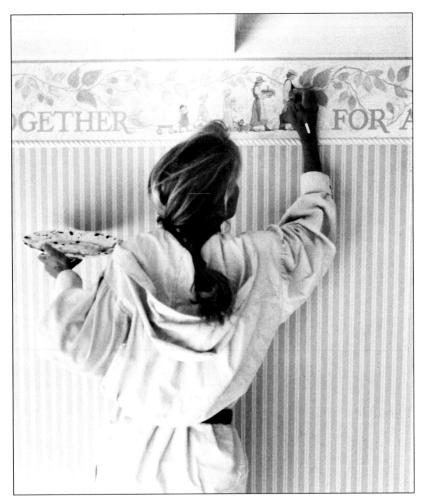

Painting a frieze at home

enough to carry me through the ups and downs of the painting, all the way to the end? Lastly, is there an element of magic in it for me — the way light plays on it and creates a mood? The ultimate magic, however, happens when every cornerstone falls into place, without belabouring thought. Then, almost by surprise, a composition takes shape. For me the cornerstones are truly divine. God has richly blessed me, and I know that it is ultimately His hand that moves mine across the paper. Without question, He deserves all the credit, and therefore my prayerful moments are times of humility and praise. An old needlepoint above the mantle in our kitchen reads "God Bless this Home". I've often thought that it should read "God BLESSED this Home!"

And He did, once again, with our third child, Whitney Rose. Maternal feelings, especially rich because she might be our last child, were likely the power behind my paintings after she was born. Every moment seemed precious, and I decided to make every memory last in a painting.

This was not an easy undertaking, however, as restorations, scheduled shows, interviews, and releases of prints continued to demand my attention. It seemed that my efforts to be supermom, artist, and commander-in-chief of construction were leading me down the path to burnout. Gary fortunately recognized the warning signs before I did, and without hesitation, he abruptly cancelled all my obligations for a whole year. I was going to have a sabbatical.

It was a year that I was to be grateful for. A great load had been lifted, allowing me to restore myself. I turned to painting a fresco-like frieze around our family dining area, which was accompanied by a verse that we sing before meals. Images of my three beautiful children began to appear on special pieces of cabinetry and furniture around the house. Whirlwinds of fabric and rolls of wallpaper fed my desire to see our home complete at last. The grand finale was the sunroom. Christmas in what was then an uninsulated conservatory became my goal. Seeing the lights of the Christmas tree glowing behind hundreds of panes of glass, just two days before Christmas, was a dream come true. As I stood outside in the falling snow, I could

hear the Christmas carols playing and see the children's excitement. And so the inspiration for "Winter Retreat" was born.

My desires as a mother differ greatly from my desires as an artist. While I would love to spend all my time with my children, not missing a single experience, I find myself thriving on time alone spent painting the things they do! Much as it did in my two years in Europe, my best work seems to happen when I am able to be one with it. My third-floor studio is my hermitage, a lofty space as high up as the treetops. When I have been intensely involved in finishing a painting, I have been known to attach a sign on my door for all to see. It reads, "IT WOULD BE WISE TO NOT DISTURB". Interruptions can be calamitous when you are working in watercolours, and so my children have come to know that time alone is vital to Mom. They also know that there will be a time when the "WELCOME" sign is up.

My studio is the place where all my "imprints" come to life, where everything that time, the rogue thief, stole away can be reclaimed, where sketches become the skeletons of paintings to follow.

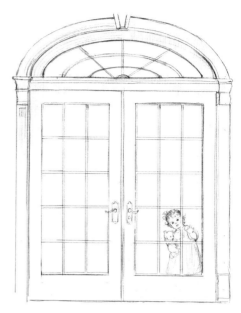

Working sketch of doors to the studio in Niagara-on-the-Lake

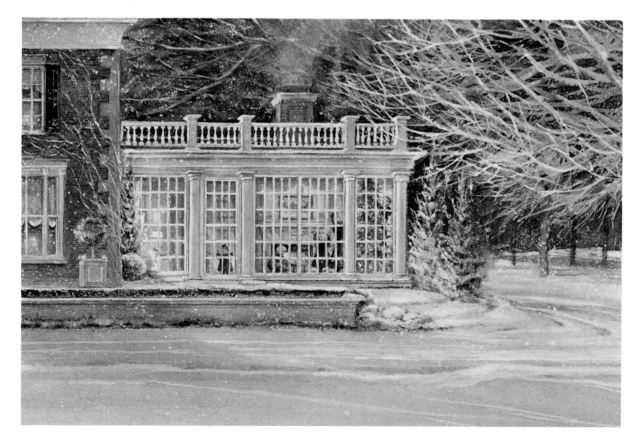

Detail of "Winter Retreat"

Unlike a decade ago, when I worked from photographs to do commissioned paintings of people's homes, I now work on location, returning to the room or spot I need to finish a sketch. When I have done a series of sketches, I lay them out on the floor to see whether they still have the same power for me that they had when I created them.

If they pass this test, they can then go on to the final stage before painting — a finished drawing complete with corrections to perspective and proportions. Sometimes even substantial changes — emotional as well as technical — are made at this point. For instance, in "Mother's Arms", Tanya was in the original sketch, sharing tea with me. Only at the last stage was she erased from the picture, leaving an intimate moment between mother and baby.

I am a strong believer in what I call "active" involvement. A painting becomes "active" when a face is looking at you, the viewer, from the painting. The eyes become the focus of attention, leading you into the painting. A painting is "passive" when the activity or subject draws you indirectly into the painting.

First working sketch for "Bright Eyes"

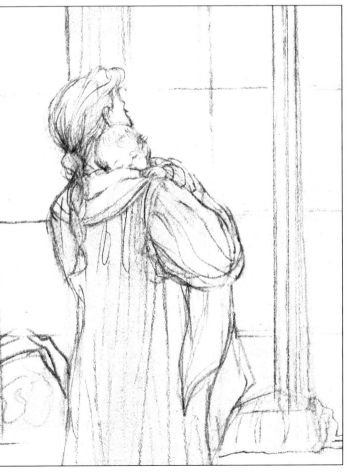

The original sketch for "Bright Eyes" was passive, with Whitney asleep on my shoulder. The painting took on a very different feeling when I decided to tell a more positive story, the story of Whitney's alertness to Nathan and Tanya when they came into the nursery each morning. Even as I painted that little face, I was pulled in, and as a mother, no longer an artist, my eyes filled with tears.

Although colour mixing, technique, and composition are all important, there must be an element of emotion for me to carry on with a painting. If I am emotional about a piece, then regardless of its technical shortcomings

Detail of "Warmth of Winter"

it becomes a part of me, and painting it is much like discovering unconditional love. The resulting painting may not be technically perfect, but for me it has an intrinsic message.

Because light is the beginning and end of all painting, capturing it becomes an artist's greatest voyage. With each painting completed, I make new discoveries. The same subject may be painted a dozen times over, but it is different to me each time, depending on the light. It sets the mood.

When I paint a home, for instance, I like to paint it in newly fallen snow. Not only does snow unveil the true countenance of a home, forming a perfect frame, but it also happens to be a great playground for light!

"Warmth of Winter" was a painting that said all there was to say about winter for me as a child, just by its light. I can remember so vividly coming home near dark in a frozen state after a day of sledding, having lost all track of time and all feeling in my

toes. When I reached home, I loved the way warmth seemed to come from the windows of our house, particularly at Christmas time. Just like laundry hanging on the line in summer, it was a comforting sign that someone was home, waiting.

It is one thing to see light, and quite another to paint it. While every artist develops specific "recipes" for colour mixing, there is a constant battle with the balance of values. With watercolour there is the added problem that light will be lost through overworking an area, and when that happens, the painting is ruined.

Although over the years I've stopped work on a fair number of paintings, in recent years I've done so more rarely. I may get to a point where I believe a painting is going nowhere, but there almost always seems to be some redeeming element that enables me to "save" the work with a little more effort. It's only in the final stages that harmony seems to come to it and pull it all together.

Old masters in watercolour would sometimes apply a sepia wash over the entire surface of their paintings to achieve a sense of harmony and balance of colour. Similarly, I have used a glazing technique with overlays of transparent colour to bring depth, softness, and patina to paintings.

Every artist has personal recipes for colour mixing that become as individual as a signature. Although I always use the basic primary colours, there are also some important pigments, such as burnt umber and sepia, that I use to add warmth to paintings. It was a great personal challenge when I painted "Winter Fantasy", because I intentionally restricted myself to the skill-testing task of using only the primaries to create all the necessary combinations. Burnt umber and sepia were the only other pigments I used. It was a special tribute to the home that has given me so much pleasure.

I think of art as a kind of birth, a constant birth of ideas. For me it comes from observing the best of life, no matter where I may be. At home in my studio, I am surrounded by bookshelves filled with volumes of works by the masters. Influences from every direction are possible. But when I sit down to paint, I must return to one place, the place inside myself where the heart and mind are one, while God moves my hand across the white space.

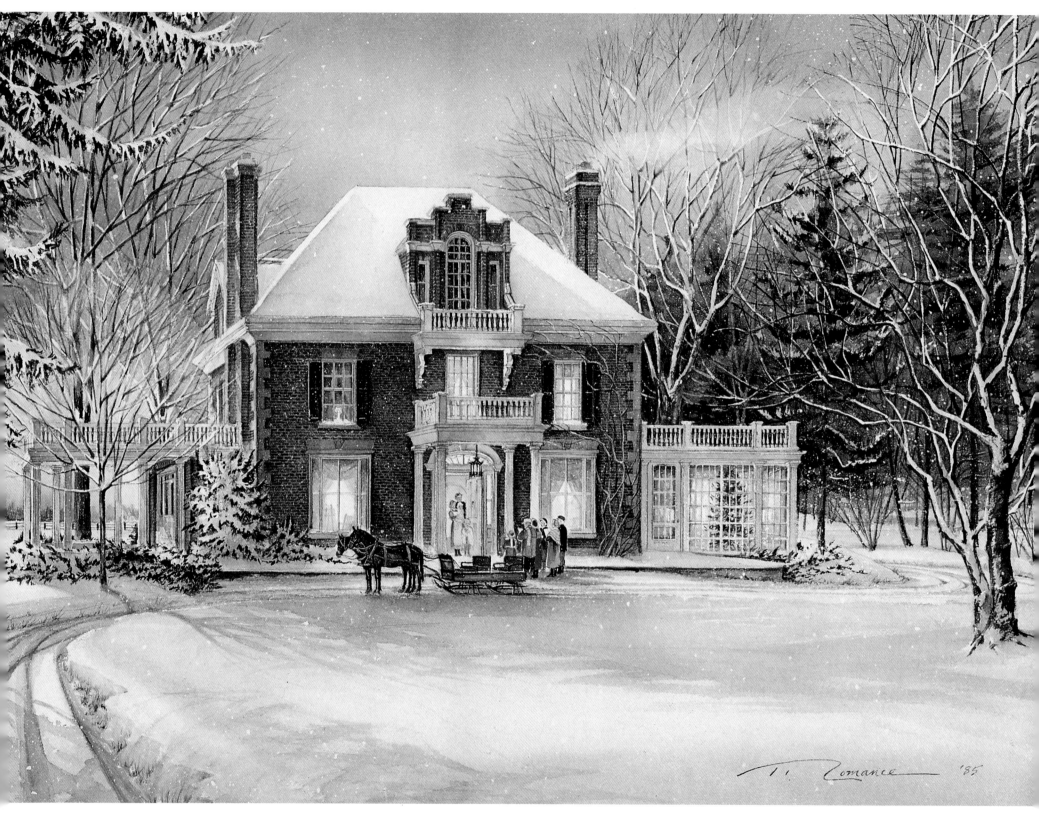

"Winter Fantasy"

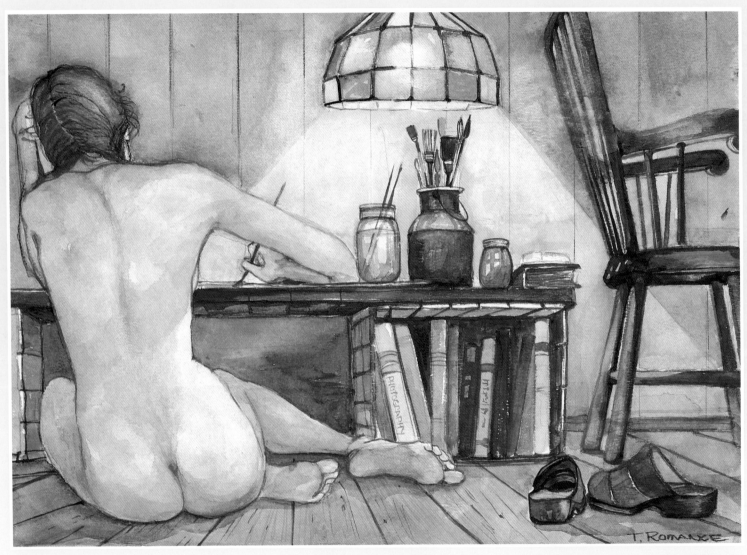

FIRST STUDIO

*T*his painting will always be a favourite of mine because it's full of things I treasure as an artist — my art books, my well-travelled shoes from Sweden, my cherished paint brushes, and my passion for life drawing.

THE PLATES

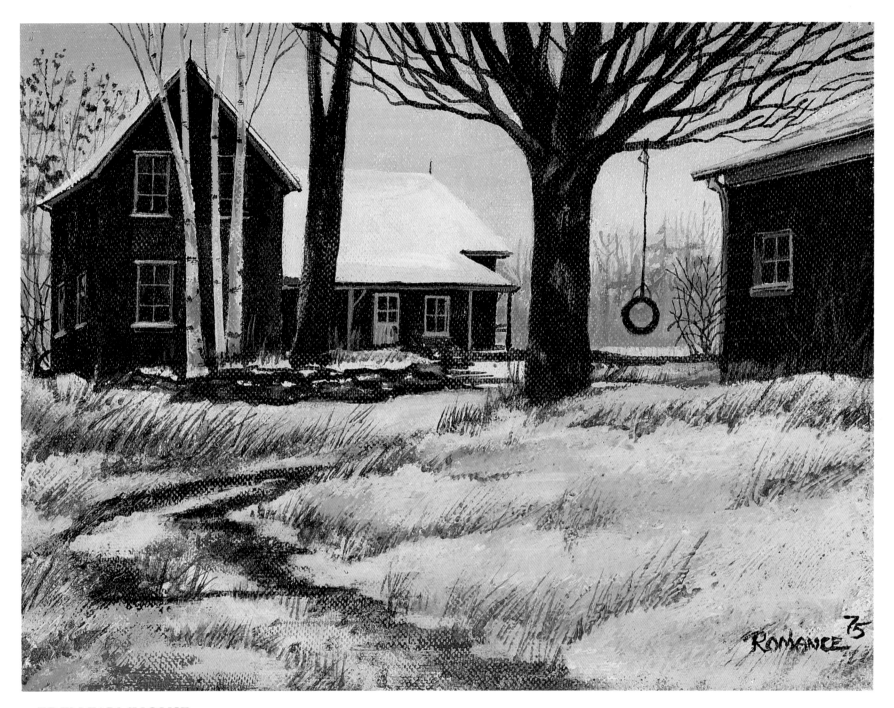

△ EDEN FARMHOUSE

*R*eturning to simple, familiar places near my hometown was a joy when I was working with acrylic. It allowed me the boldness and spontaneity that were so much a part of my early impressions.

▷ SPRING CHASE

*I*t has been said that geese make good watchdogs, and so I found out while painting this fine barn. The geese created such a flurry that my visit was short, and I had to continue my work from a distance.

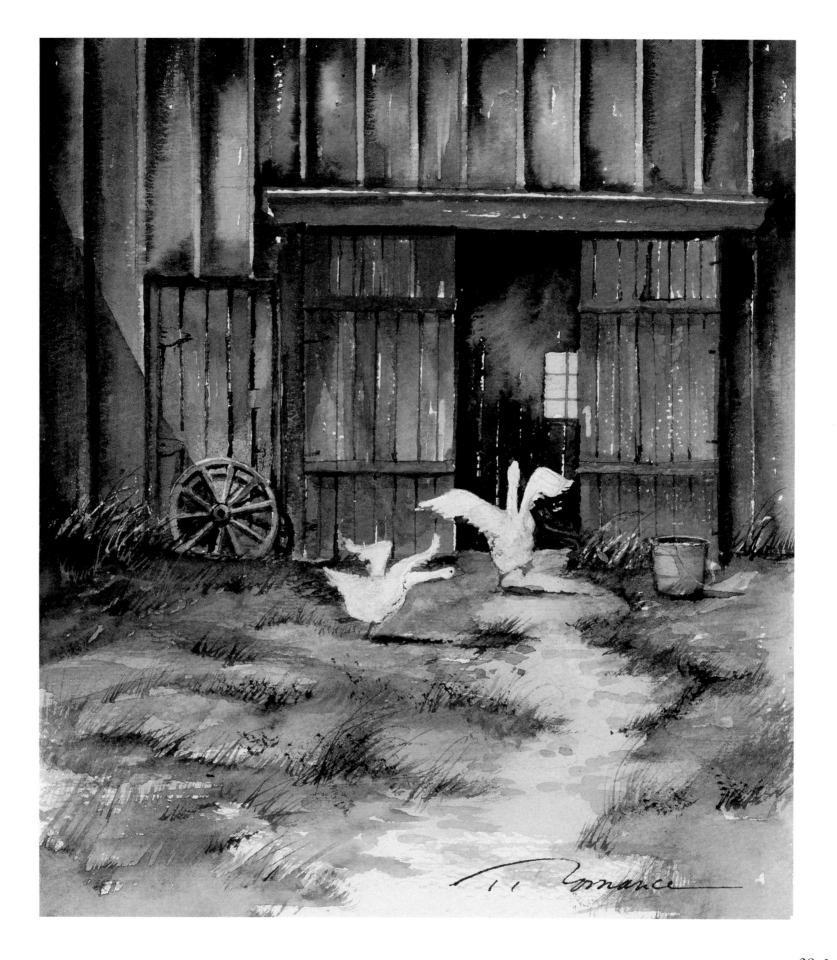

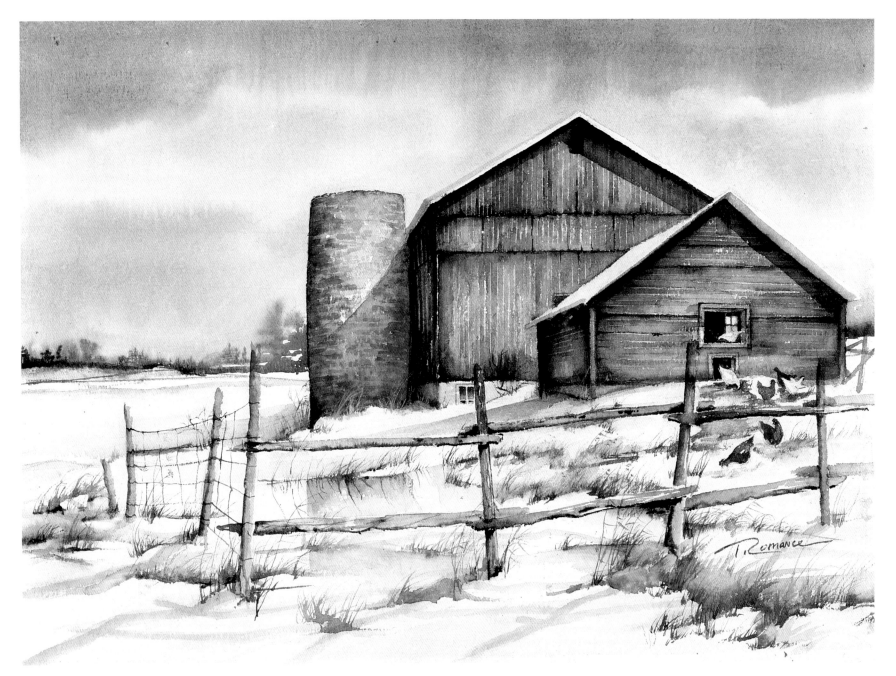

△ MARCH THAW

*O*n my frequent painting trips to the country, it was always nice not to have to trespass. This farm belonged to friends of ours, and unlike many of the abandoned barns I painted at the time, it had an active chicken yard.

▷ OCTOBER WINDS

I've always loved how carpenters seemed to "plant" barns in the landscape so beautifully, thinking always of prevailing winds and using hillsides as natural ramps to the hayloft.

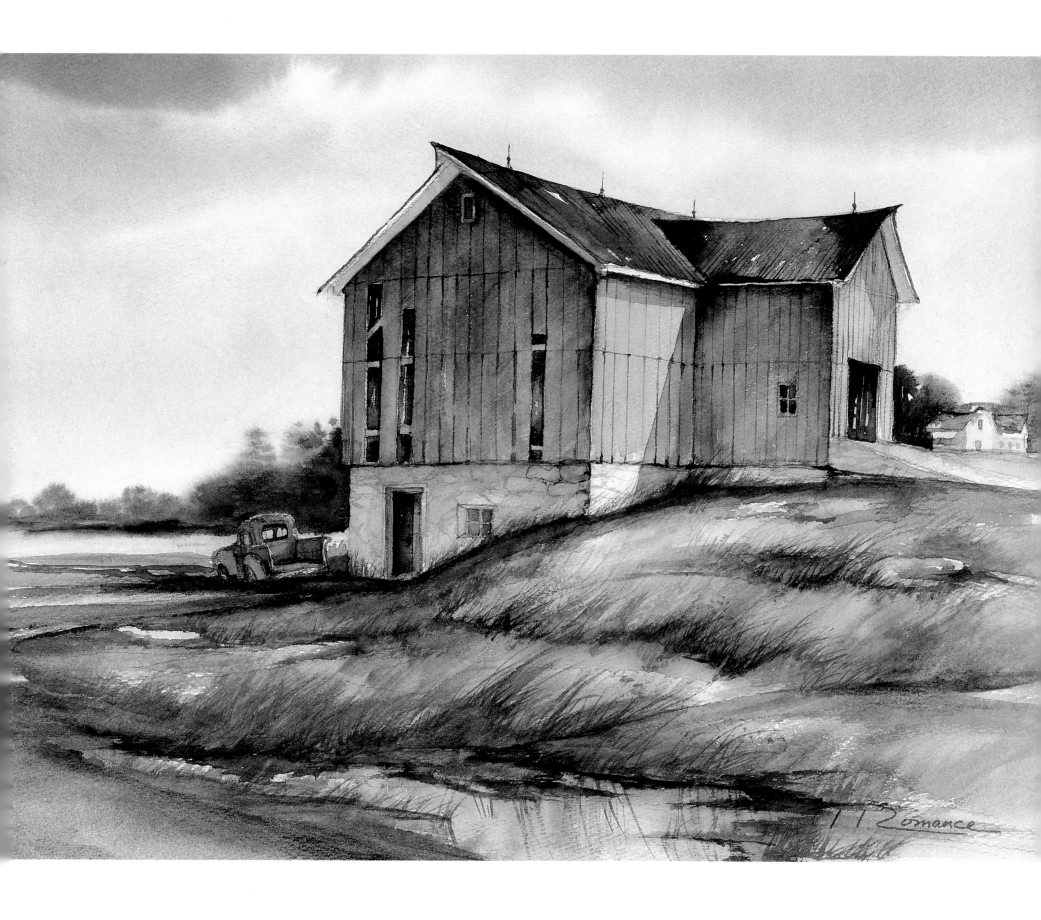

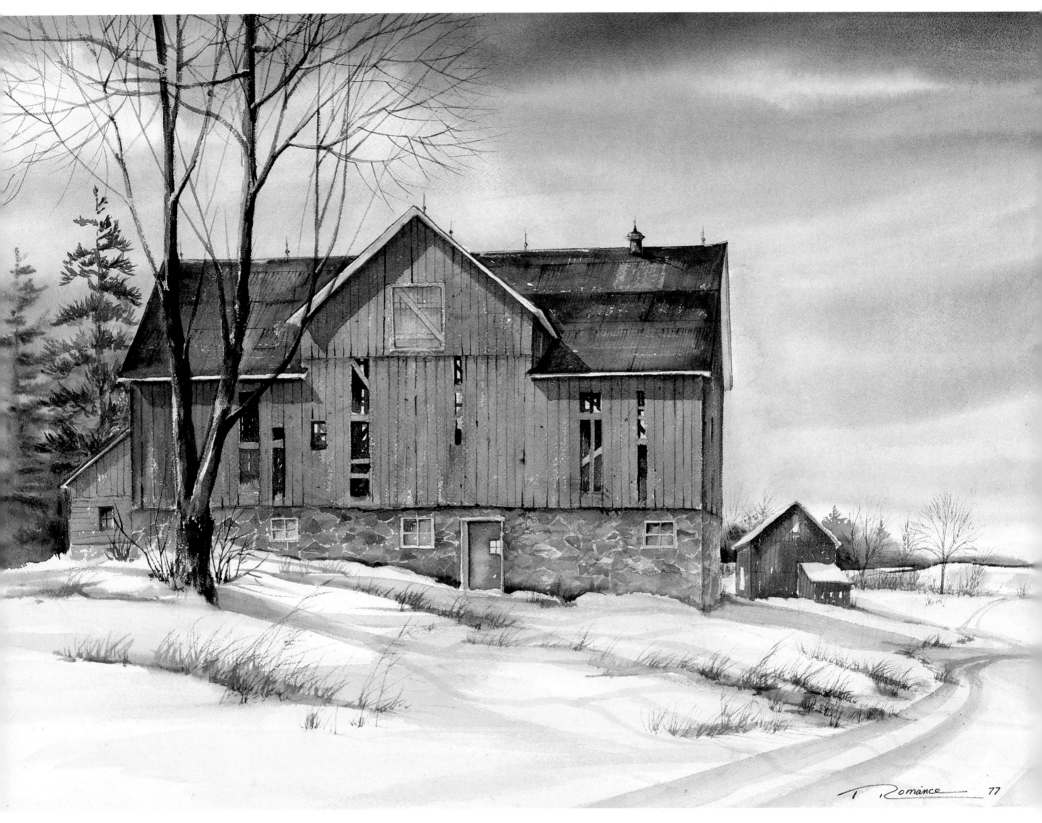

ONTARIO BARN

*A*long the back roads of Ontario, I was ever in search of barns, monuments to our past. Even in various stages of disrepair and abandonment, they continue to grace our landscape with character and history.

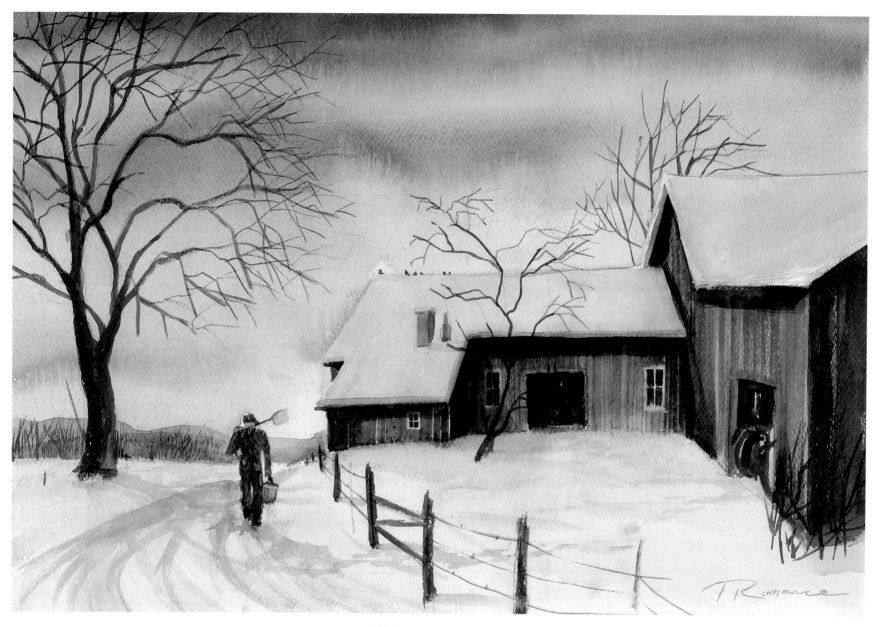

THE FARMER

After painting numerous barns, I found that many I thought were deserted were still full of life. Chores were often under way when I approached, and after a while painting a barn without activity seemed somewhat sad to me.

▷ FARM LIFE

*O*ne of the comforts I found in my escapes to the country was the laundry I would see hanging in farmyards. Like welcome flags the sheets waved to all, a sign that someone was home.

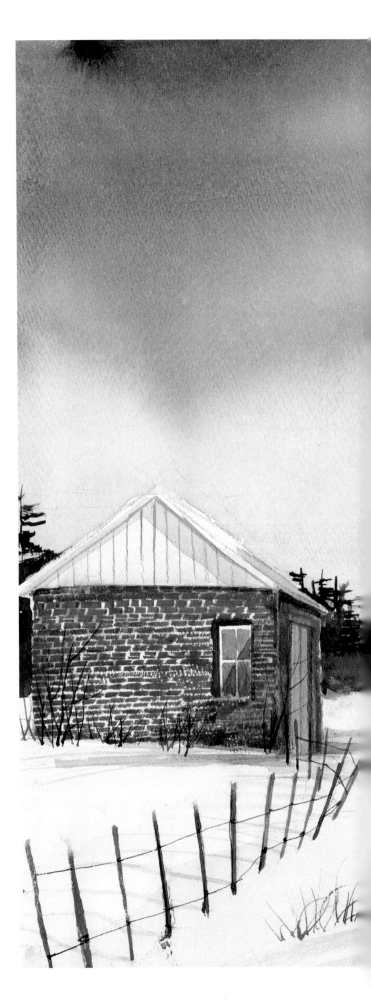

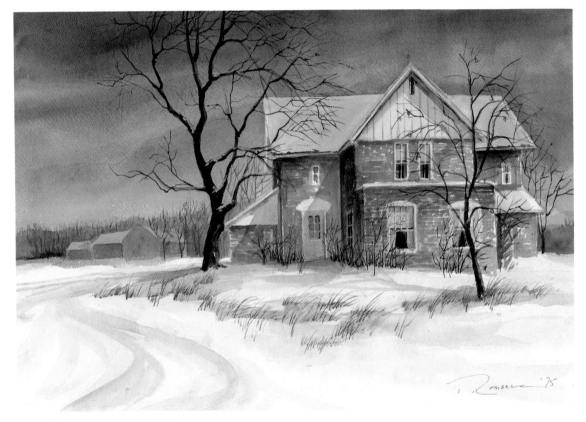

△ COUNTRY HOUSE

*O*n my trips away from the city, sometimes it was the most architecturally unimposing places that inspired me. Their uncomplicated simplicity, so different from city life, drew me.

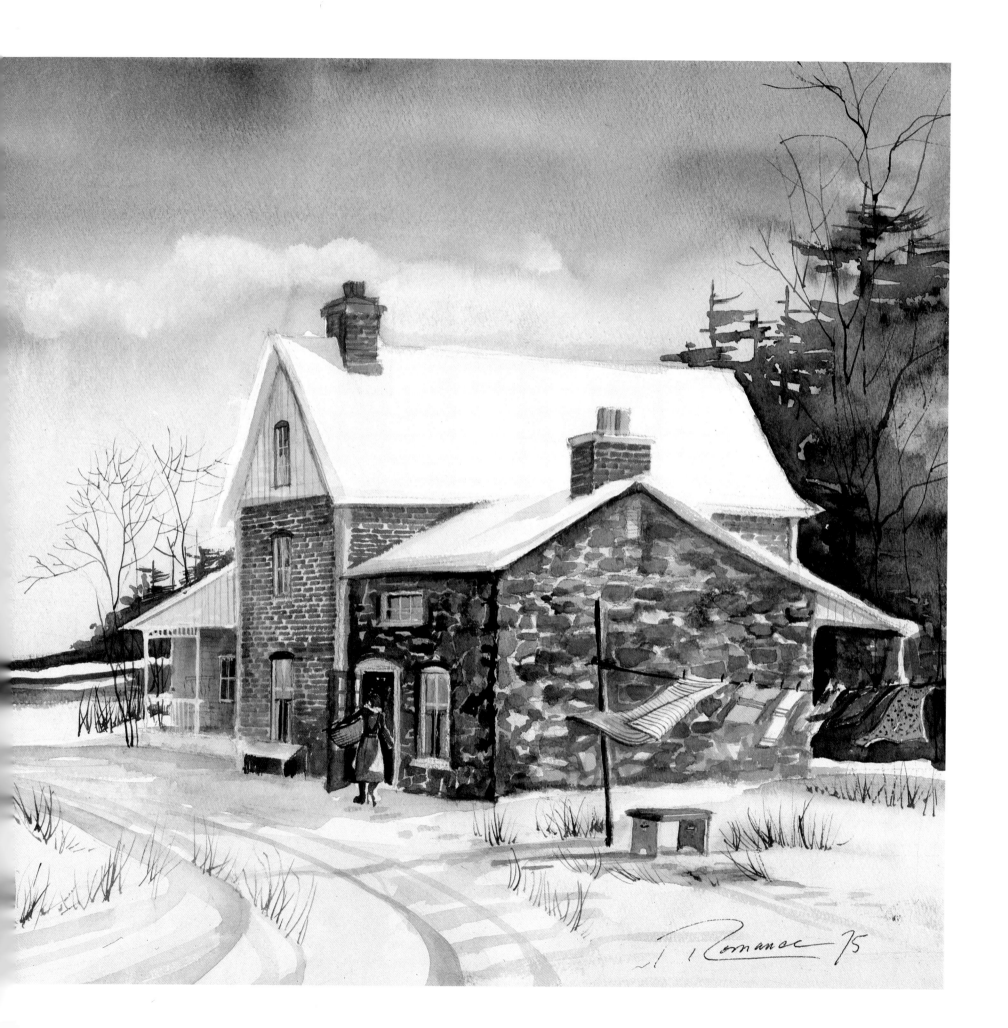

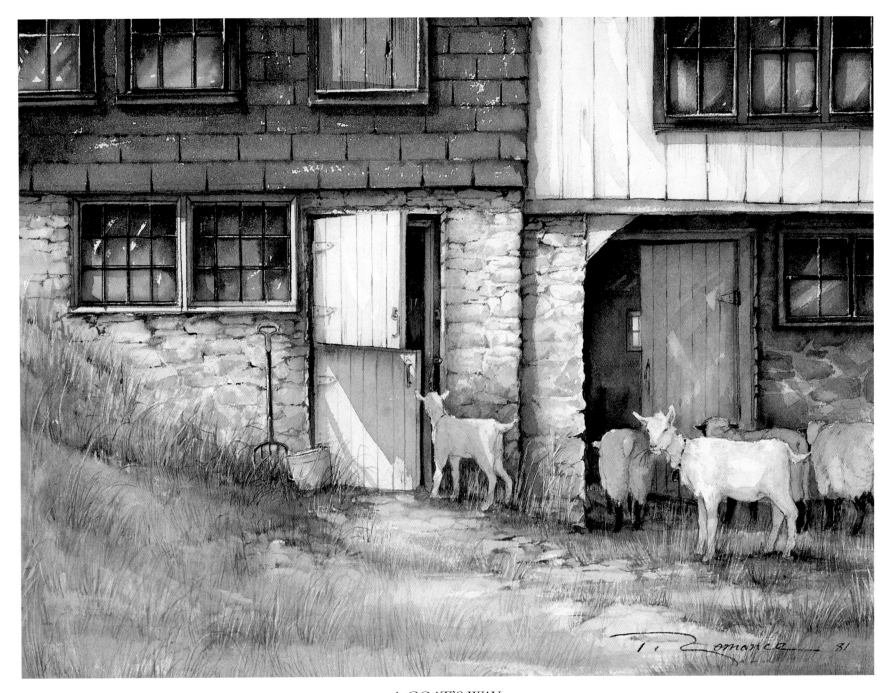

A GOAT'S WAY

While living in Sweden, I had a goat, Ingvald, and his impish behaviour, curiosity, and undiscriminating appetite always kept me smiling. Whenever there was an open door, there was only one way to go as far as he was concerned.

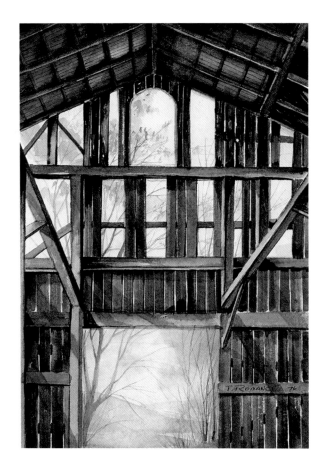

▷ BARN INTERIOR

*W*hat I loved about painting barn interiors was the play of light in them. Just as the wind would whistle and howl through their ribs, so too would the light pass through every crack, creating wonderful patterns of light and shadow.

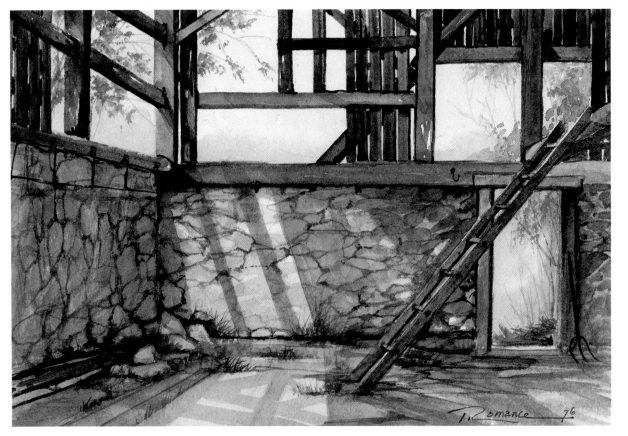

◁ TO THE HAYLOFT

*A*t one point I became intensely interested in the fortress-like foundations of barns, partly because their texture was a complement to the barnboard above, but mostly because they were created by gathering stones from nearby fields.

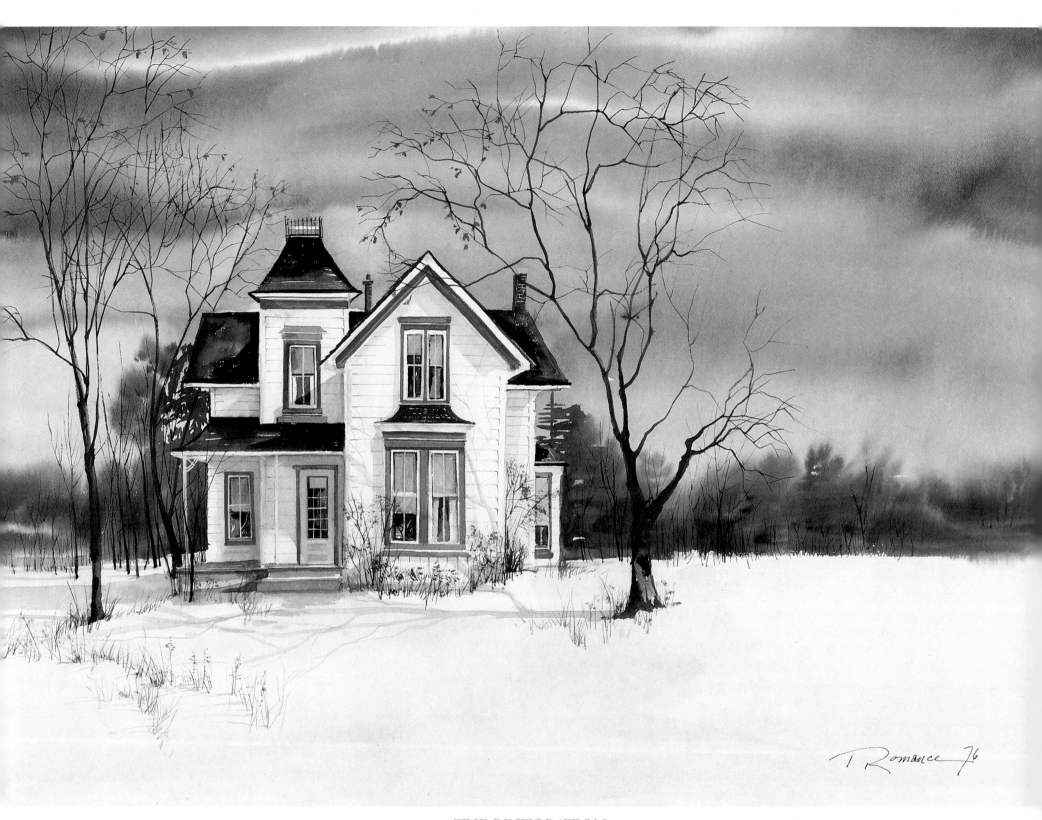

THE RESTORATION

So familiar was this house to me while I was growing up that I suppose
I took it for granted. But later, when I returned after years away, I saw it
differently. It had been restored, and I never again took it for granted.

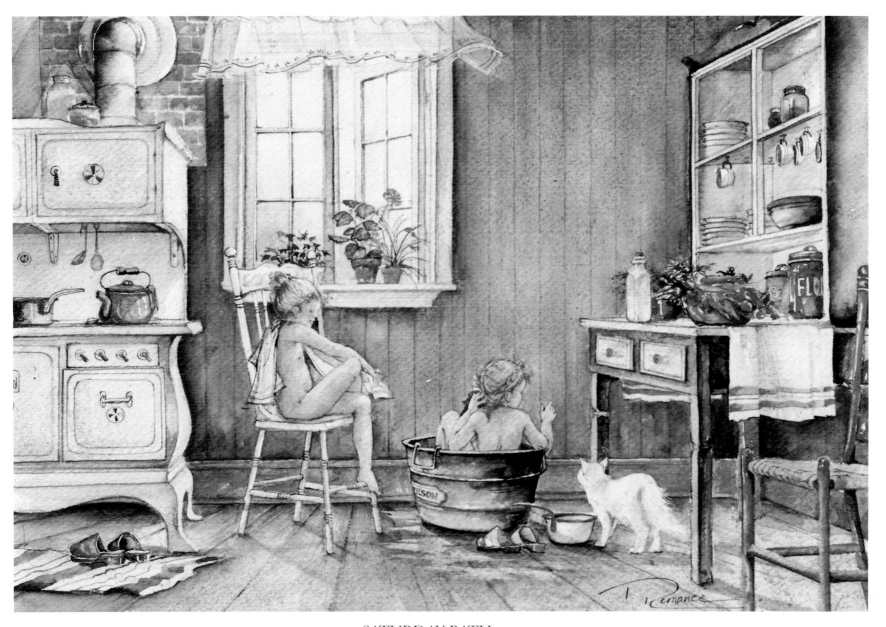

SATURDAY BATH

*M*any times I would knock on a farmhouse door, wanting to know more about the place. Often I was invited inside into another world. Behind the screen door, I would find a kitchen unspoiled by modernization.

▷ LOST SHEEP

From the original sketch done in Sweden to the final painting featuring sheep, a strange transformation occurred. While I decided that a lurking bear was too threatening, I also ventured to tell another tale, the story of how my independence while skiing often left me lost, but not alone, in my friendly forest.

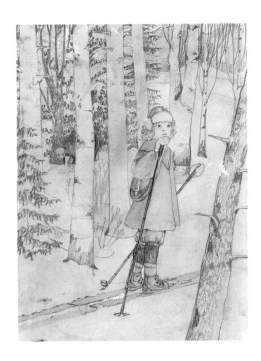

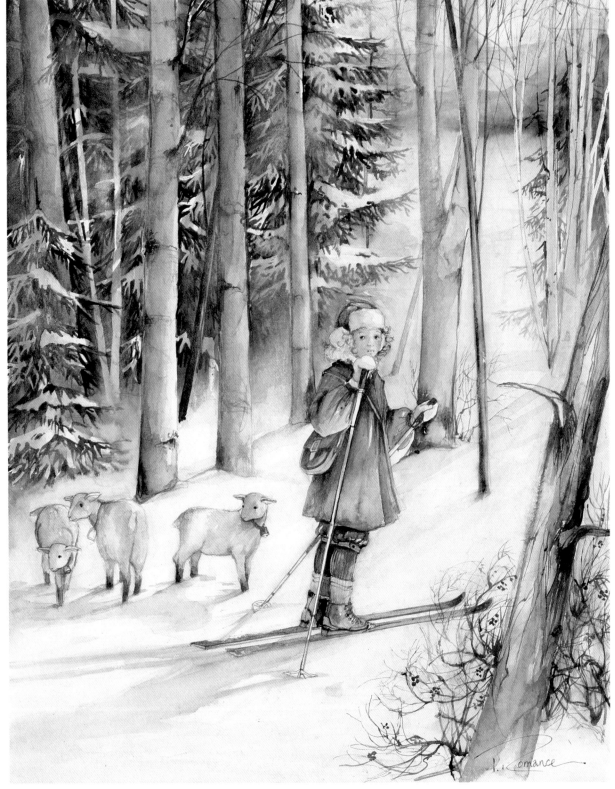

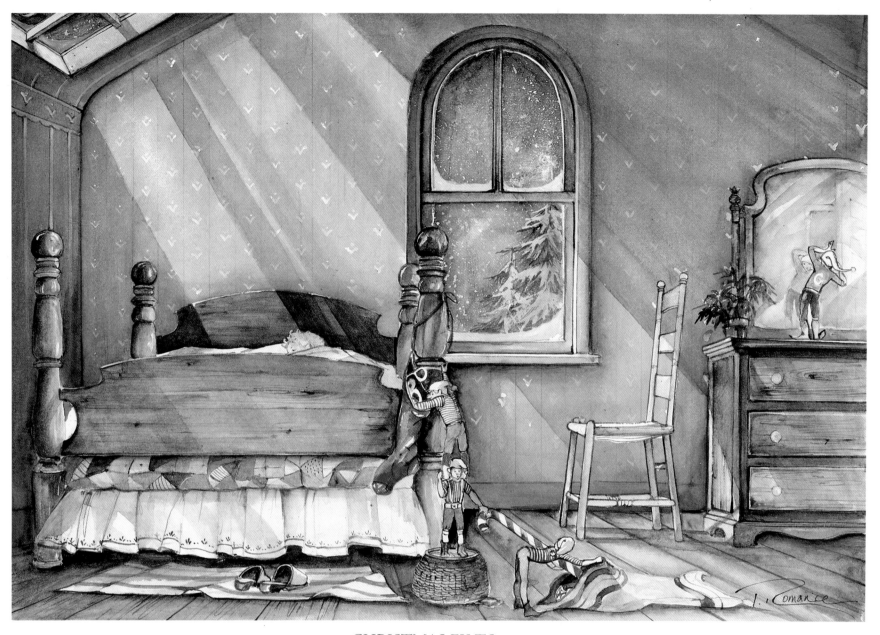

CHRISTMAS ELVES

It was Christmas Eve, and every childhood fantasy I'd had came alive again through our first-born, Nathan. At one time, fairytale painting was a direction I wanted to pursue in my work, and perhaps one day, as a grandmother full of tales, I will.

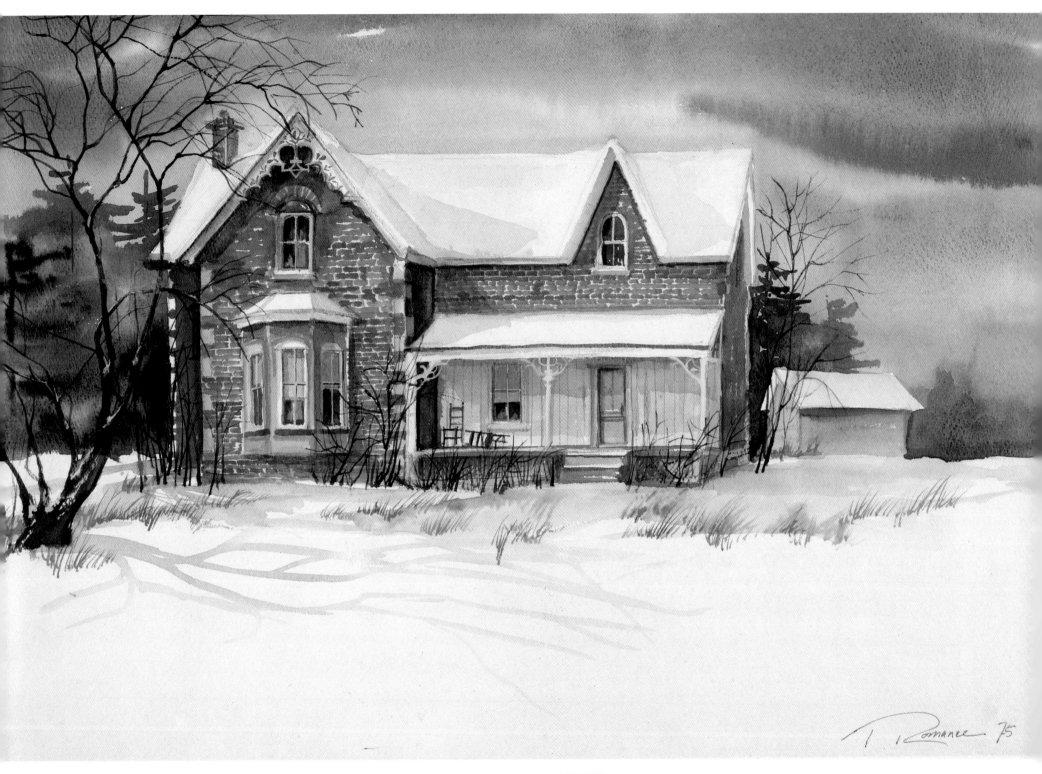

TRAFALGAR HOUSE

I once longed to live in this house, but part of the intrigue it always held
for me was that no one ever answered the door when I called. To this day
its interior remains a marvellous, tantalizing mystery to me.

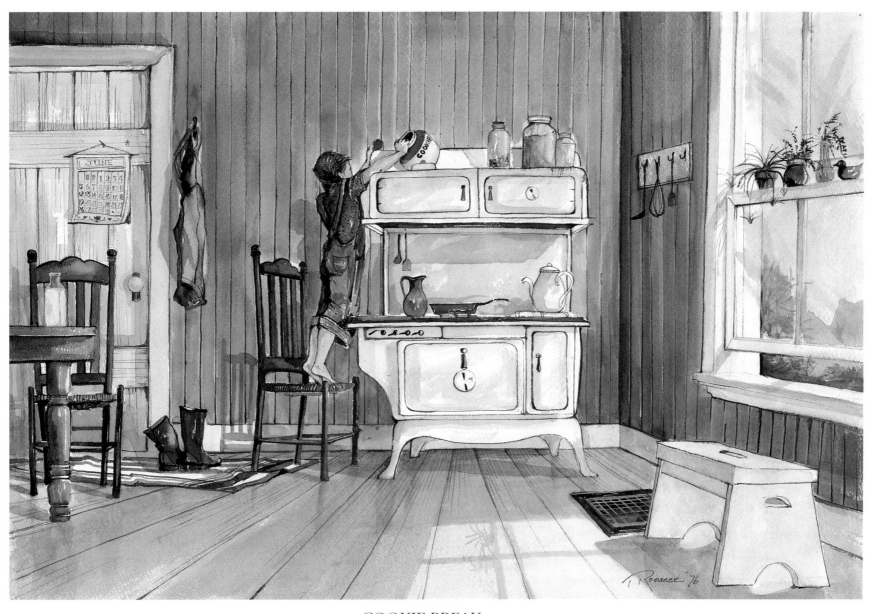

COOKIE BREAK

*I*nevitably, the focal point of any interior painting is a piece of furniture that is the centre of life in that room. It may be a piano, a window seat, or, as in this painting, a wood stove, a source of warmth and comfort — and an after-school snack.

◁ WAITING FOR SPRING

*W*hen I saw this little boy in Toronto's Cabbagetown, I also saw a painting. Although in the finished work he was perfectly centred, contrary to the rules of artistic placement, he seemed to bring a heart to an otherwise stark scene.

▷ FORSYTHIA

*T*he open gate in this little painting defies all clichés about crossing the path of a black cat. But he looks so harmless, lying there enjoying the first warm rays of spring.

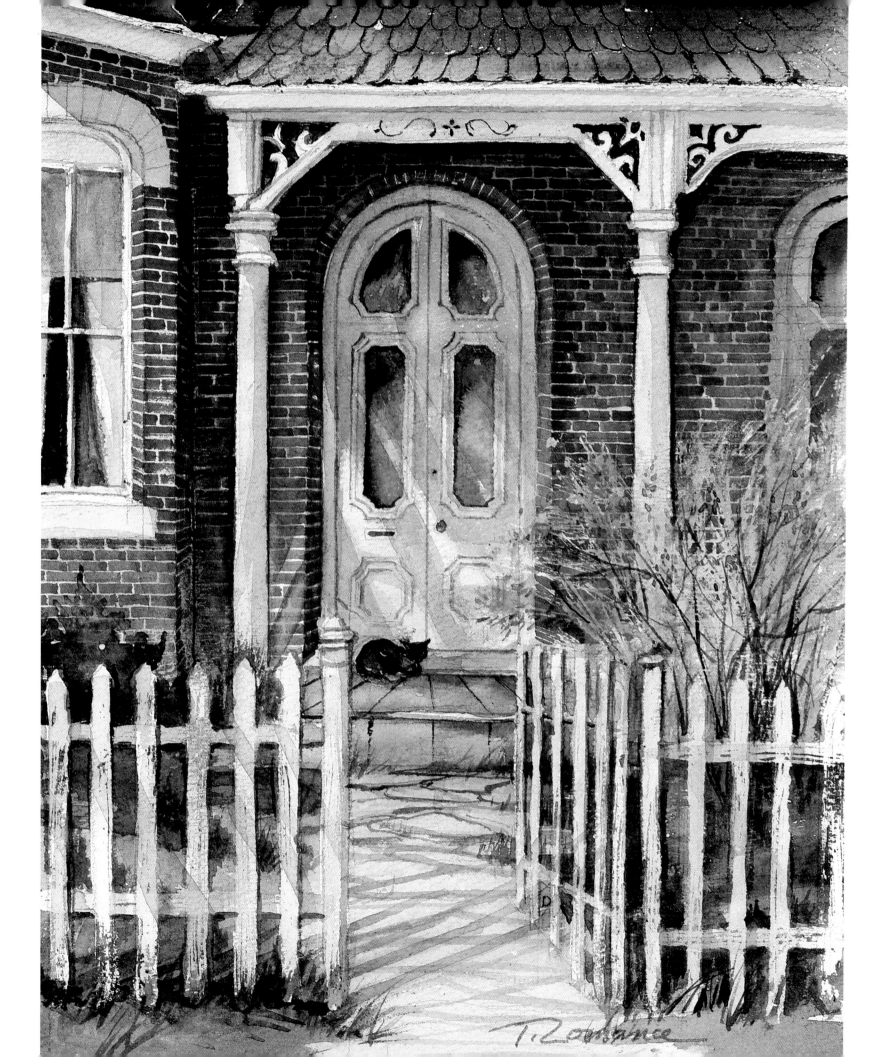

Romance

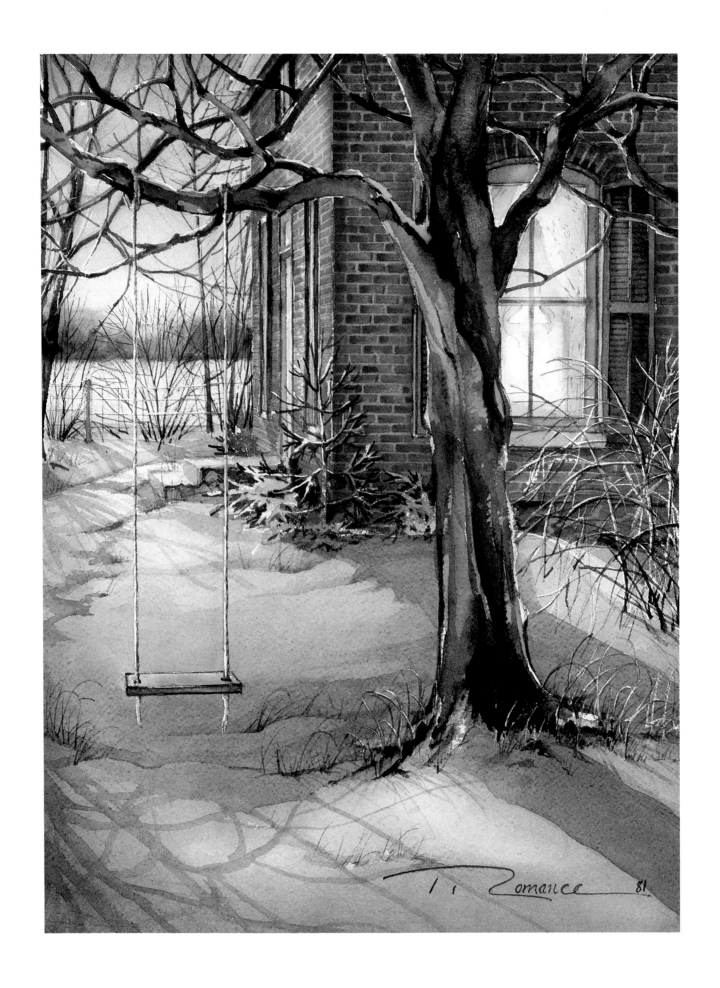

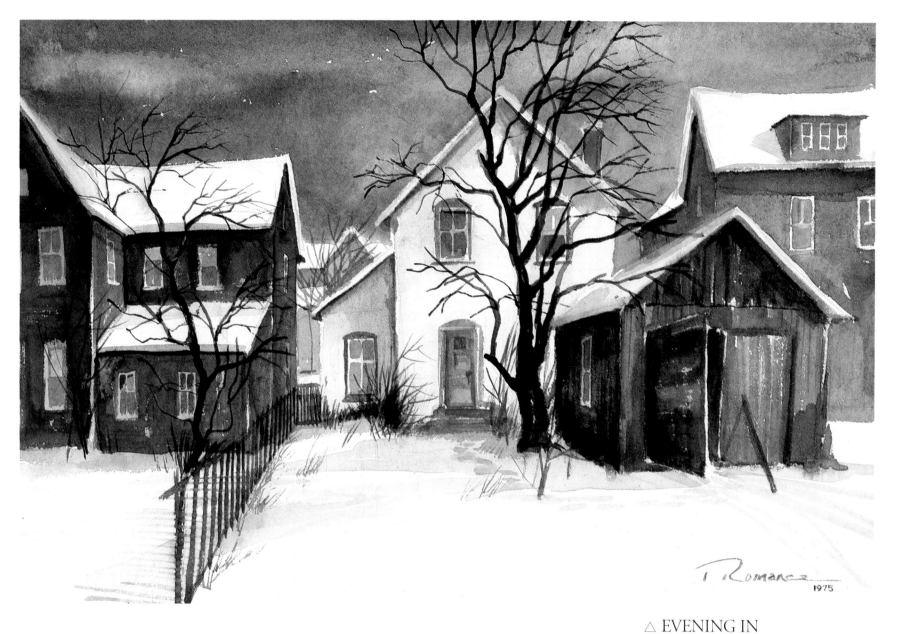

△ EVENING IN
CABBAGETOWN
I found great satisfaction in painting
the imperfect back streets and alleys
of Cabbagetown. They were full of
character and in contrast to the richly
decorated front façades of the houses.
It was a quiet world, so quiet you
could almost hear the snow fall.

◁ TILL NEXT SEASON
*W*hat is a yard without a swing? As
a child I could spend hours on the
swing at home, and to this day I
keep ours hanging all winter long,
a reminder that spring isn't too far off.

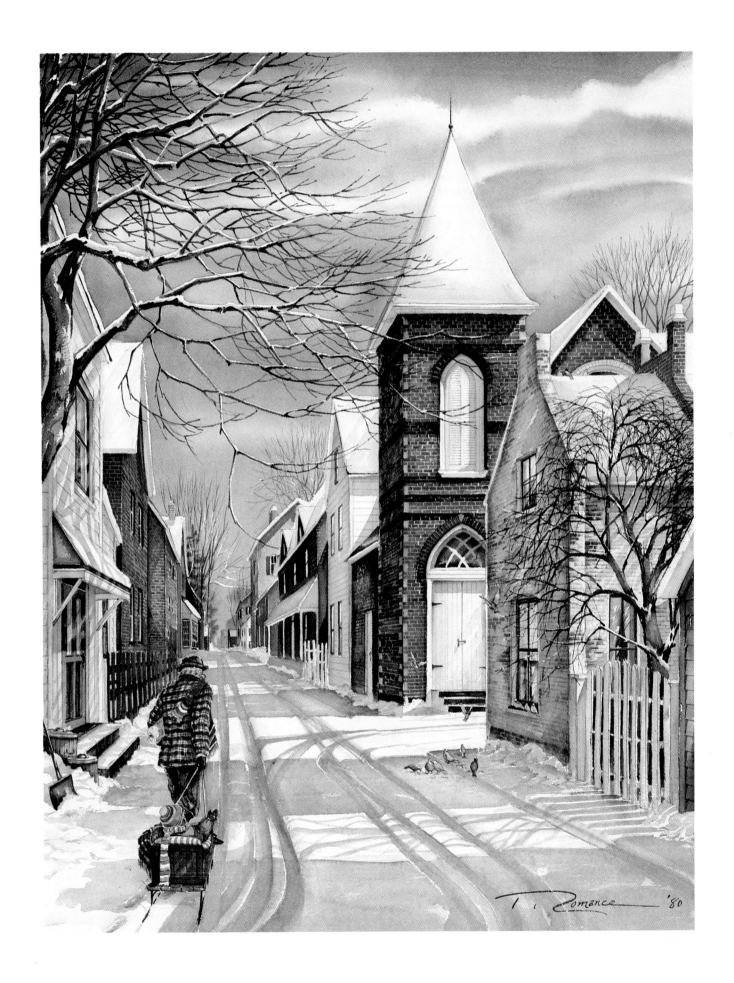

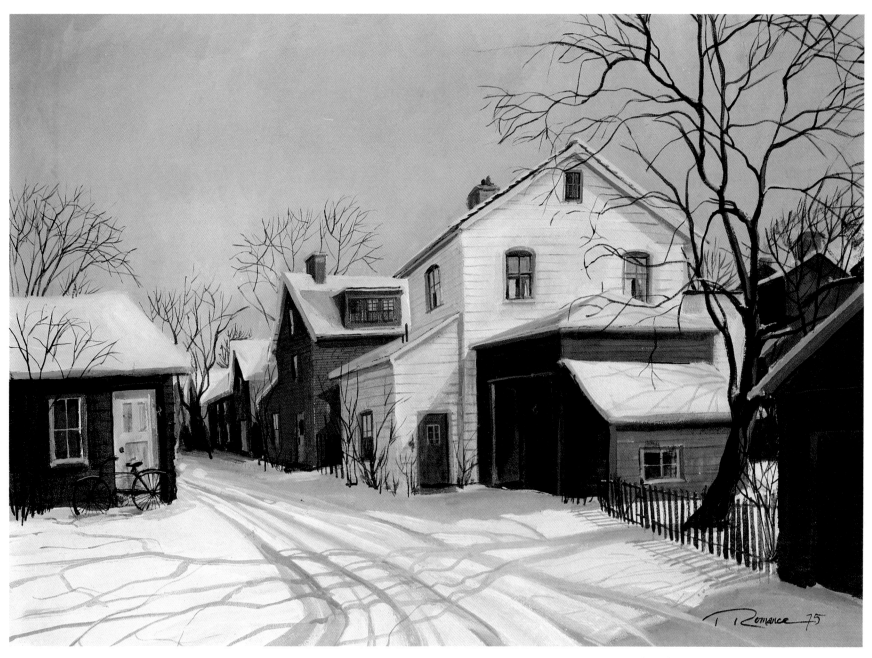

◁ MORNING WITH GRANDPA

I often painted the back streets without people to force others to appreciate the silence there. But there was something more important to be said when the silence was broken by a grandfather pulling a joyful little passenger on a sled.

△ QUIET MORNING

In my attempts to paint the back lanes of Cabbagetown, I decided to experiment with a more spontaneous medium — acrylic. I found the change refreshing. I also began to see what had endeared the place to Albert Franck, an artist who painted it in oils.

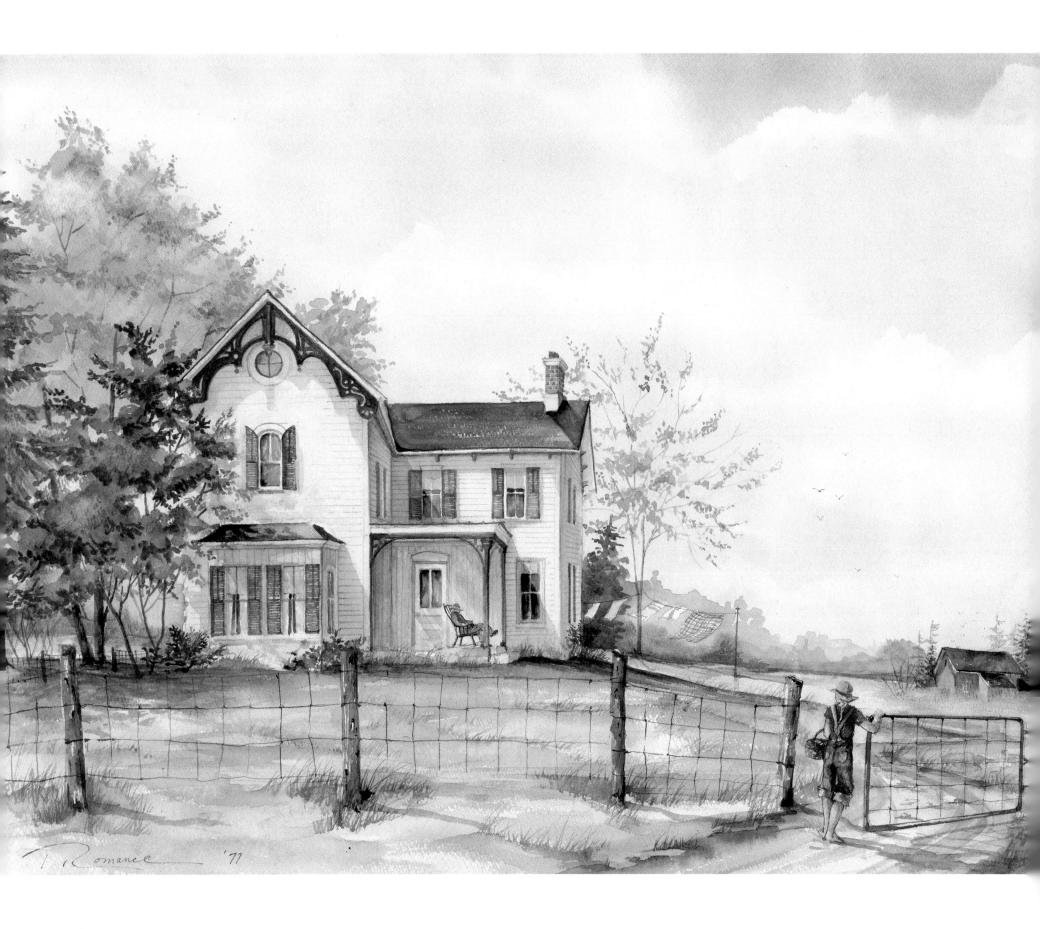

Romance '77

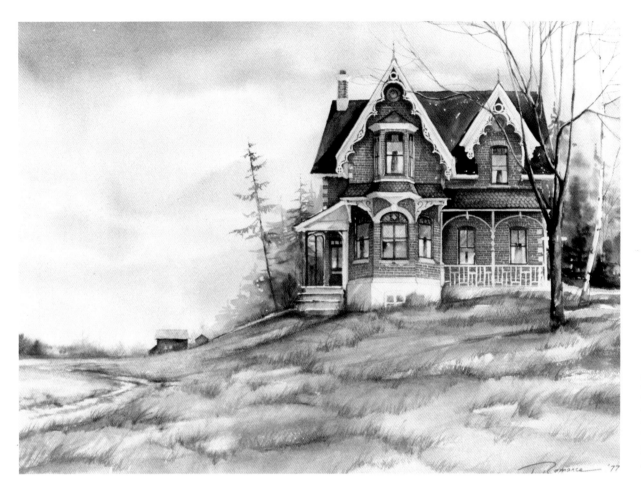

◁ COUNTRY CASTLE
*L*ike the tornado that lifted Dorothy's house in *The Wizard of Oz*, I transplanted this Toronto home to a hillside in the country, giving it room to be seen and views that every wonderful window deserved.

◁ VISIT TO GRANDPA'S
*M*emories of visits to my own grandfather's house gave me all the feelings I needed to paint this scene. You may not see the dish of mints on the buffet in the dining room or smell the woodchips in the workshop, but they are part of this picture!

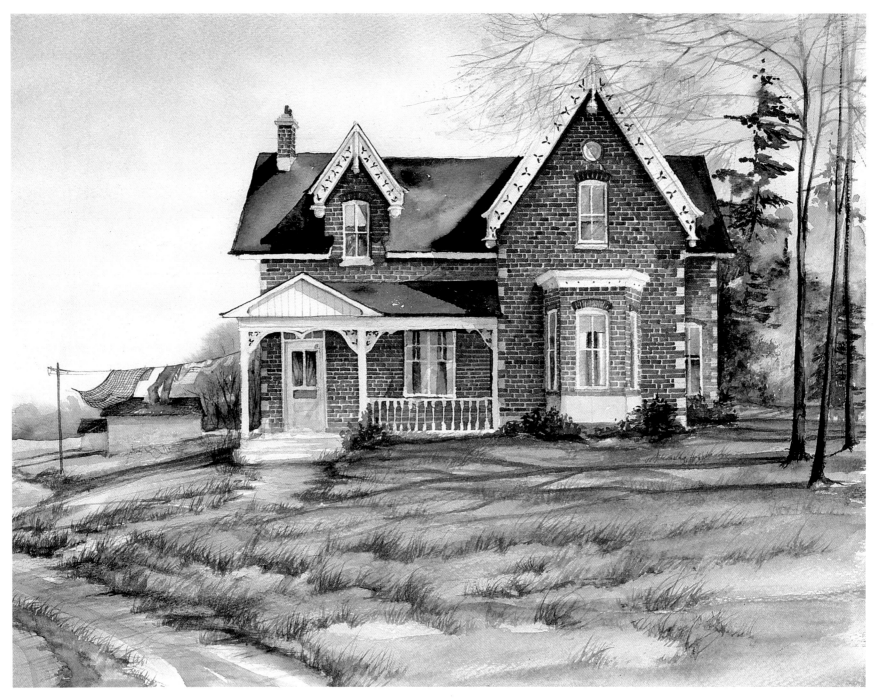

△ HOMESTEAD

It wasn't that long ago you could
head north of Toronto and find
yourself immediately in the country.
Today places like this are just a
pleasant memory of one of my many
needed escapes.

▷ SPRING WASH DAY

On the farm, wind would sweep across
the fields and make sheets hanging on
the clothesline billow like sails. I loved
the way the sunshine played on them
until I gathered and folded them at the
end of the day.

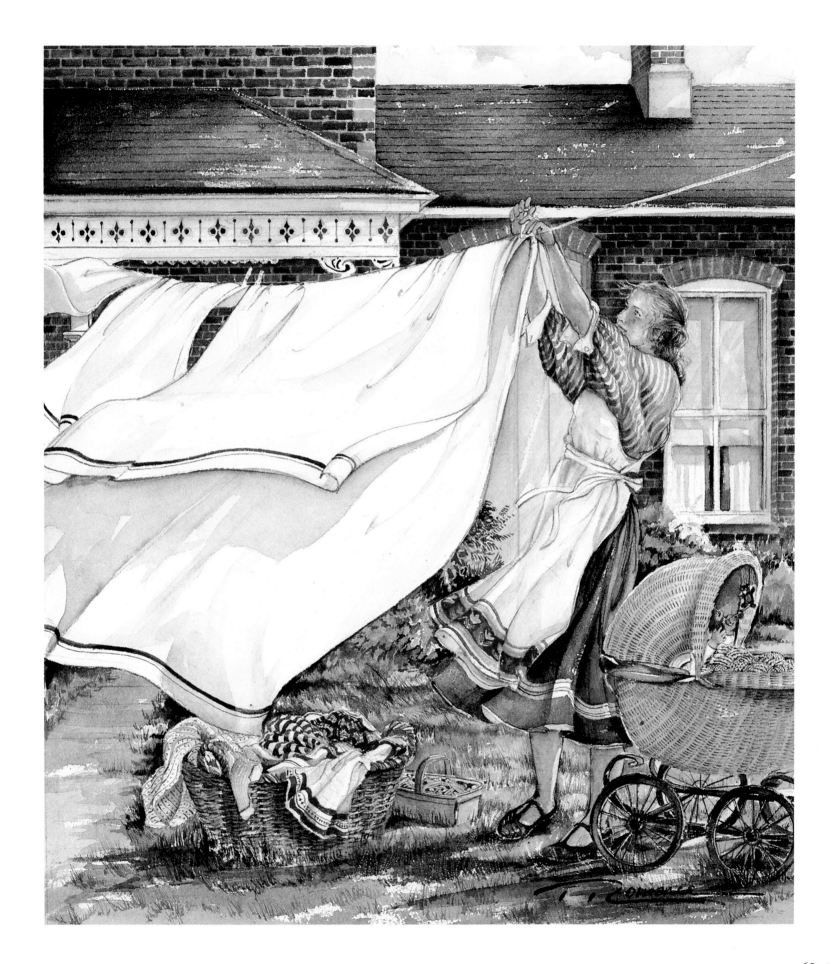

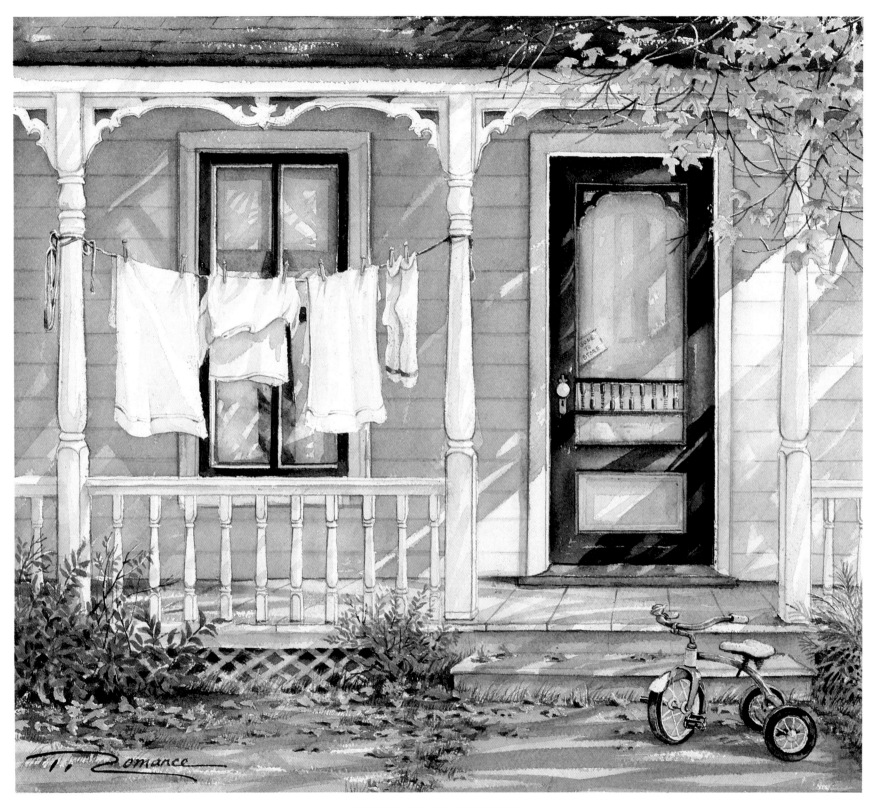

GONE TO THE STORE

*W*hile this little painting seems to be about one of my favourite subjects, laundry, the personal focus for me is the little tricycle. Not only was it mine when I was little, but it was also — after their grandfather repainted it yet again — used by all of my children.

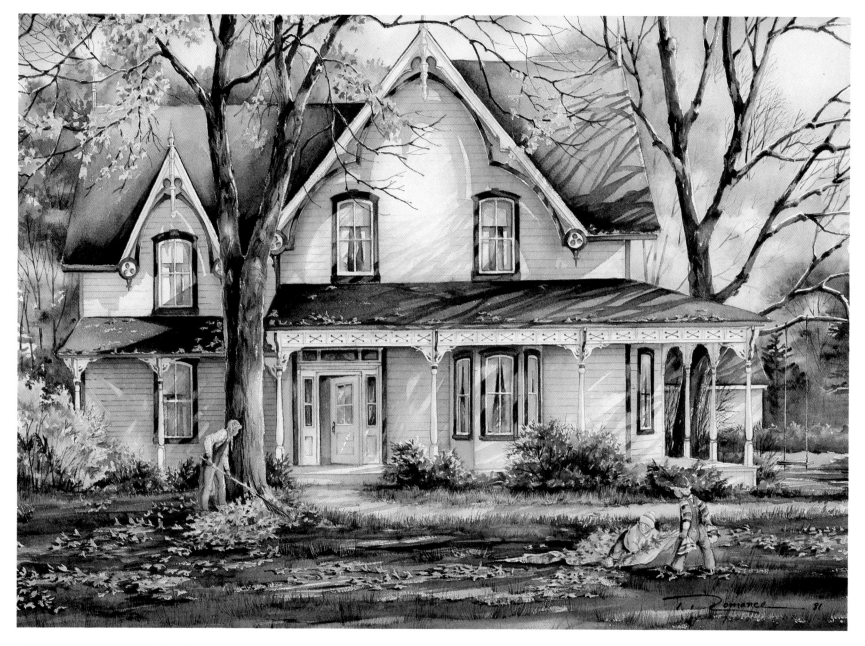

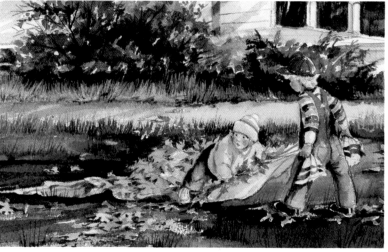

△ BROTHER'S
LITTLE HELPER
*T*he annual task of rounding up leaves
eventually turns to fun for young
children. Good intentions are soon
forgotten as a pile accumulates on the
street. To the youngest, this bed of
leaves can mean only one thing: hop
a ride!

◁ DRESS UP

*T*his was a snug home in Hamilton, Ontario, and its side veranda seemed to be the perfect stage for the drama unfolding there. So involved were these little girls that even their pet was given a role in the play.

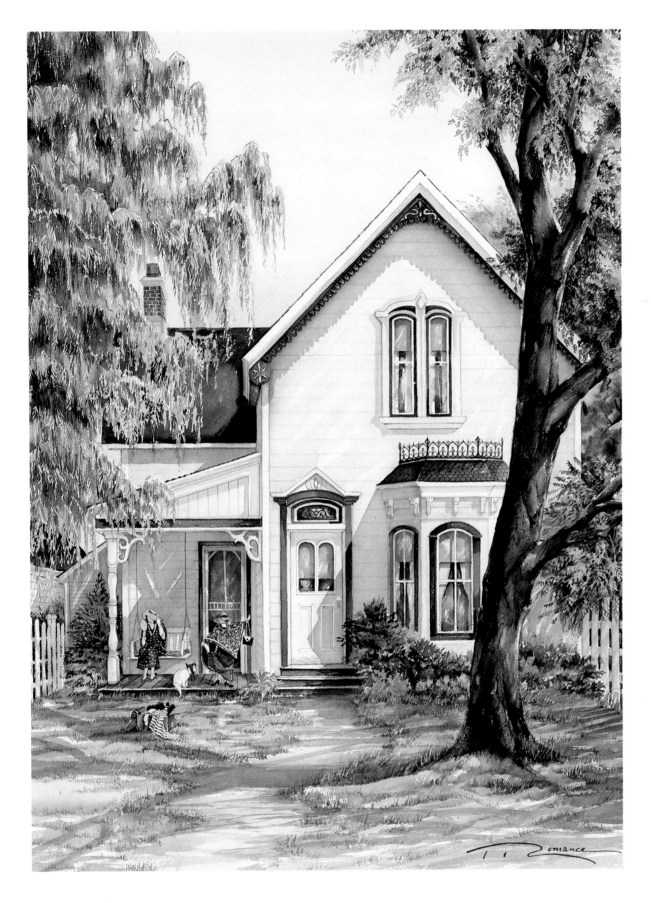

▷ BEST FRIEND

*W*hen I travel, I'm always in search of special local homes. I found this one on a quiet street in St. Augustine, Florida. Covered in the distinctive foliage of the South, it was a welcome challenge to paint.

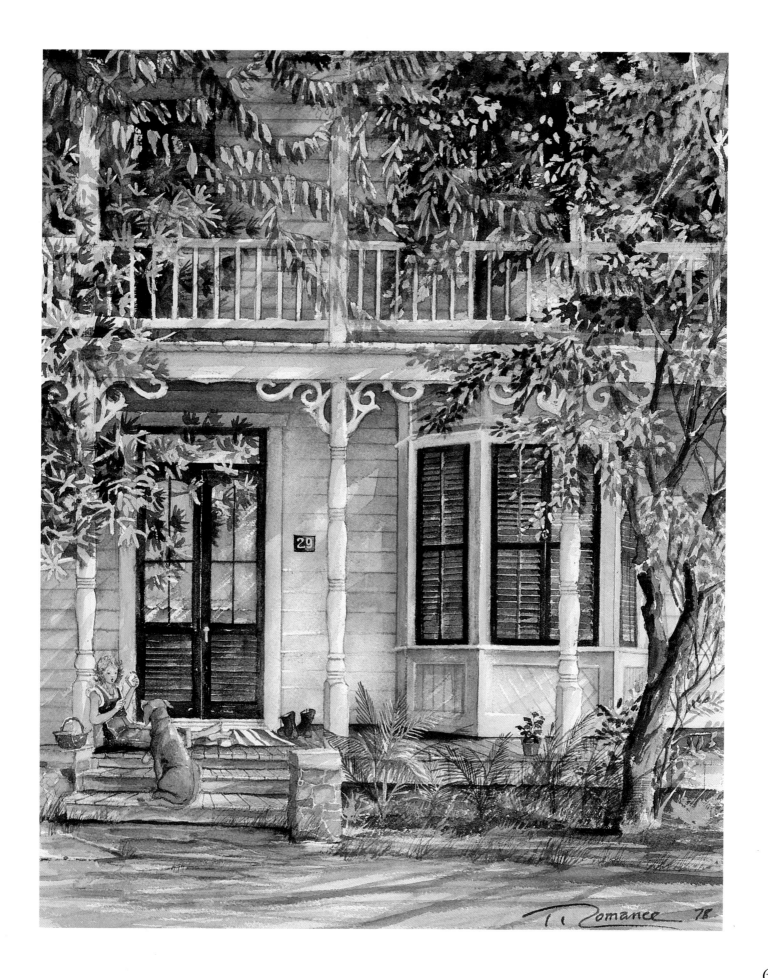

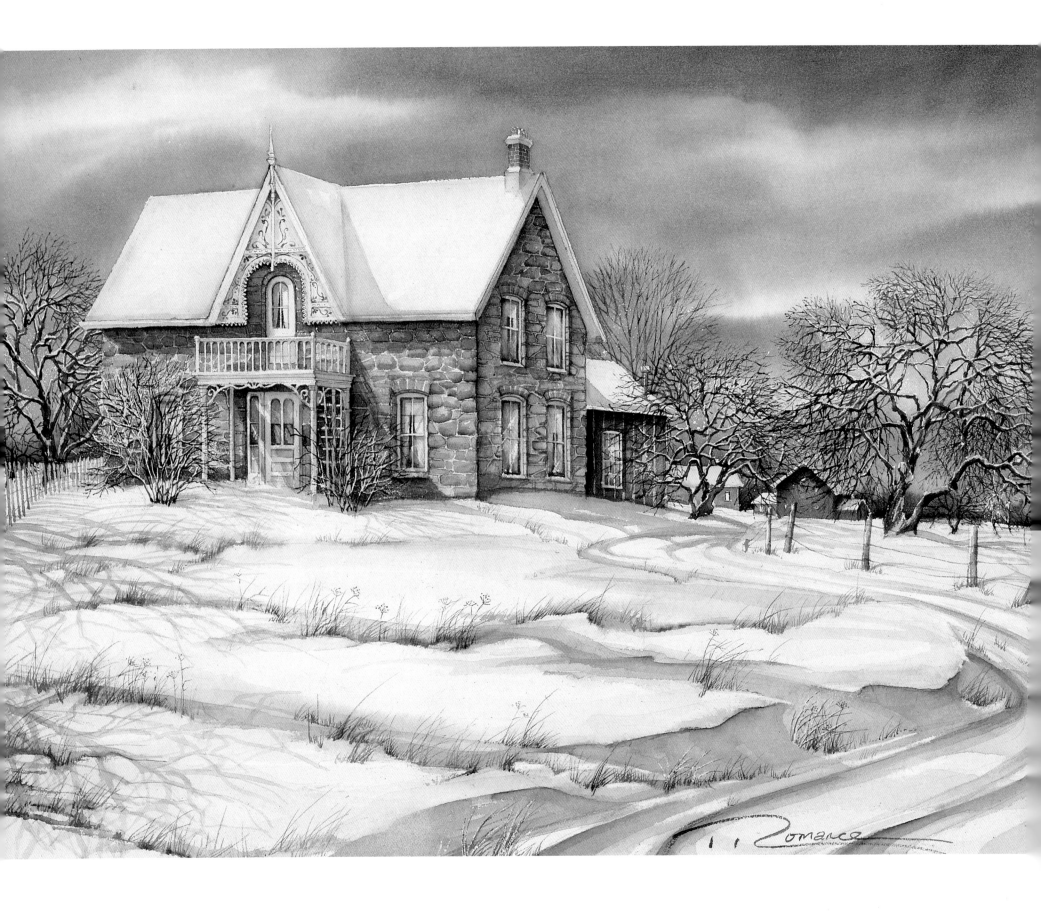

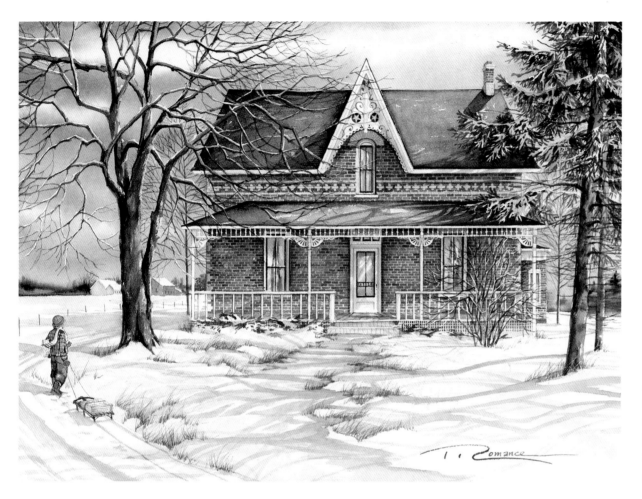

◁ NEWSBOY

Some of Ontario's best houses can be seen along Highway 27, which runs north from Toronto. I loved this one for its filigreed gable and detailed brickwork. Wishing I was a newsboy who could enjoy it daily, I painted this scene.

◁ ORCHARD HOUSE

What drew me to this house were its aesthetic contrasts and harmonies. The bold stone and "lace" gingerbread contrasted beautifully. The delicate tracery of the tree branches against the clouds created a pattern as exciting as the gingerbread — another contrast that just had to be painted.

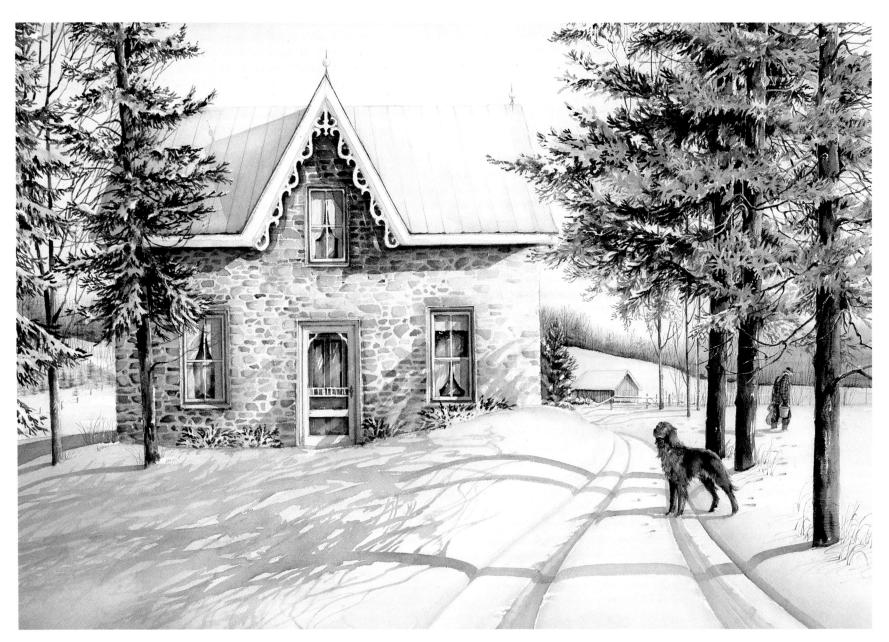

△ MORNING CHORES

I experienced the luxury of familiarity while painting this home of close relatives. While his master headed out to the barn, Murphy, a curious dog, was easily led astray by any noise coming from the surrounding wooded acres.

▷ FRESH BREEZE

One of the most exciting things for me about painting cherished old places is that while painting them I actually believe I'm living in them. When I paint the curtains I feel as if I'm inside hanging them. Even the footprints in the snow are mine.

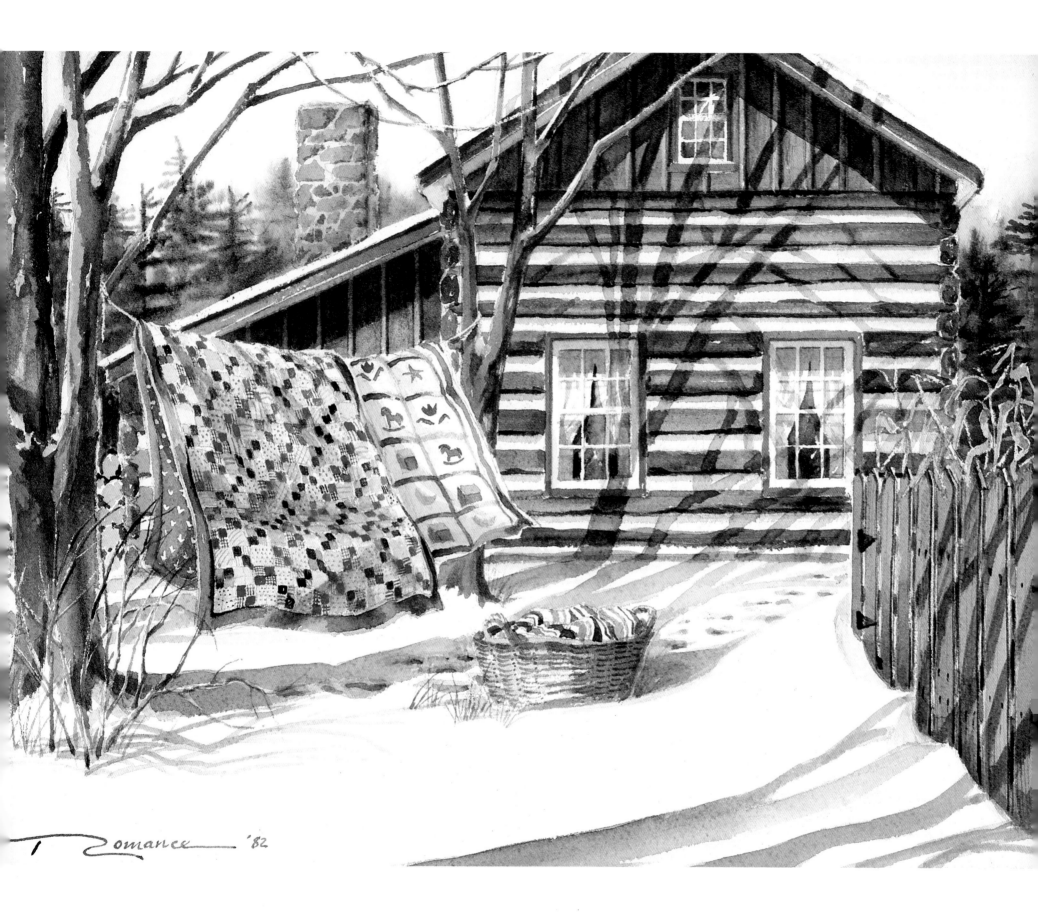

Romance '82

THROUGH THE EYES OF A CHILD

From the time Nathan was a newborn, I would walk down this lane from the house to the barn every day, pointing new things out to him. Before I knew it, he was pointing things out to me, through the eyes of a child.

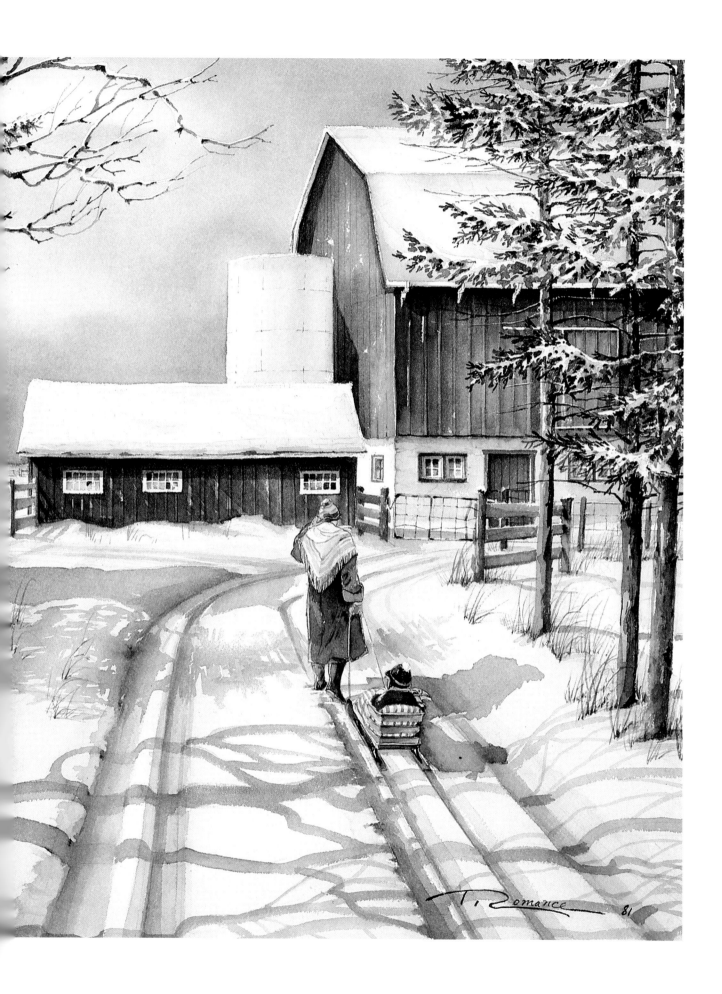

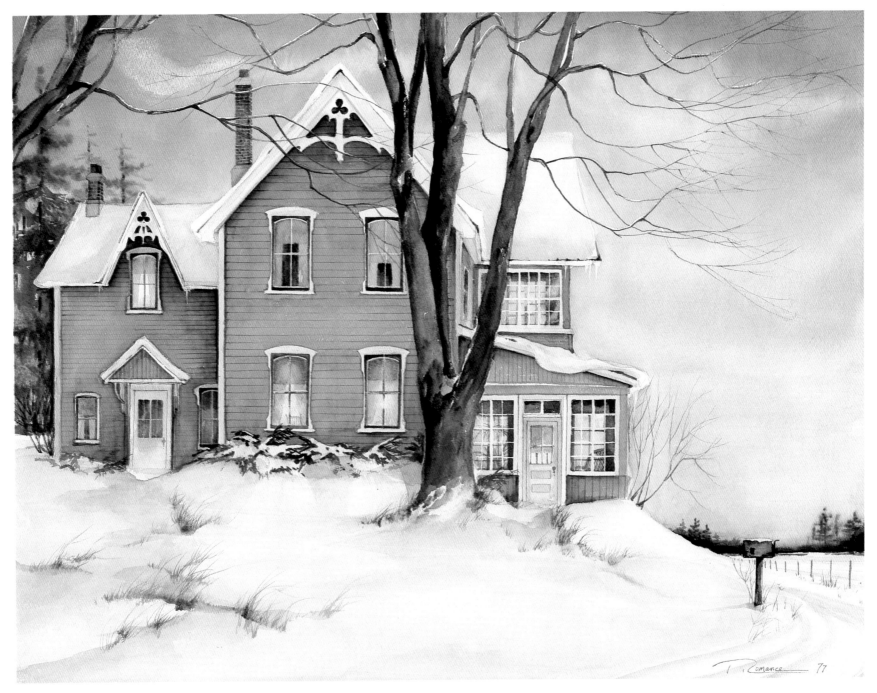

DUSK

It took a certain amount of boldness for me to paint this house, because in watercolour the danger of a blue house becoming a "shadow" is great. But I wanted to be true to the house as I had actually seen it, complete with shamrock gables and towering trees.

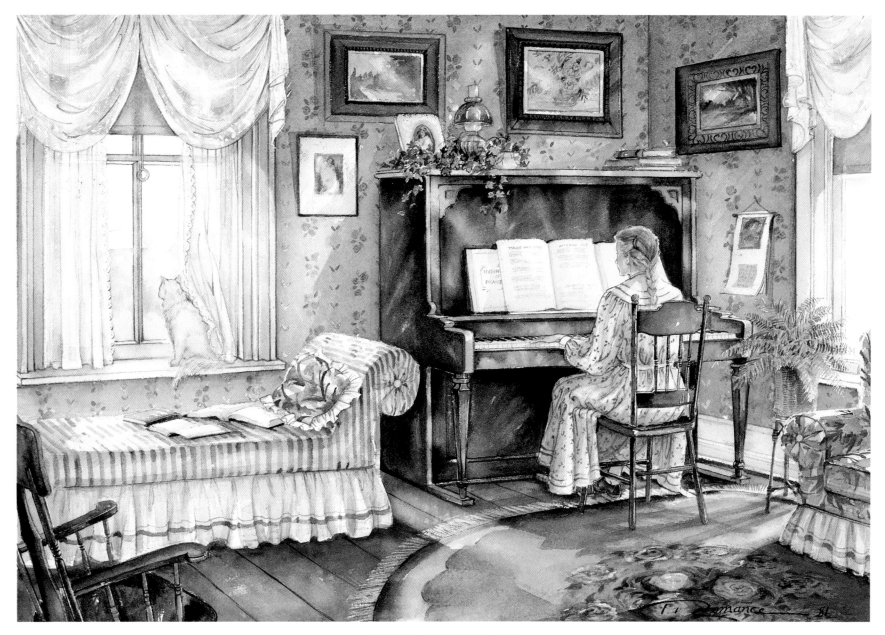

THE MUSIC ROOM

Being surrounded by favourite things seems to be part of the comfort of music rooms — paintings, family photographs, and well worn books. In our home you will always find my favourite hymns among the pages of music.

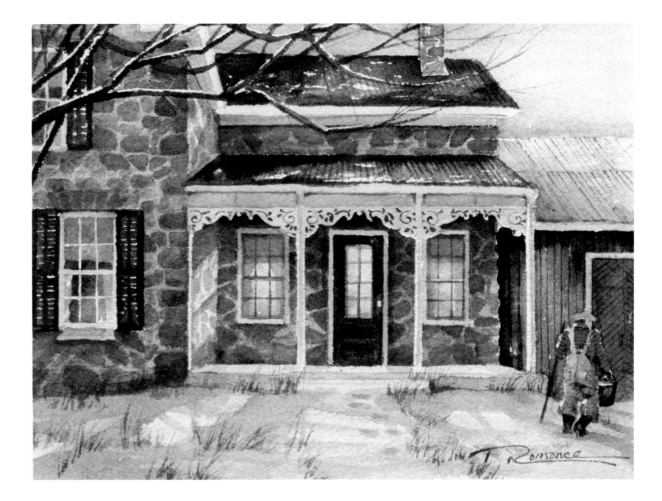

▷ EVENING CHORES

It seems it's the paintings that happen quickly that remain in my heart the longest. The short visit I made to this home had a sweetness to it that lingered long after my rendering.

▷ CALFING HOUR

One of the great joys of life on a farm is the birth of a calf. No matter how many times one witnesses it, the miracle never seems to lose its impact and wonder.

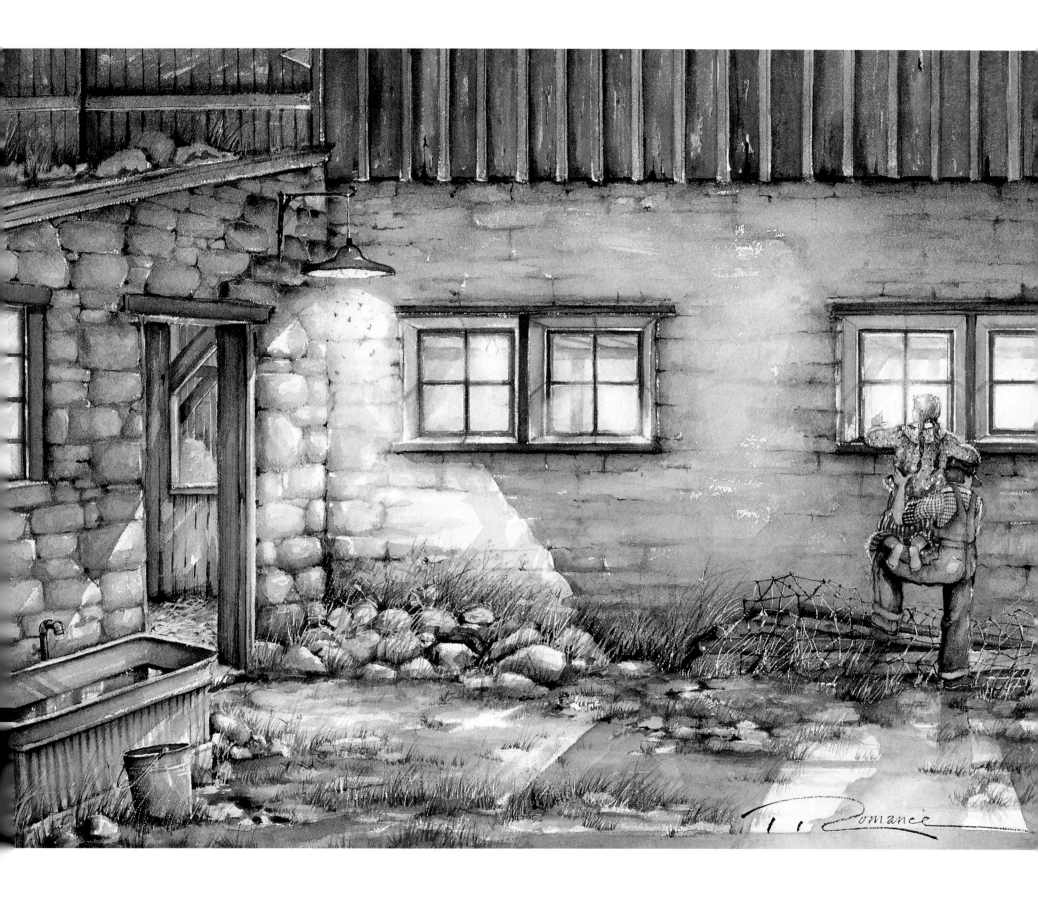

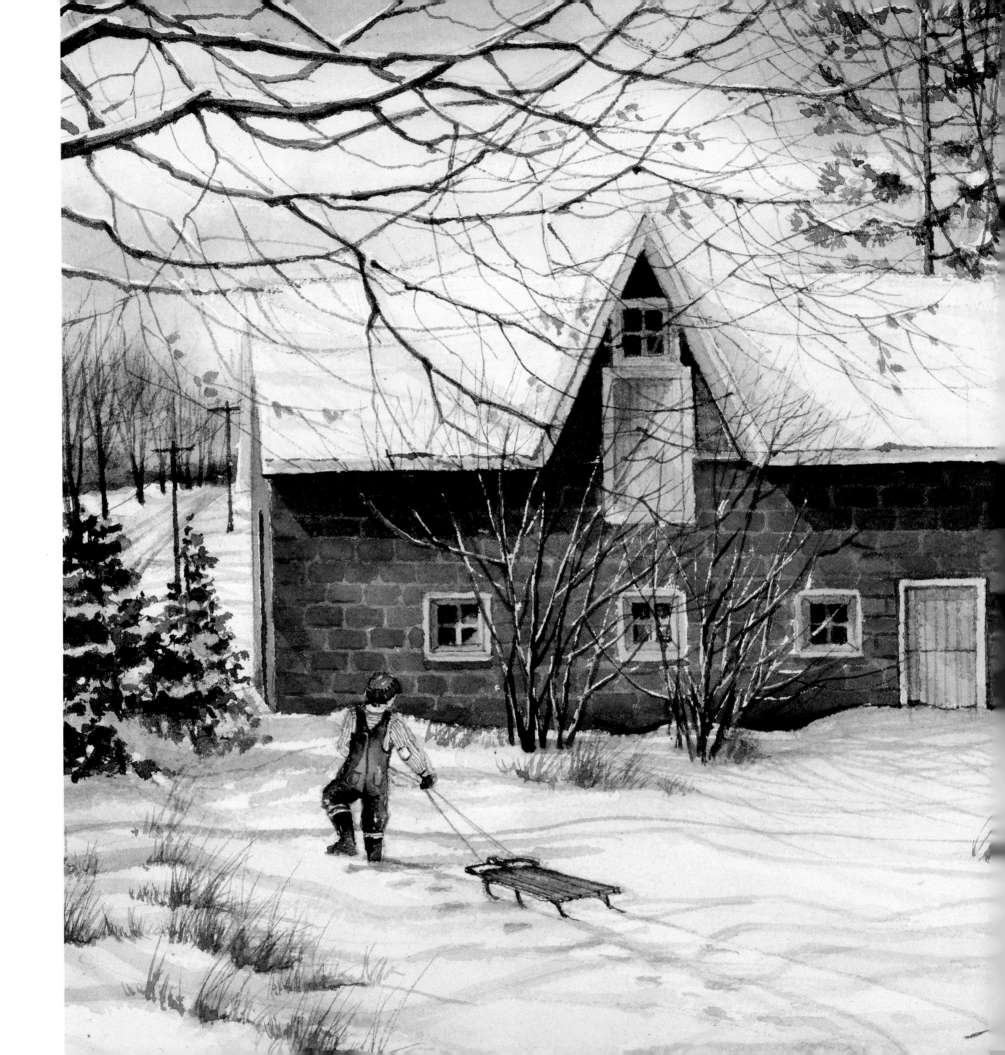

△ CURIOSITY

In the early years, I did many commissioned paintings of people's homes — work that could be frustrating if the owners didn't feel I'd captured the spirit of places they loved. Sometimes, though, I could spend enough time with them to glean details of their lives. In this painting, I included the family's beloved pets.

◁ COACH HOUSE

*T*his charming building was an important part of the same property as the one in "Curiosity". In creating the original trio of paintings commissioned by the family, I felt that this wonderful old coach house should be included.

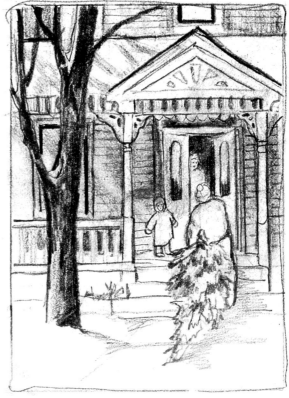

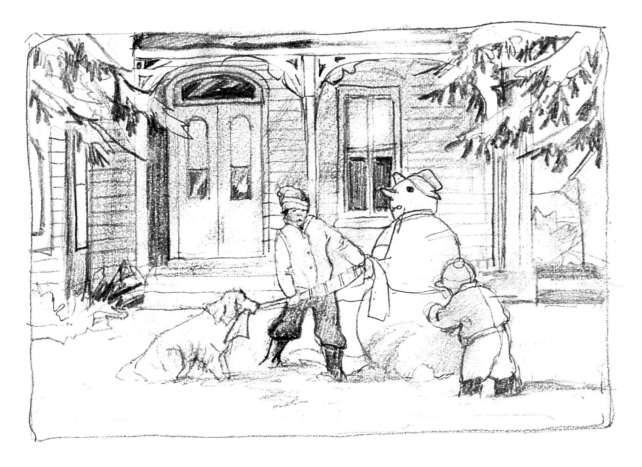

▷ CHRISTMAS CARD
COMMISSION, 1982
This was a special 1982 Christmas card
commission for Mutual Life of Canada.
I gave the company a selection of
four rough designs. The final choice,
with its humorous elements, turned
out to be their favourite.

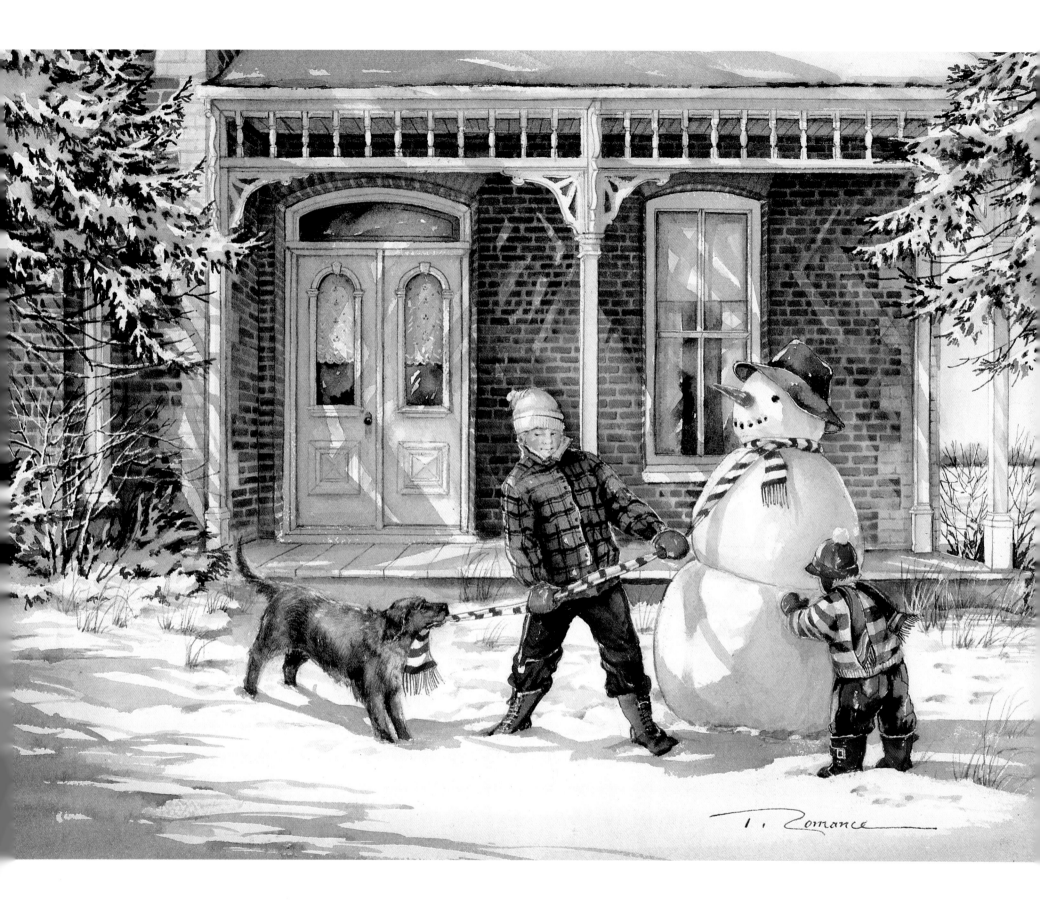

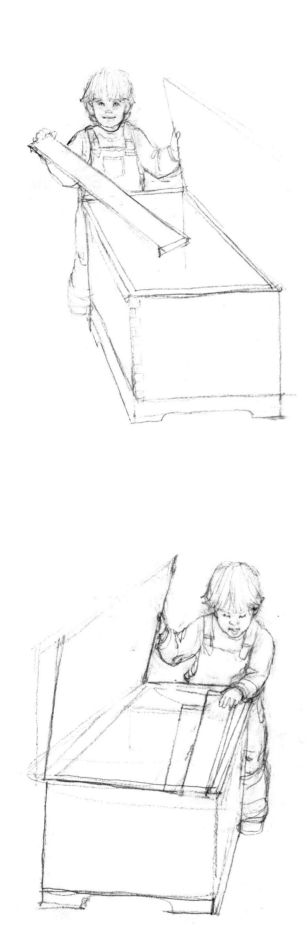

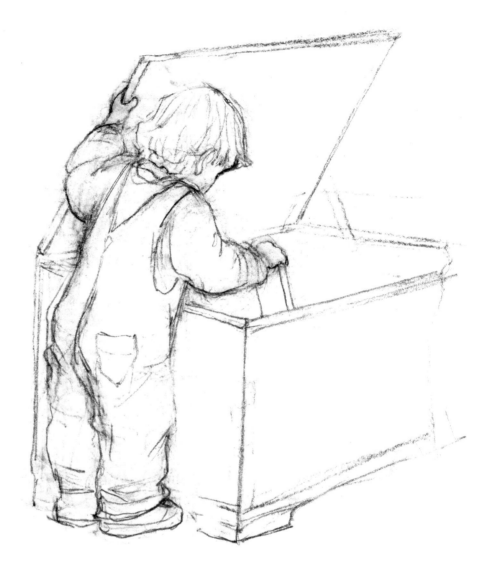

THE NEW TOYBOX

I often heard hammering and sawing as Gary made furniture, or whatever our farm home needed, in the workshop next to the kitchen. When I opened the door to call my carpenters to dinner, I hated to disturb the intense activity there. But as Nathan looked up, all kinds of ideas for a painting came into my mind.

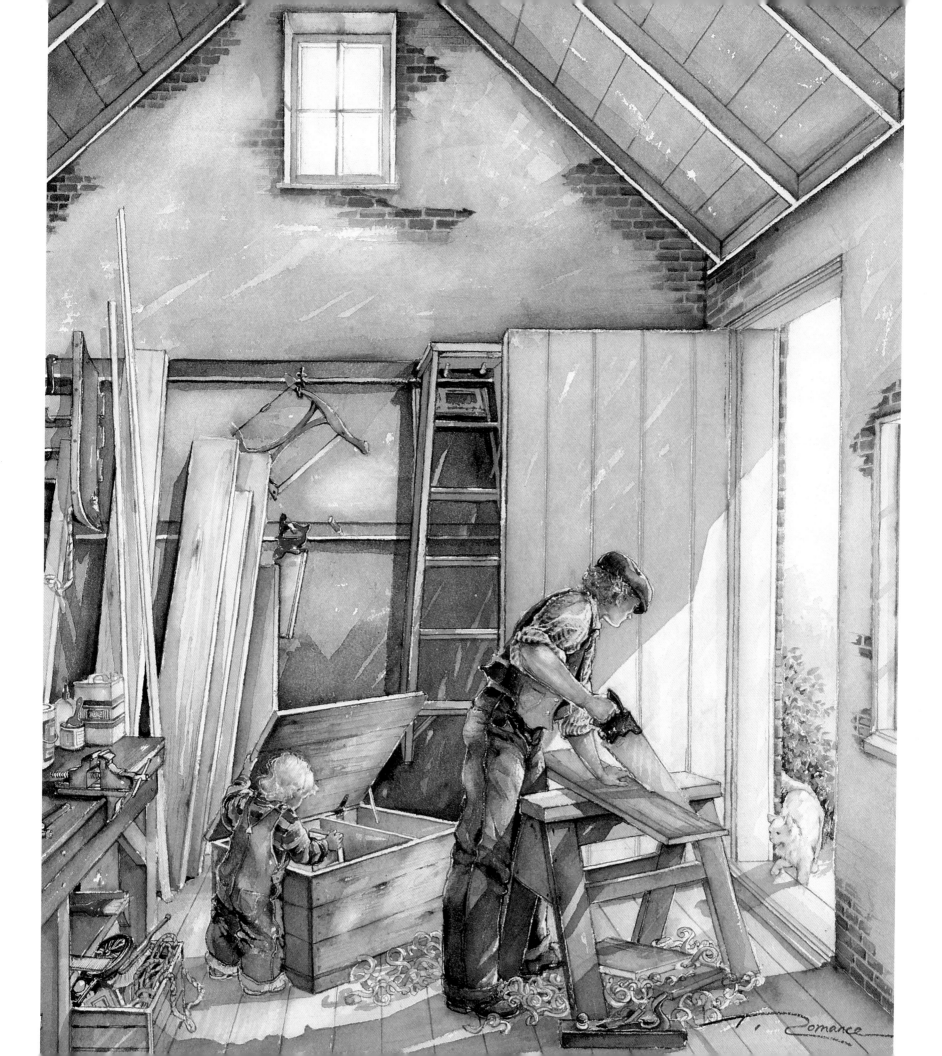

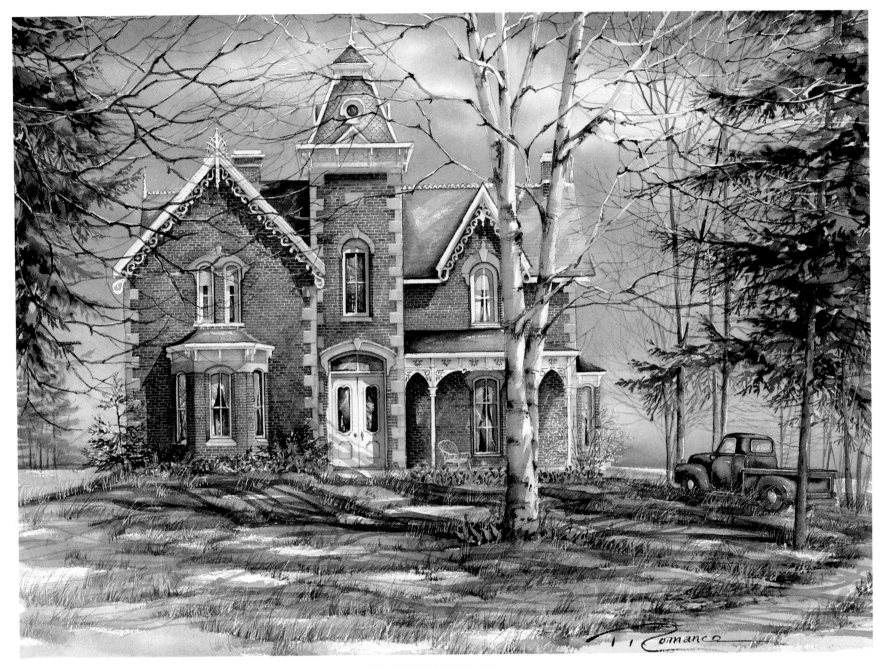

KANEFF HOUSE

This was a "castle" we could catch a glimpse of from the highway. I was determined to paint it, and one day in our old truck we took a detour to where the highway was only a memory. After walking around the house, I decided to paint it from the front, so I could always enjoy the "Rapunzel" tower.

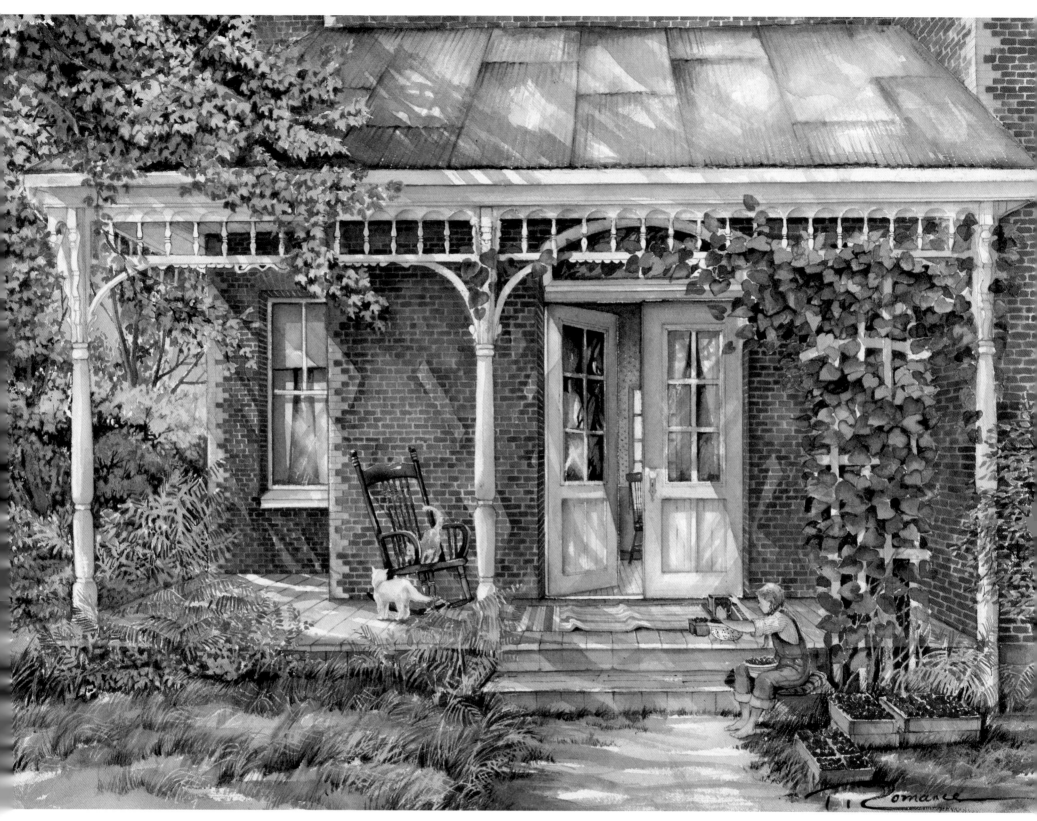

STRAWBERRY JAM TIME

Surrounded as I was by many productive farms when I was young, picking
berries was a way to earn a little extra money. The benefits were great: you
could eat as many as you liked and still have lots left over for Mom's great jam.

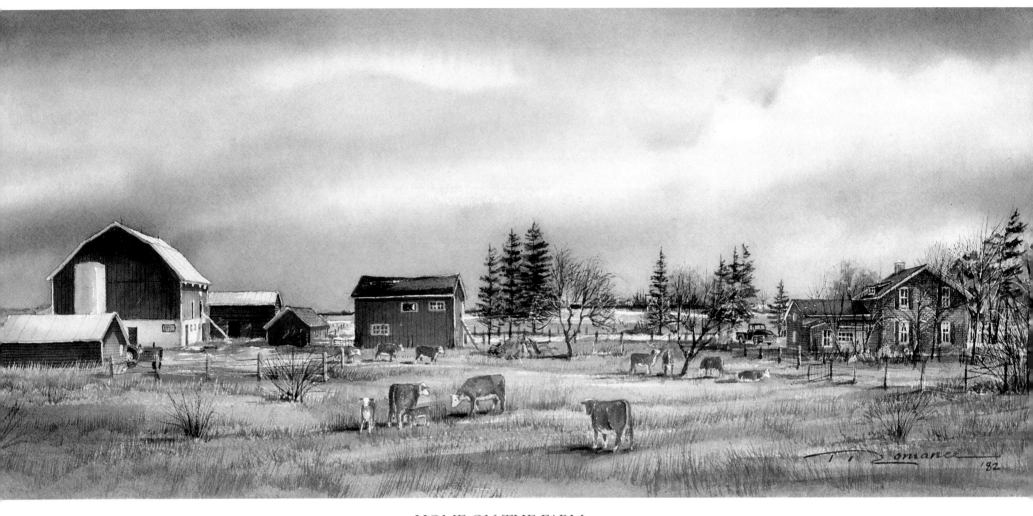

HOME ON THE FARM

Our farm home in Milton was just that. Surrounded by cows, barns, and orchards, it was always a joy to drive down the lane in our old truck, singing a little song for Nathan: "We're home, we're home — Nathan's house, Nathan's house!"

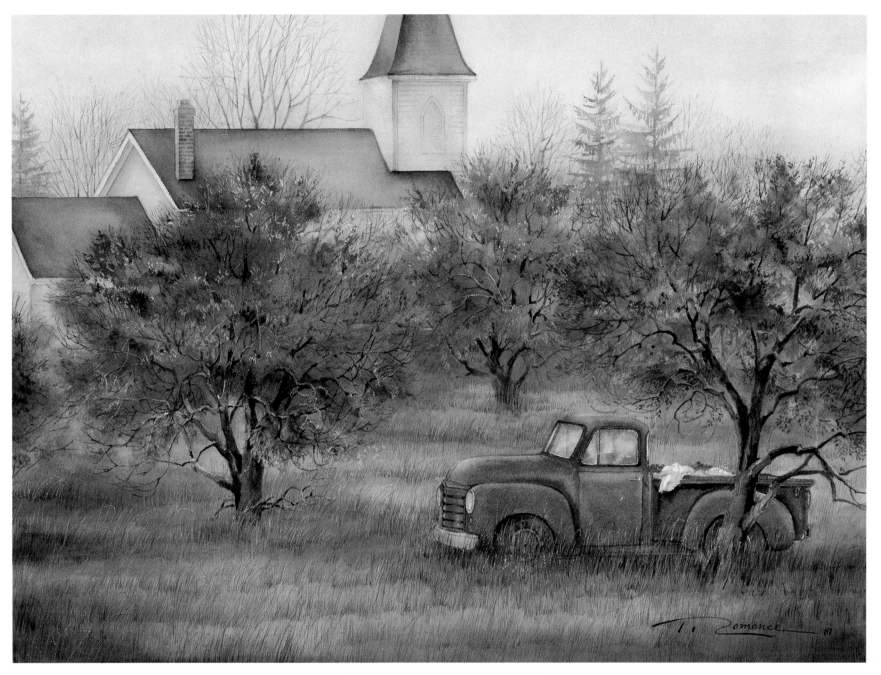

DEW ON THE ORCHARD

From my kitchen window at the farm, I could look southwest and see the steeple of the church beyond the apple orchard. One fall morning, while giving Nathan his breakfast, I looked out. We had left our truck in the orchard until apple picking was over. It had to be a painting.

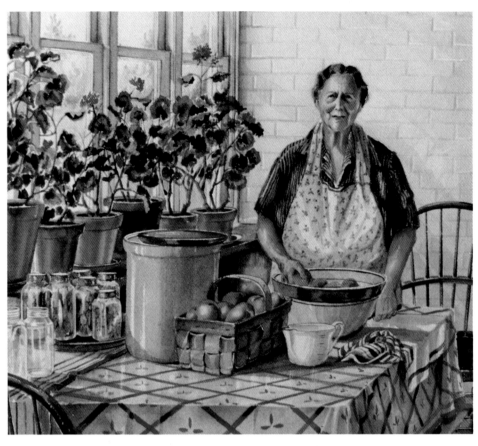

AGNES

*I*n our search for a farm to buy, we met Agnes. I should have been interested in her house, but I was more taken with her beautiful character, her genuine warmth, and a face that inspired me numerous times.

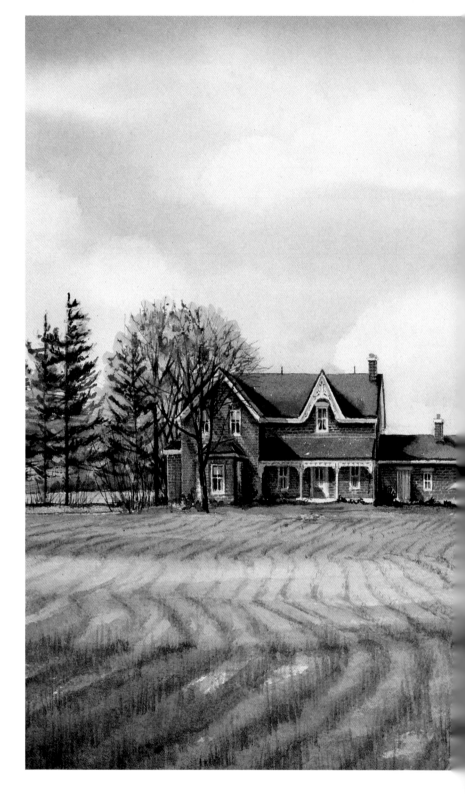

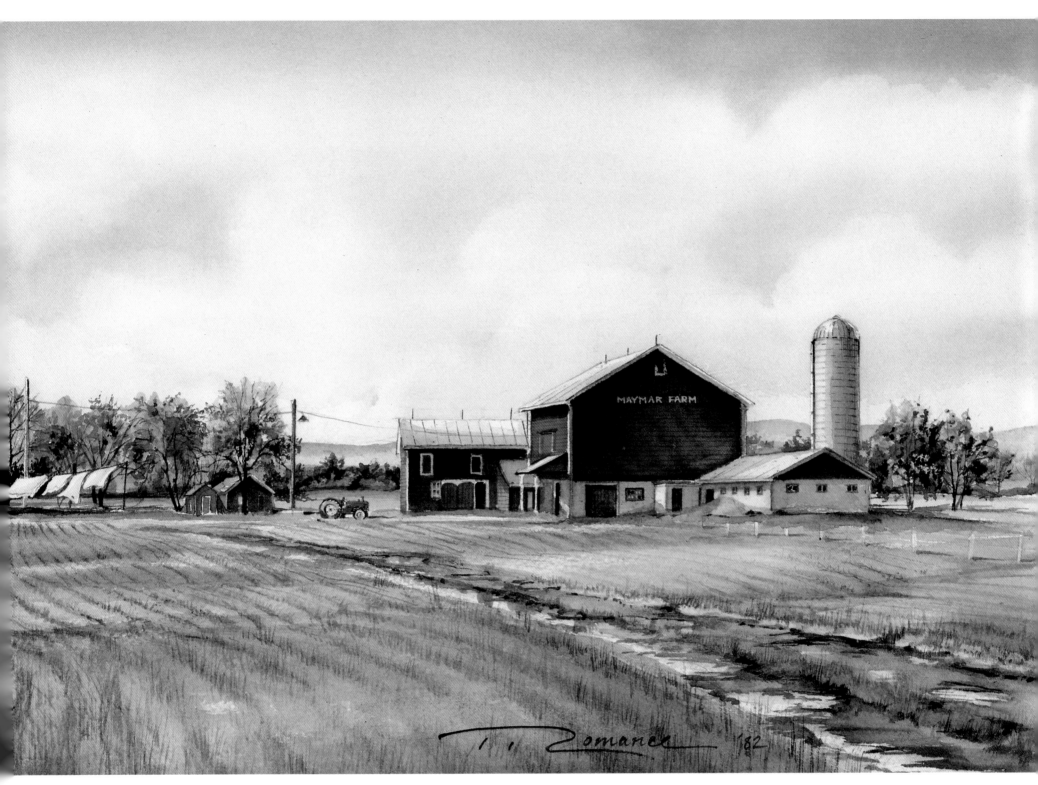

MAYMAR FARM
*F*rom my kitchen window at the farm, I saw this scene every day. It was ever-changing, yet forever constant. I particularly loved the way the furrows drew me in. Such patterns sometimes become the inspiration for my work.

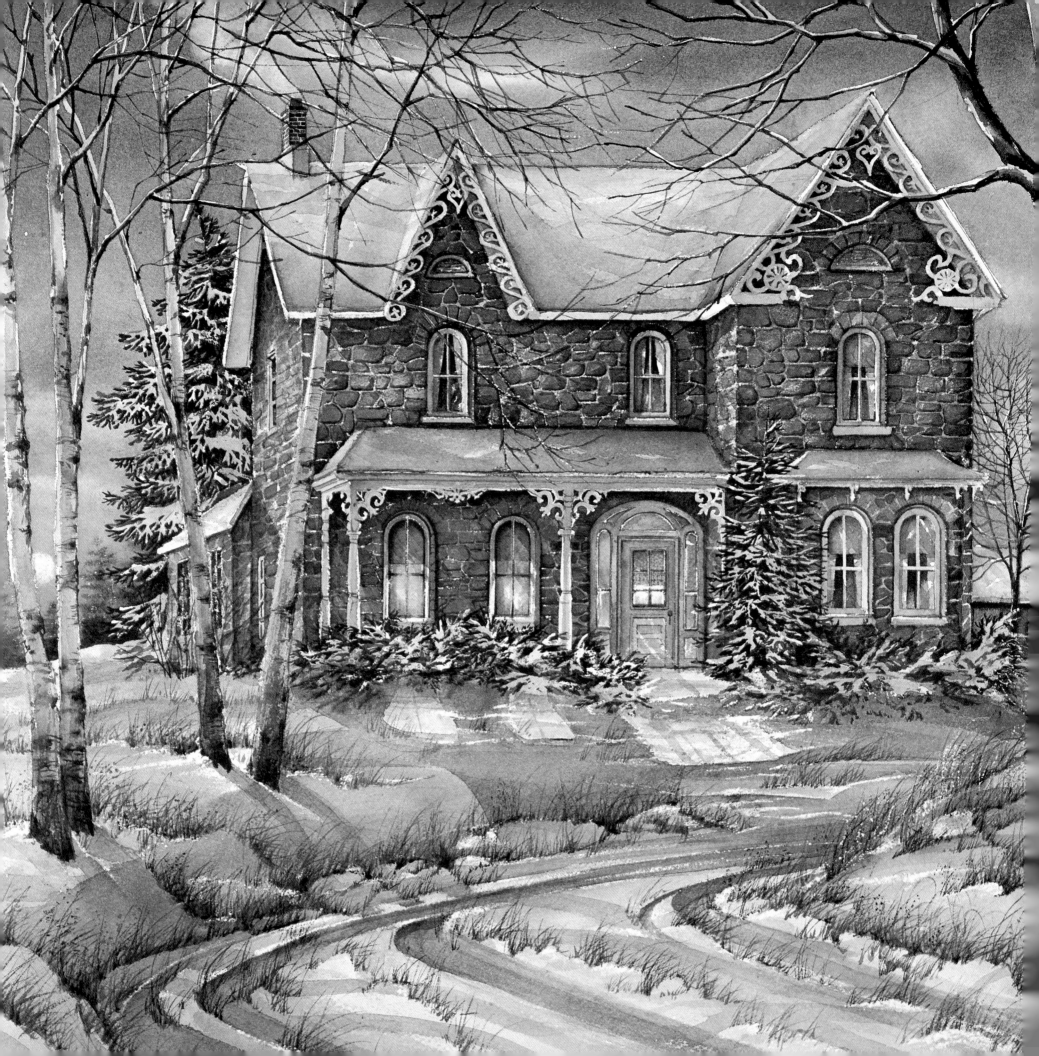

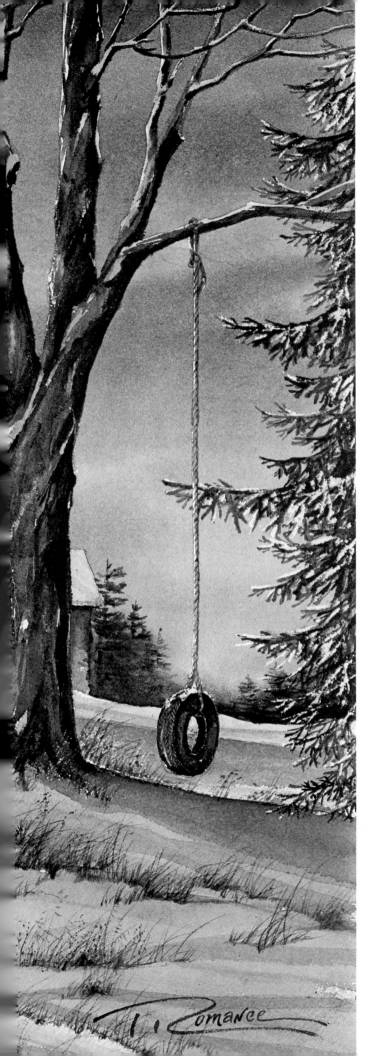

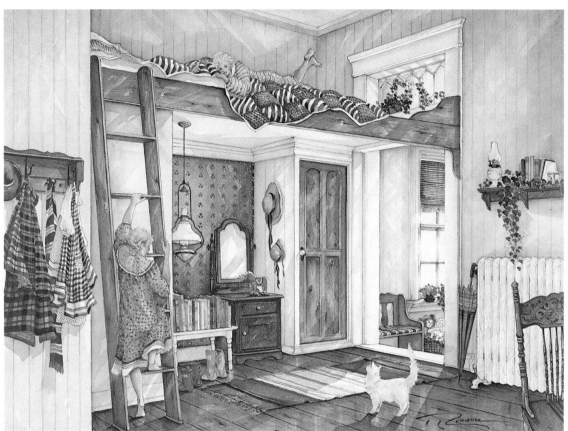

△ THE LOFT
How proud I was of my first studio apartment! Who cared that it didn't have a kitchen sink? It was loaded with charm and light, and, thanks to Gary's carpentry, it had a loft.

◁ WARMTH OF WINTER
As a child I never knew it was time to head home from sledding until my nose and toes were frozen. But the light cast from the windows onto the snow when I returned gave me a sense of warmth and a feeling I love to carry through every winter painting I do.

SCARECROW

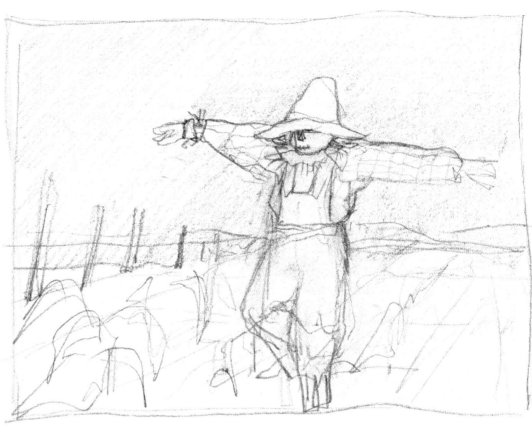

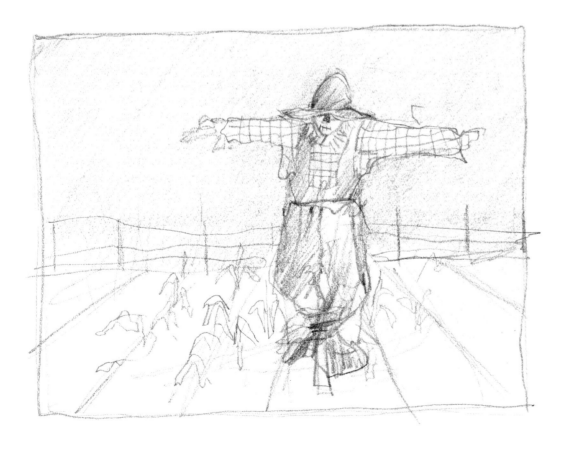

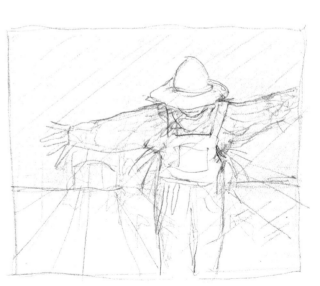

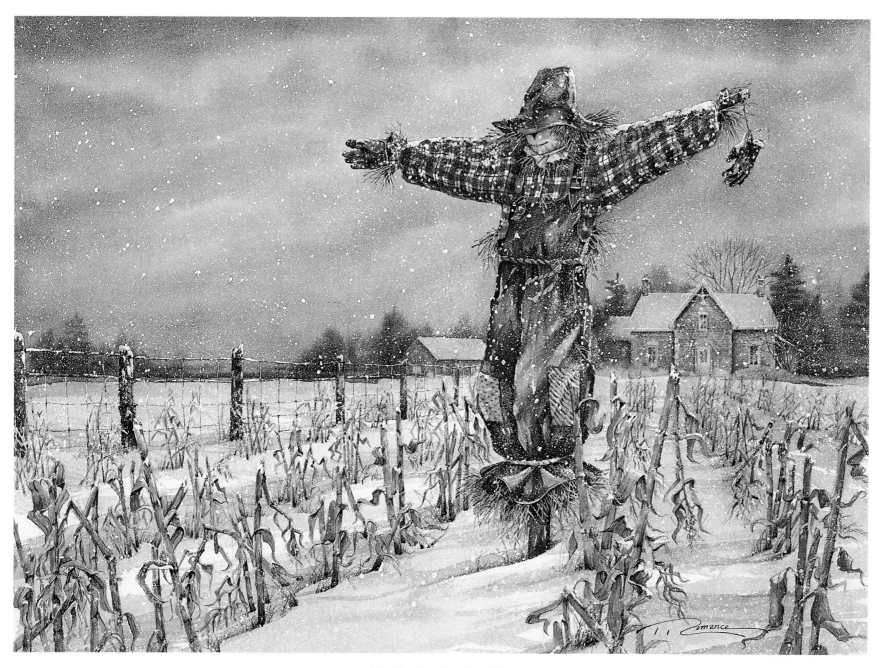

THE SCARECROW

*W*hen we were on the farm, we made a scarecrow even before the garden was planted. When I decided to paint one in winter, I soon found that making a scarecrow in real life was much easier than sketching him. He went from sad to dancing to forlorn and finally to proud.

THE APPLE PICKERS

*T*here will always be a special place in my heart for cows. Watching them on the farm was a constant source of entertainment. While their oddness was a great challenge to paint, their aura of contentment enriched our lives.

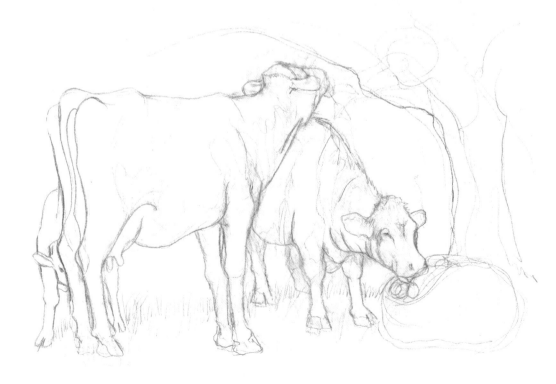

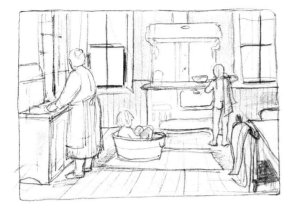 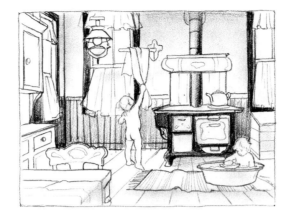 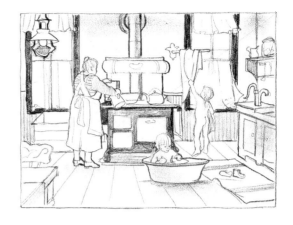

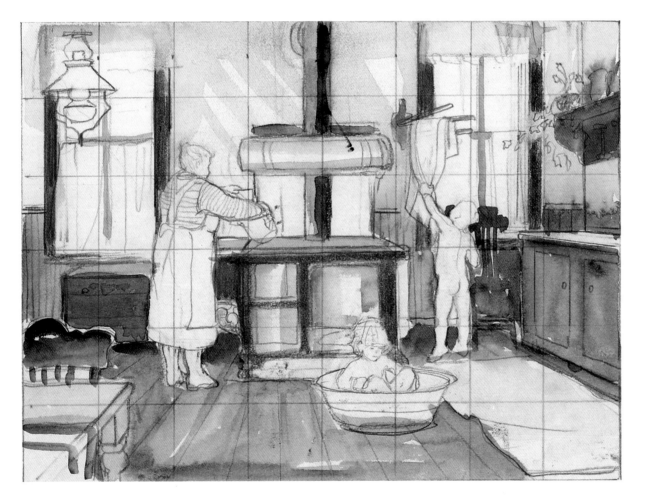

▷ KITCHEN BATH

*S*pruce Lane Farm is a lovingly preserved, old-fashioned working farm near Oakville, Ontario. You can see the many choices I played with while painting the kitchen here. In the end I felt it was important for the grandmother to be safely watching over the hot water on the stove.

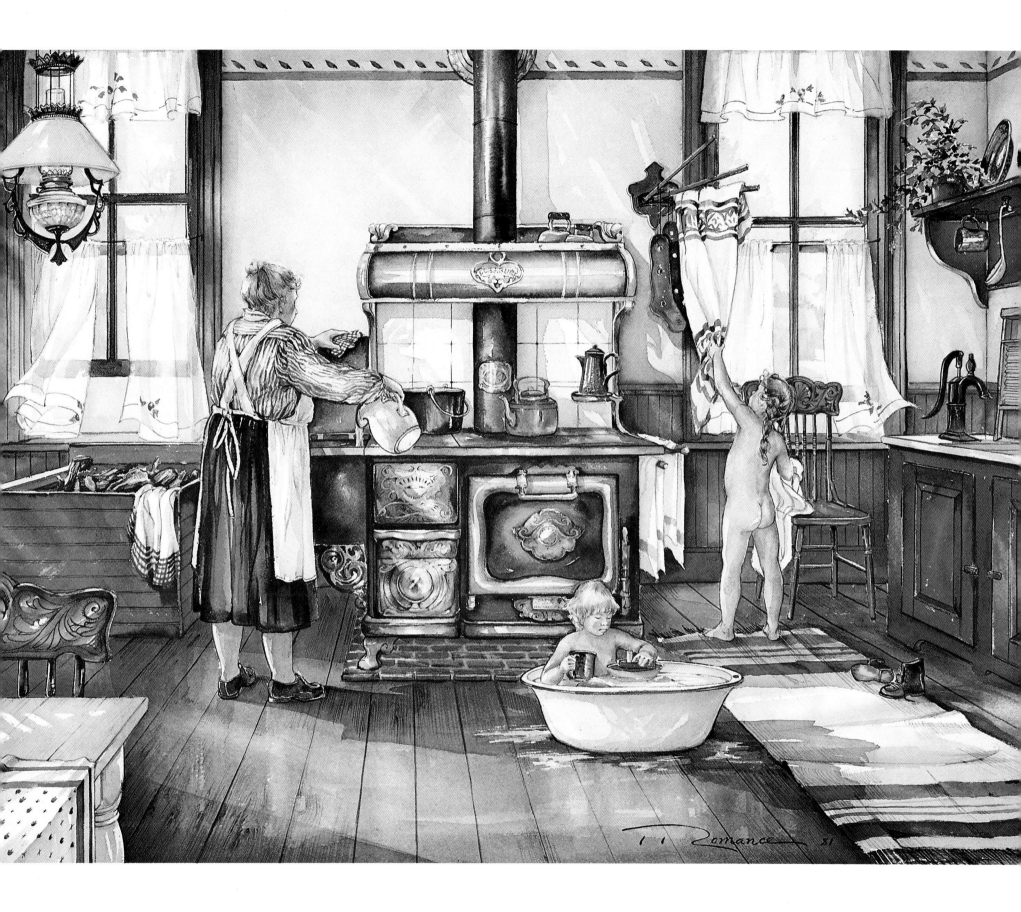

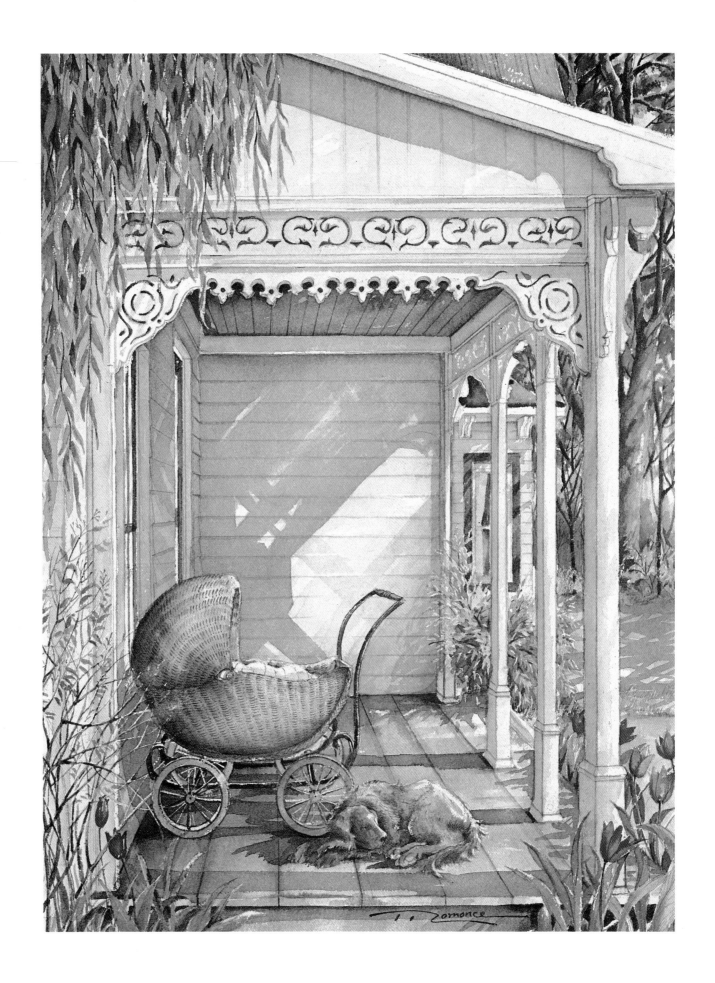

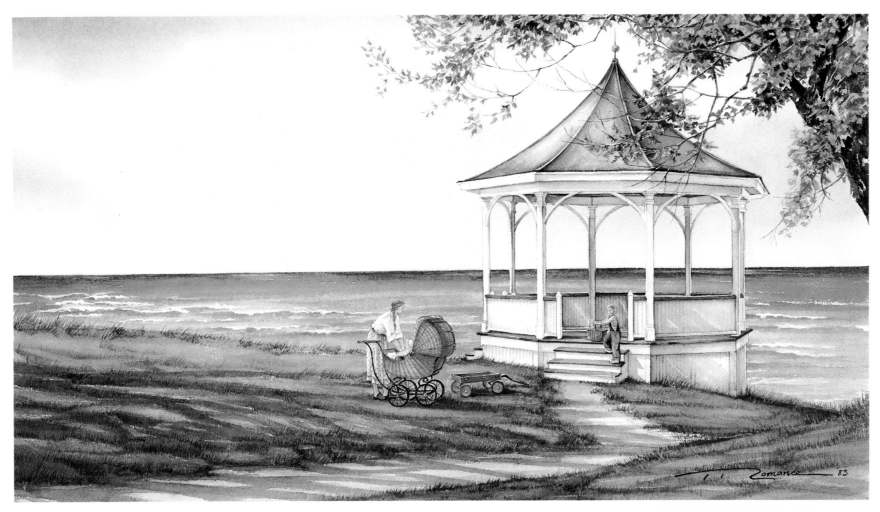

△ SHORELINE PICNIC

*M*y search later ended when, as a wonderful surprise, friends arrived at our door with the carriage of my dreams, which they had discovered at an auction — just in time for our move to Niagara-on-the-Lake, and for the many picnics we would enjoy there with baby Tanya.

◁ SPRING BABY

*E*ven before I had children, I was in search of the perfect baby carriage! The one in this painting appeared in a 1927 Eaton's catalogue. Not only did it become the focus of "Spring Baby", it also gave me new hope for my ongoing search.

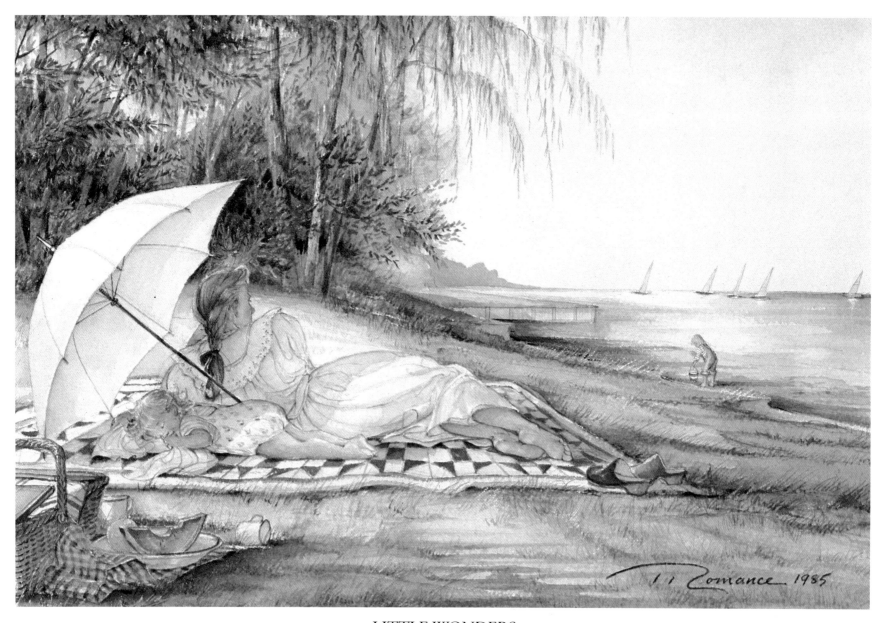

LITTLE WONDERS

I know that for years to come this painting will be special to me. When Nathan was four years old he used to look for pieces of glass washed up on the shore. He called them jewels, and when he found the perfect one he would give it to me and ask me to marry him.

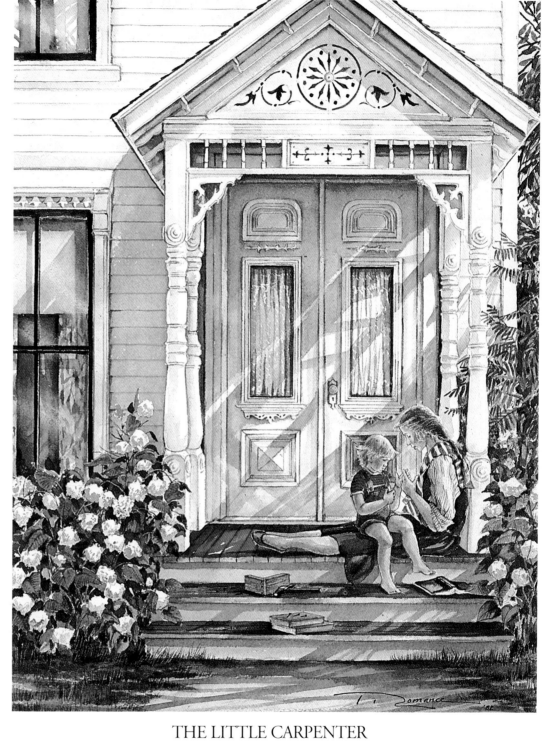

THE LITTLE CARPENTER

*A*lthough the original idea for this painting was to have Nathan taking a watermelon break, it changed in midstream one day when Daddy's hammer proved too much for little fingers.

THE ICE CREAM MAKERS

*During a trip through Vermont with the family, I spotted this sunny
yellow home and thought it looked delicious with all the floral colours
around it. What better way to express it than by adding ice cream making?*

WASH DAY

*P*eople often ask about the white cat that appears so frequently in my work. Our deaf white cat was a little lost soul, always there watching everything I did. Even when I was painting, he'd perch nearby, following every stroke of my brush.

▷ THE REINDEER KEEPER
*W*hen I lived in Lapland, steeped in folklore, I dreamed of having a little boy of my own to share wonderful tales with. I was blessed with Nathan, whose Swedish features could launch a thousand paintings — and tales.

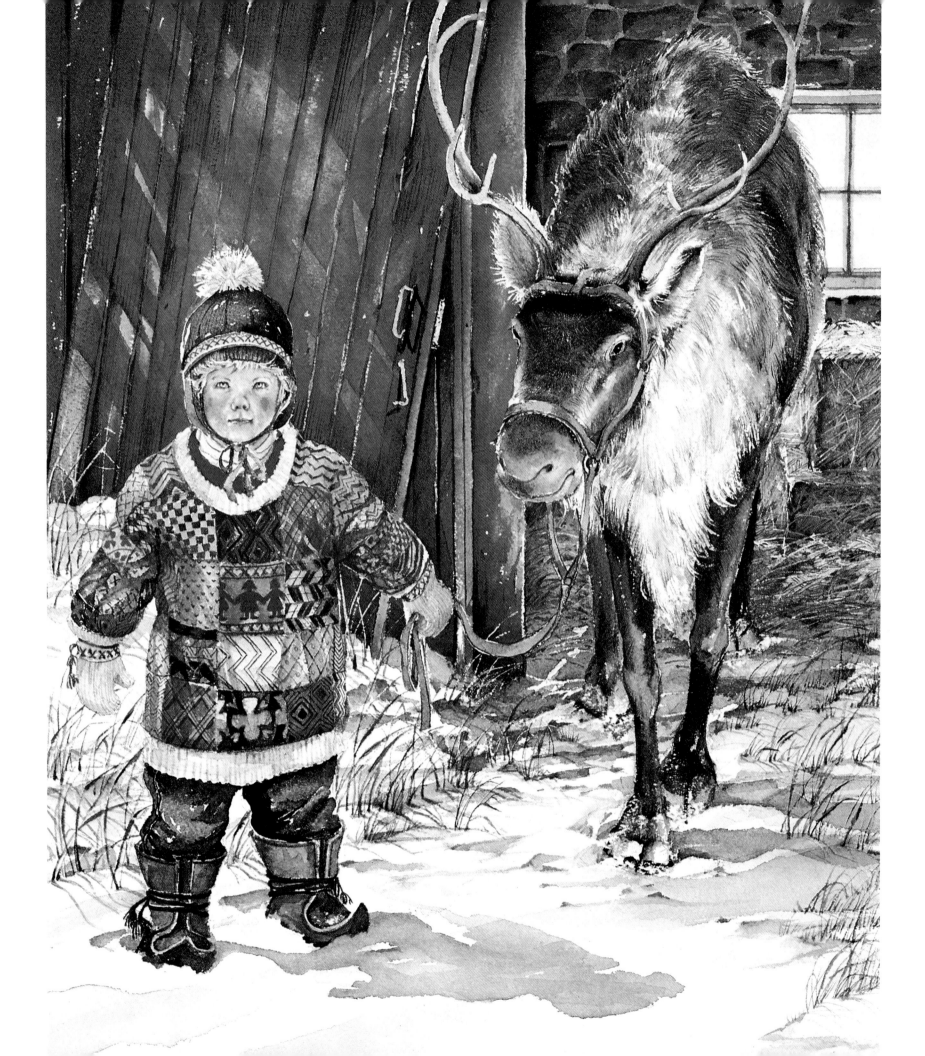

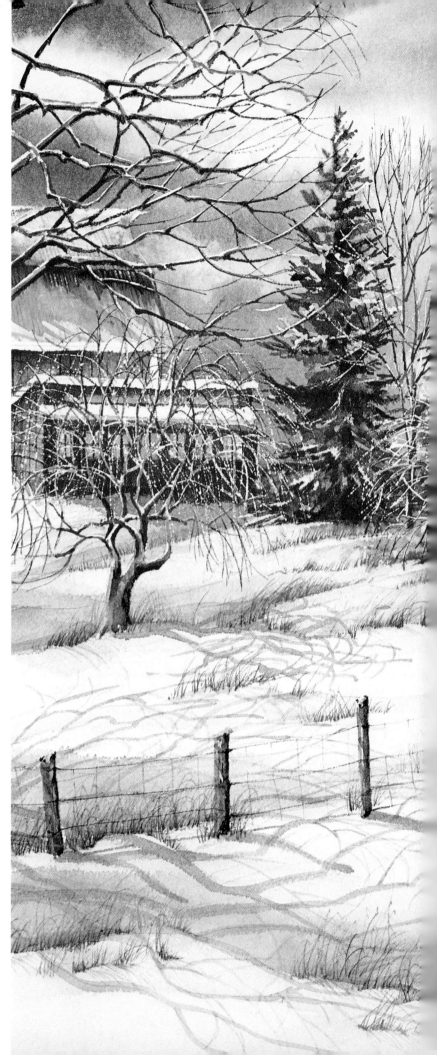

▷ VICTORIAN MAJESTY

I have the greatest admiration for the early Ontario builders who had such magnificent architectural vision. As an artist, I am grateful for the chance to rebuild these homes, piece by piece, in paintings.

△ A DAY TOGETHER

*T*he original sketch for this showed me in my apron standing on the porch saying goodbye to Nathan, who was going skating. As you can see, I decided to forgo the housework and join him for a day together.

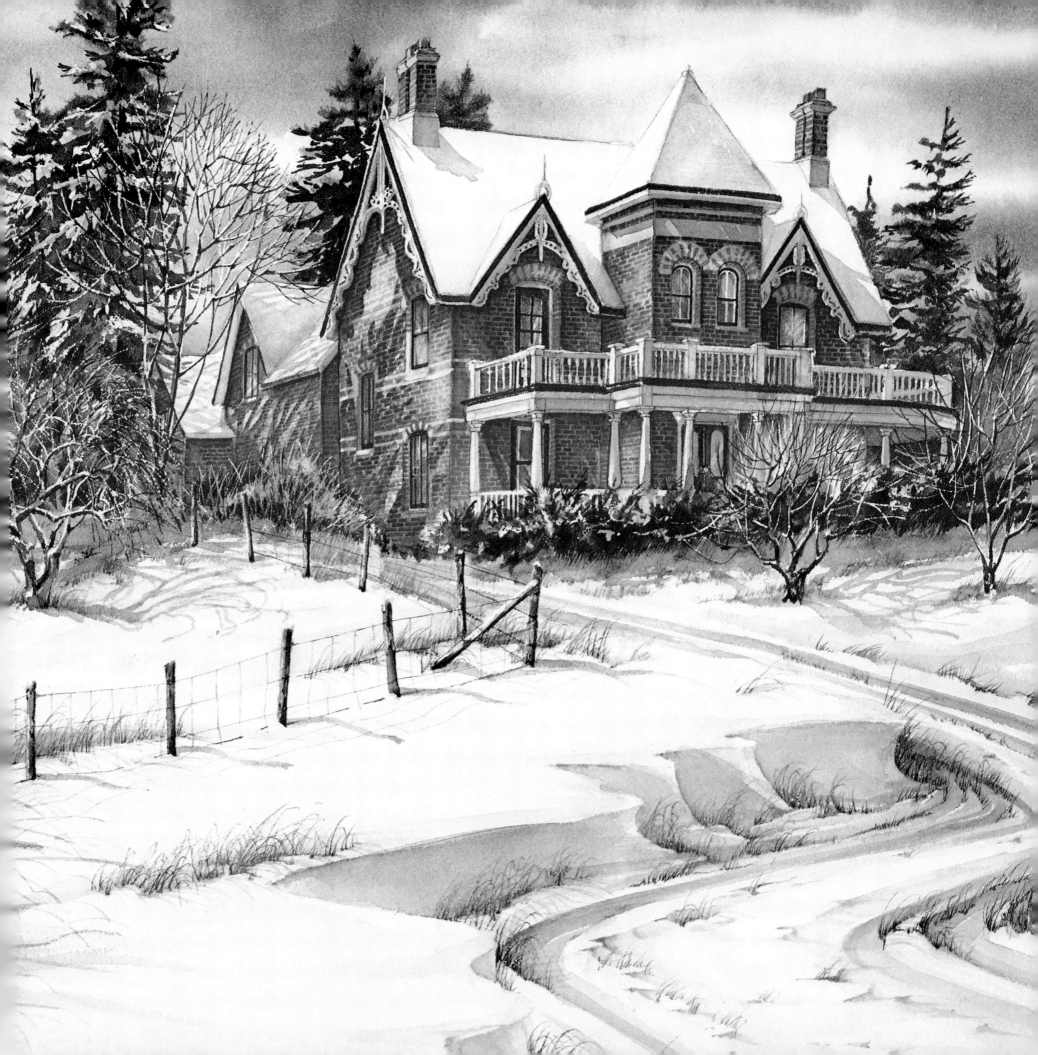

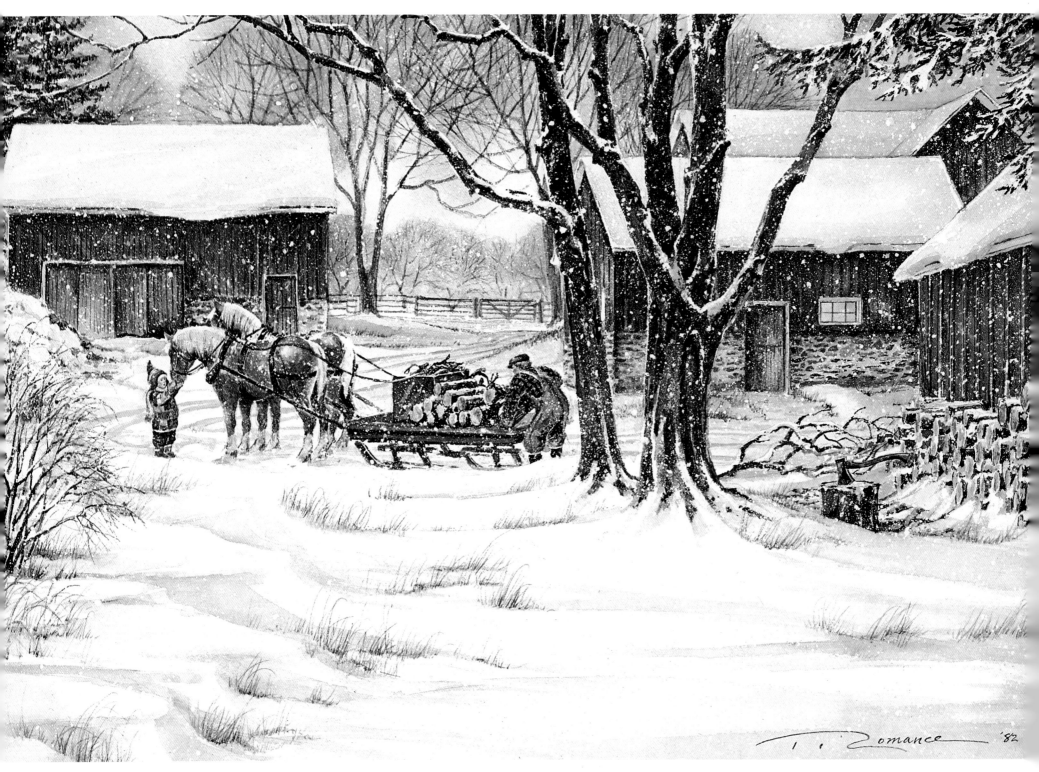

THE WOODCUTTER

*J*ust outside the kitchen window at Spruce Lane Farm you can see this
scene. We used to love visiting the friendly Belgian horses there as they
went about the business of reminding us all of a pace of life that has all but
disappeared.

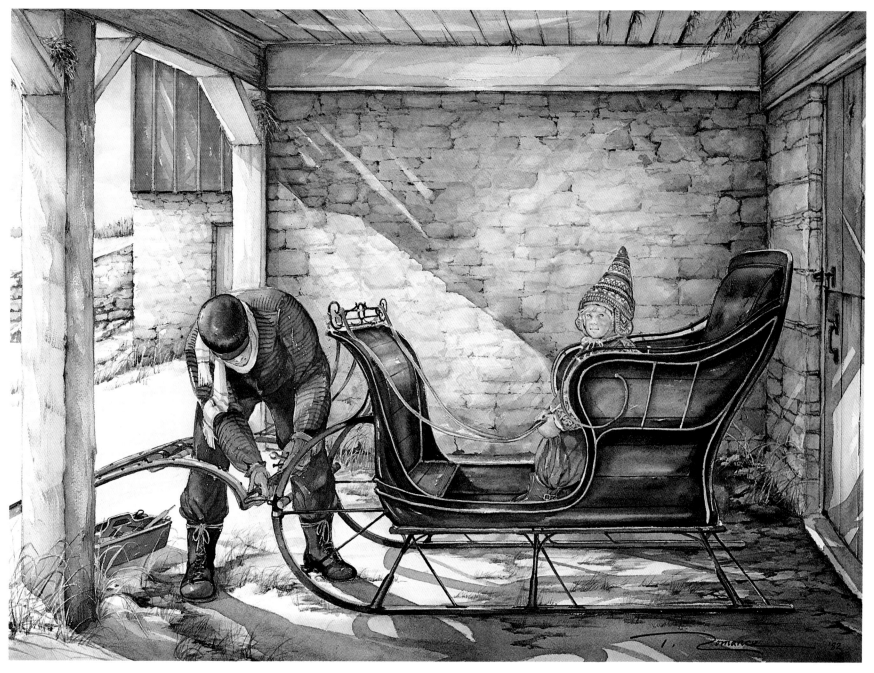

ANTICIPATION

I love cutter sleighs, with their graceful, magical lines. Our modern age can never come close to duplicating them. When I go for a ride in one, my heart flutters and for a moment I can believe I'm flying over rooftops.

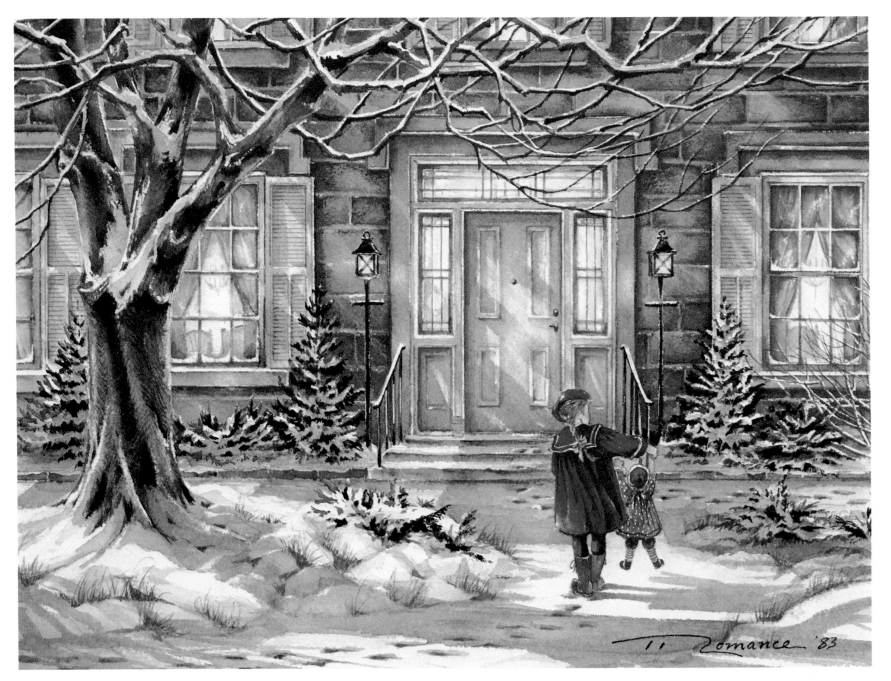

△ HARROP HOMESTEAD

The original sketch for this painting showed the little girl with her new doll leaving this lovely old gallery and restaurant in Milton. But because of the warm feelings I had for the place after many visits, I decided I liked the idea of having her return for a visit there instead.

▷ WINTER TWILIGHT

This is another view of Harrop, which stands proudly on a hillside. Like twilight itself, the place is magical: even when you leave it, a little of its warmth is sure to stay with you.

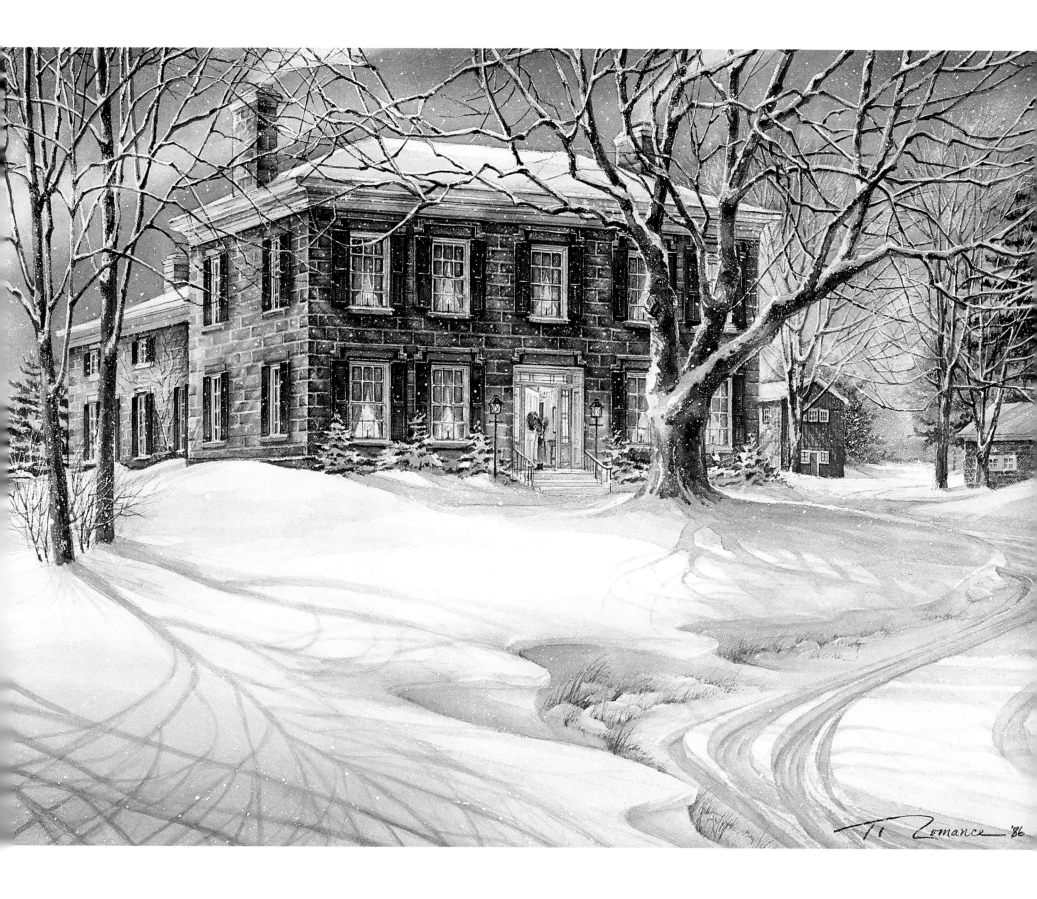

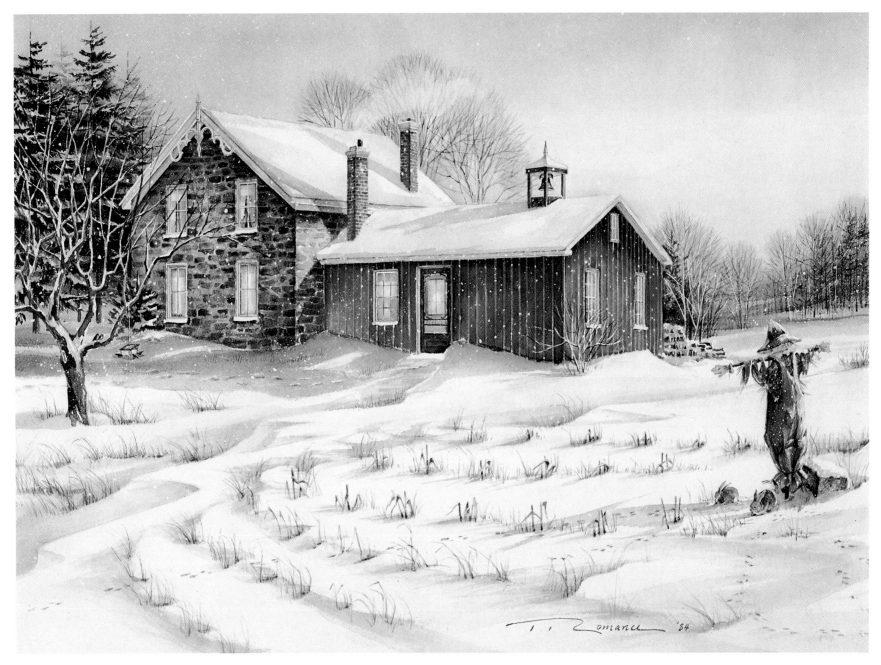

WINTER GARDEN

When visiting the home of relatives in Huntsville, Ontario, one of the first places I go to is the garden. It's always reassuring to hear that others have setbacks in getting a garden going. If the rabbits don't get there first the sheep or goats do. There are little visitors no matter what the season.

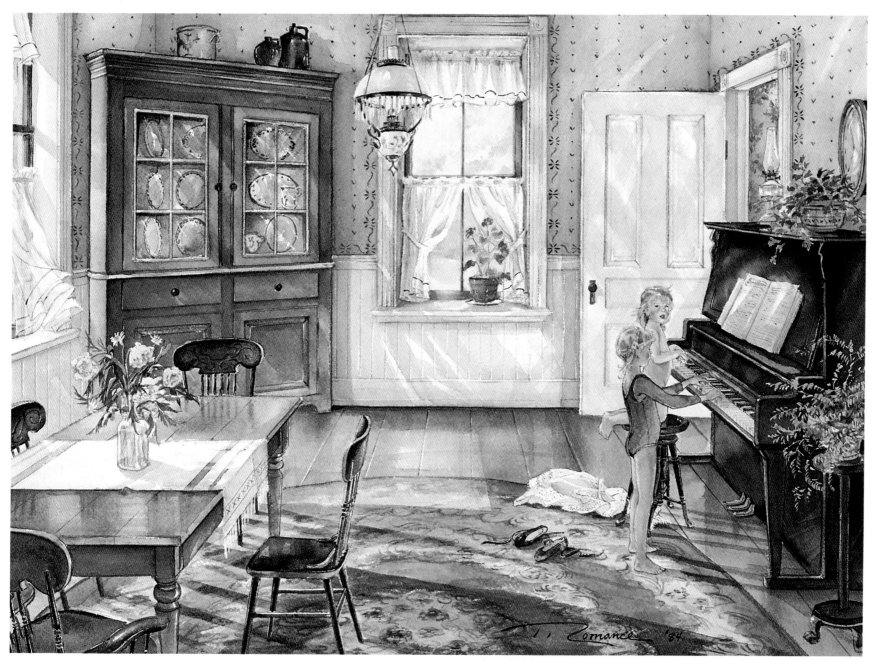

THE DUET

*H*ow precious are nieces and nephews and the all too few visits we share. Because they are family, painting them is as important for me as painting my own children. Fleeting moments and memories can live in a painting long after the children have outgrown their ballet slippers.

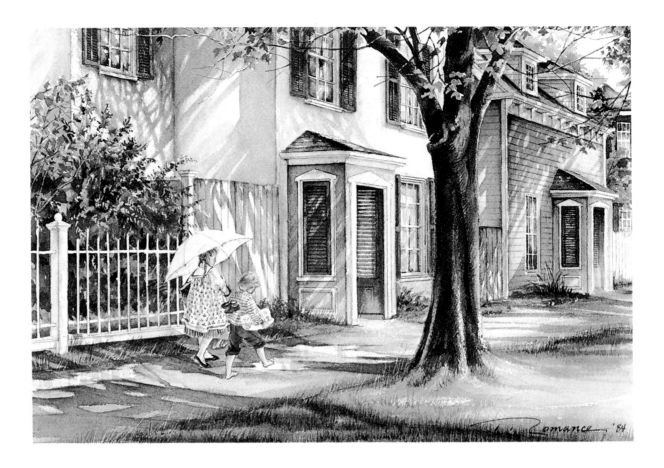

▷ SCHOOL DAYS

It came as a lovely surprise when, after I'd painted this, someone told me it matched the lyrics of the song of the same name: "You were my bashful barefoot beau, I was your queen in calico"

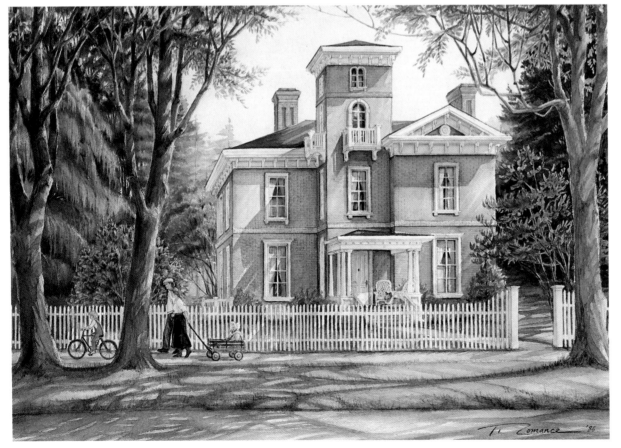

◁ THE RECTORY

*T*he Italianate tower of this rectory in Niagara-on-the-Lake seems to rise to the heavens. Towards sunset, the yellow brick catches the light of the sun as it descends over Simcoe Park.

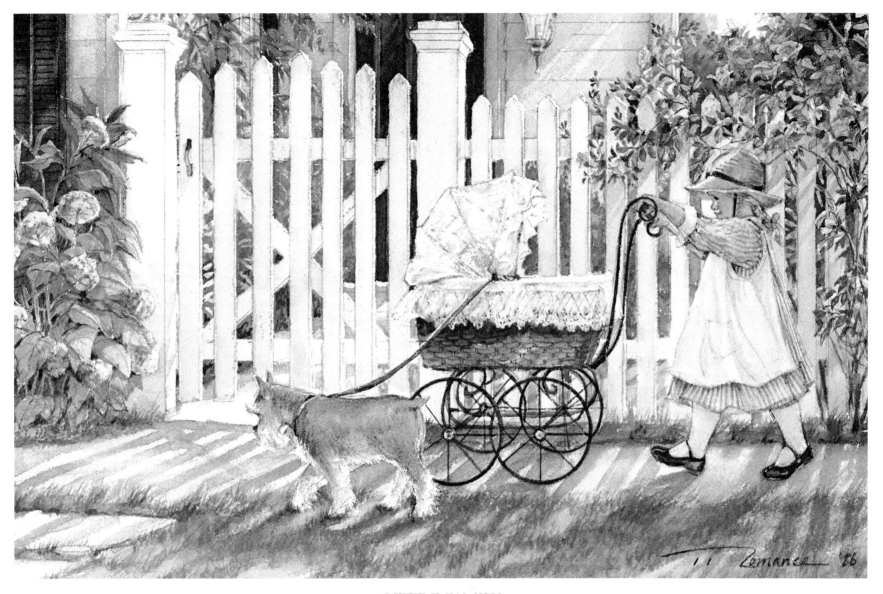

LITTLE FAMILY

Artistically, picket fences give rhythm and pace to a painting, and who better to keep pace with than Tanya, who learned to run before she walked?

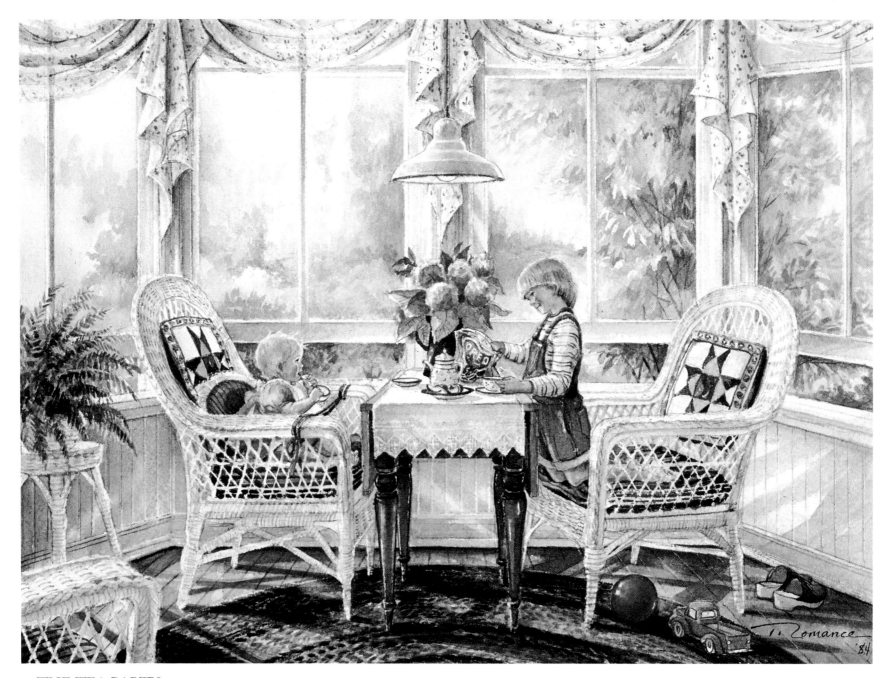

△ THE TEA PARTY

When Tanya was a baby, Nathan was anxious to have her join him for an afternoon snack, so we propped her up with pillows and secured her to her seat.

▷ A MOMENT'S REST

There was only one thing that could stop active Tanya in the middle of the day — the irresistible combination of her favourite blanket, teddy bear, and chubby little thumb.

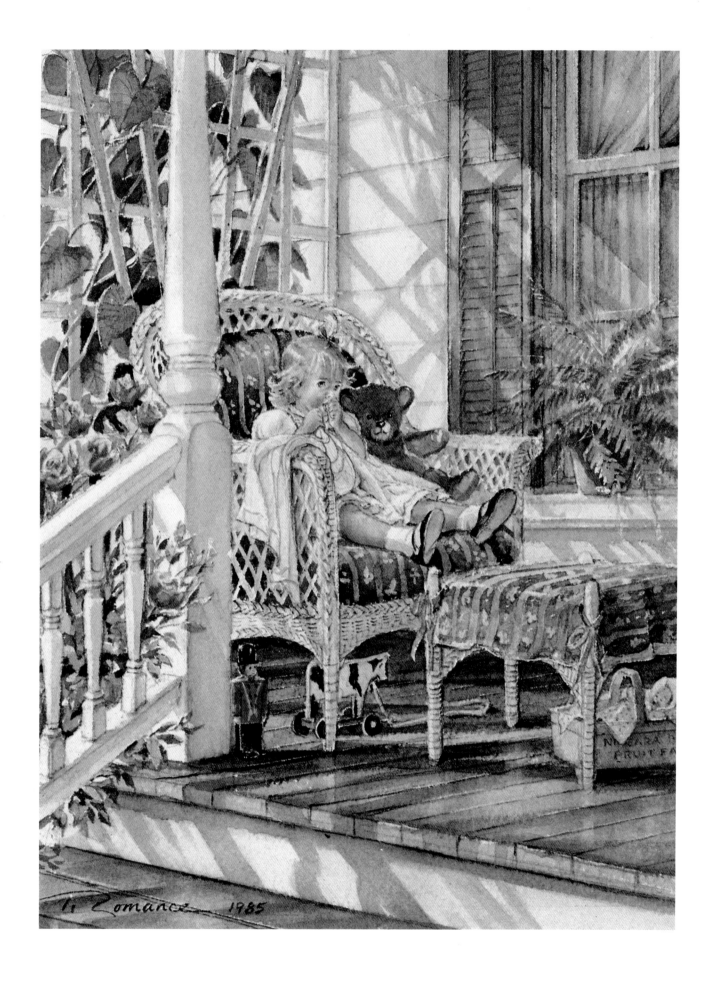

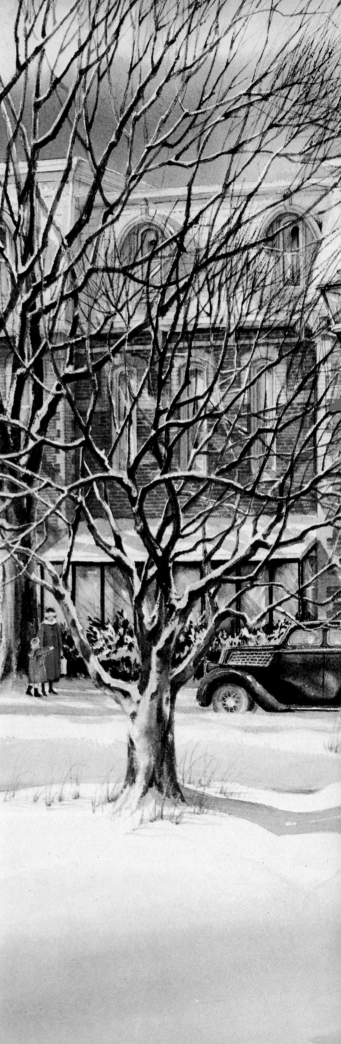

THE PRINCE OF WALES

*T*he Prince of Wales Hotel stands regally at the edge of Simcoe Park in Niagara-on-the-Lake. A proud landmark of the town, it has entertained royalty and welcomed many from near and far for a restful stop over a cup of hot chocolate after a winter walk.

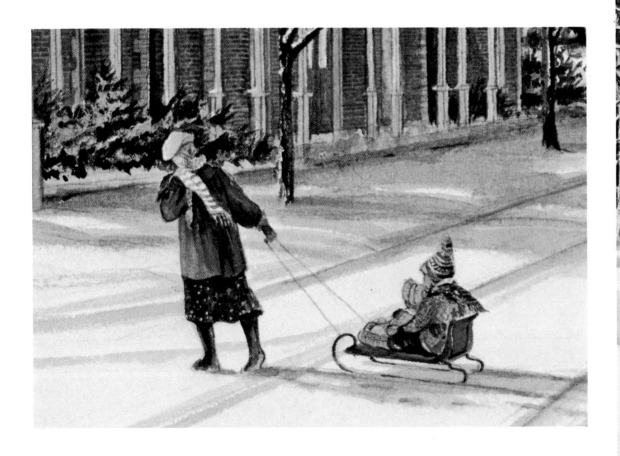

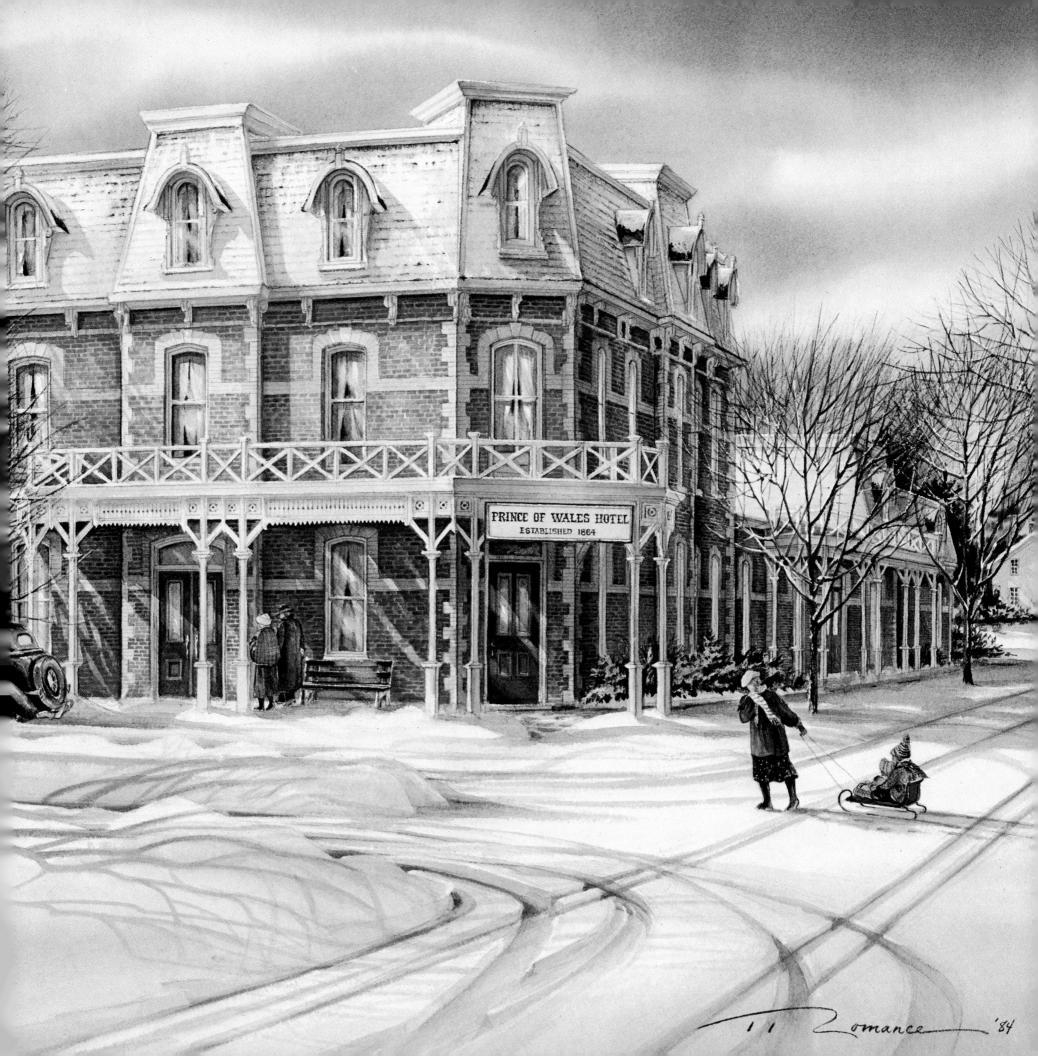

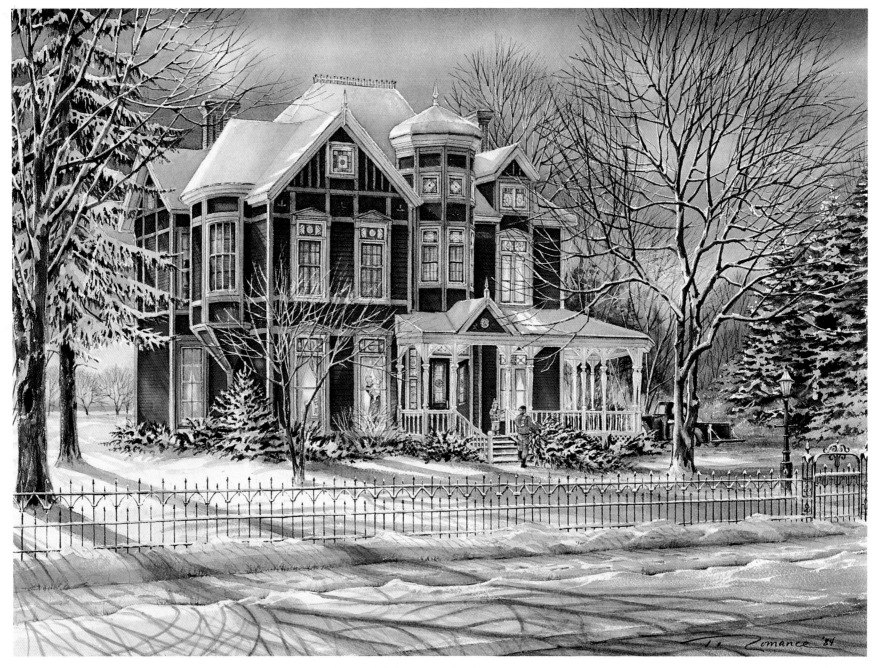

HOME SWEET HOME

*F*or a while, what is now our gallery on King Street in Niagara-on-the-Lake was our home. It was stuccoed at the time, but I found a photograph of the way it had once looked and fell in love with it all over again. This was my homage to its finer days.

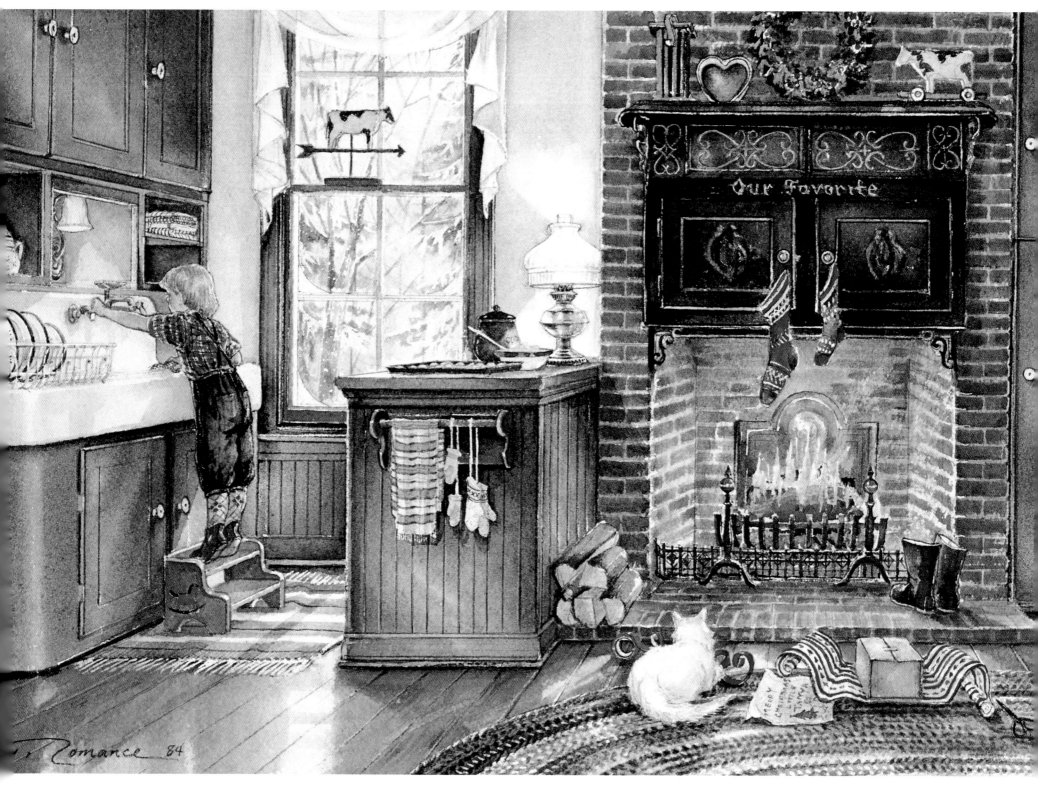

THE KITCHEN ELF

*In his knickers, suspenders, and leather boots, Nathan was a little elf to me,
especially when he became as excited as I did about the coming of Christmas.
This is the kitchen of our house on King Street as we lovingly restored it,
complete with original porcelain sink.*

▷ THE CHRISTMAS STORY
Our cheeks still rosy from a walk in
December, there's nothing like settling
in for a good Christmas story. I've
collected children's Christmas tales for
years and love to get lost in the magic
of them, never forgetting the story told
by the crèche under our tree.

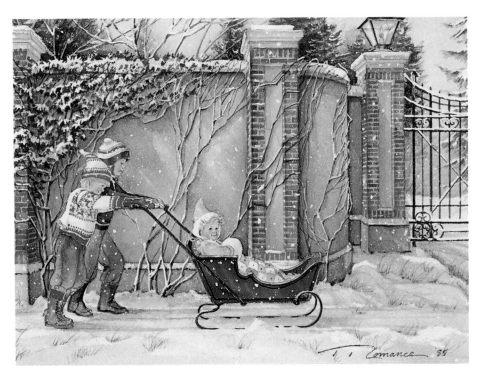

△ THE SNOW QUEEN
I've always thought the walls surrounding
Randwood, an old home near us in
Niagara-on-the-Lake, to be magical.
As if she were the Queen of Camelot,
Tanya charmed her subjects Nathan and
Kyle into pushing her on her sled.

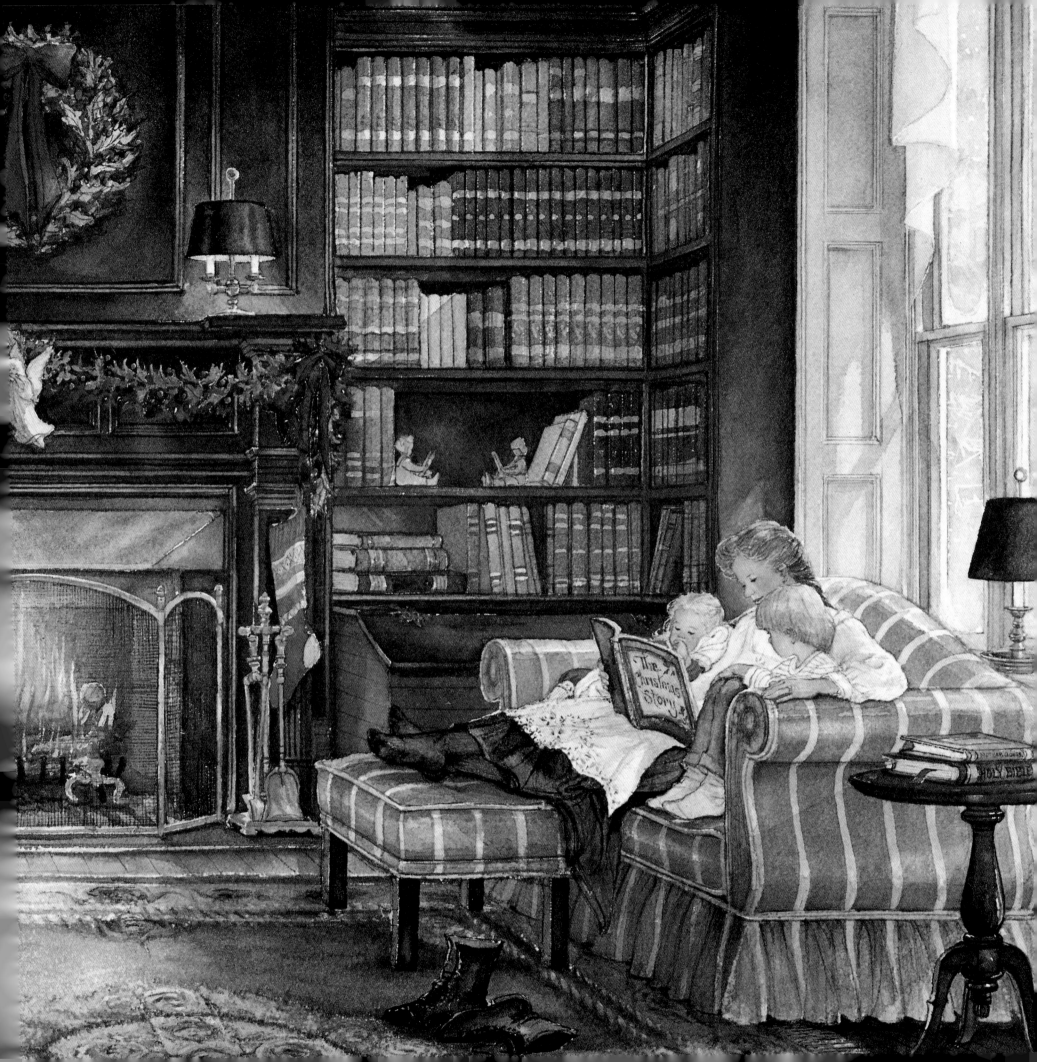

◁ THE ROOT CELLAR

*A*rtistically, it was the sculpted maple tree that excited me when I first came upon this scene. But there was also the brilliant azure sky, and the orange pumpkins in their last performance of the season.

▷ THE APOTHECARY

*N*ow a museum, this old building stands in the middle of our town as a reminder of a place once vital to the health and well-being of any community.

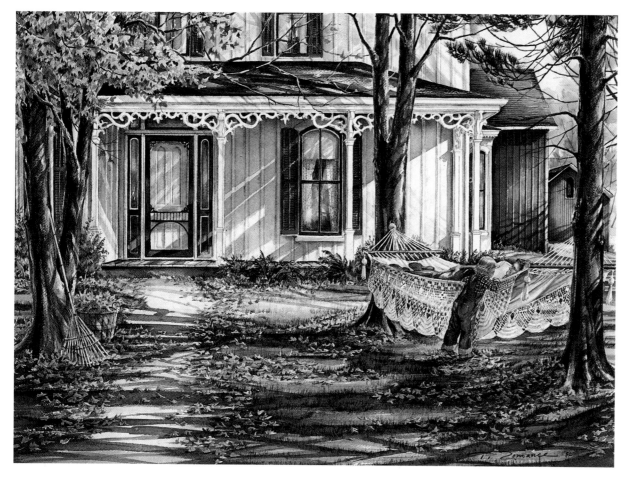

◁ FATHER'S LOVE

*T*his hammock was a Father's Day gift to Gary. Nine years later the children may be bigger, but the scene really hasn't changed: he is never alone there for long.

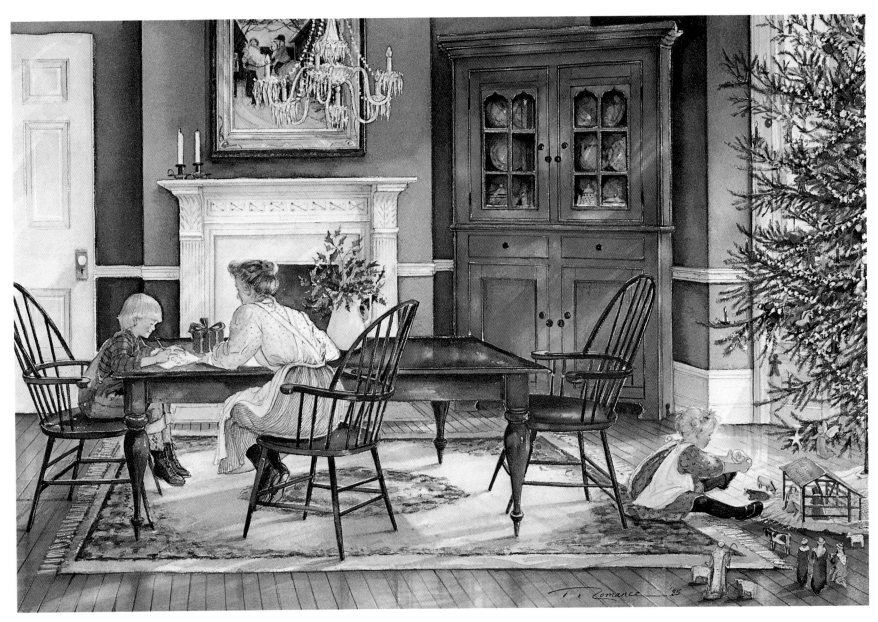

THE GIFT

The birth of the Christ child is a gift we celebrate joyously generation after generation, with every Christmas card we write and every gift we wrap.

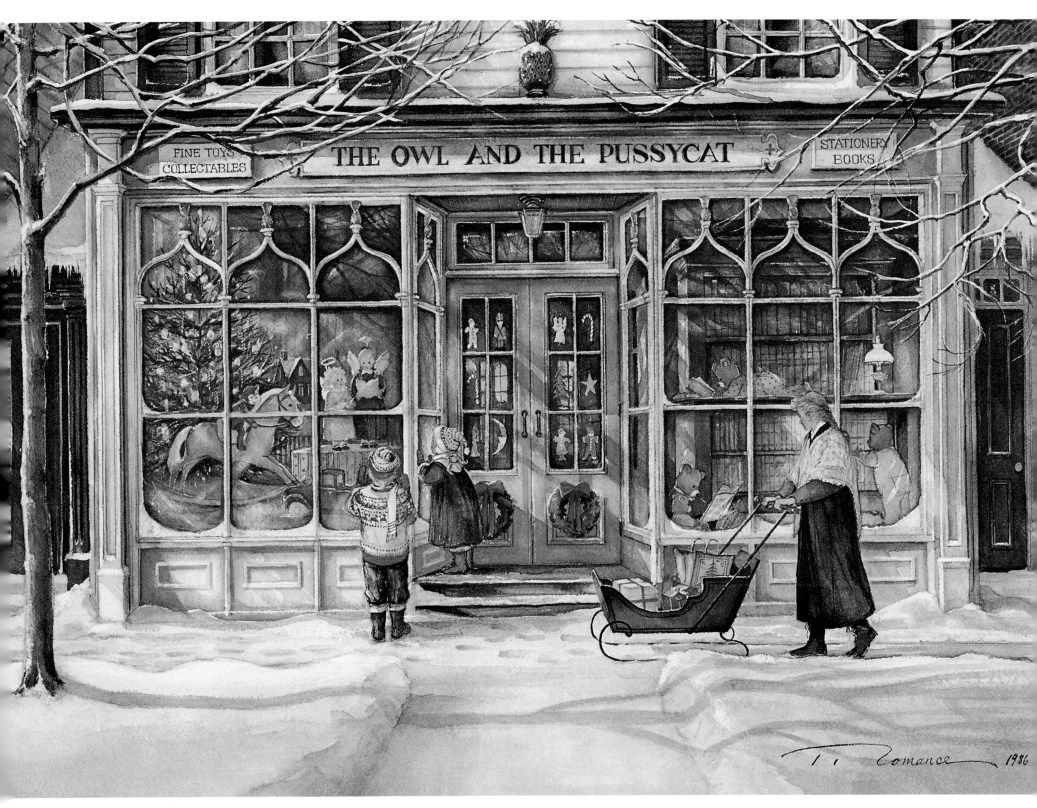

THE WINDOW SHOPPERS

Experiencing our town at Christmas time is for me like becoming a character in a Dickens novel. We each have our favourite places which we hope will never change because, like the classics, they should last forever.

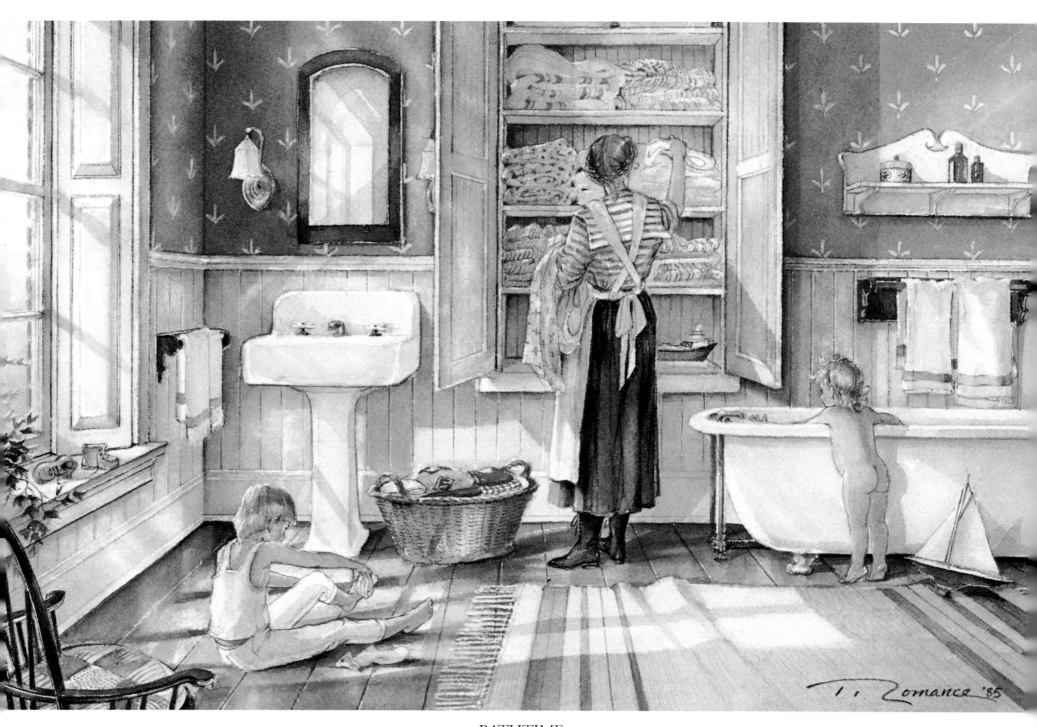

BATHTIME
Sometimes elements from a single sketch may end up in more than one painting. After changing the viewpoint in my early sketch for this piece, I arrived at the final composition and finished the painting of bathtime at our house.

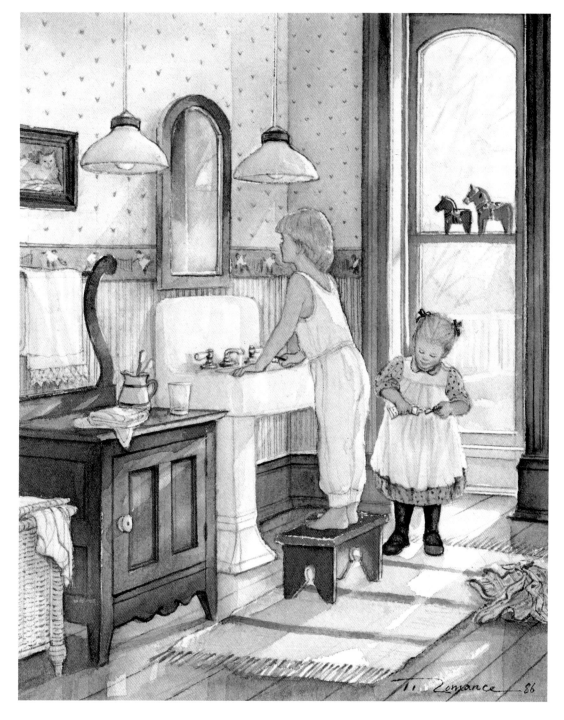

▷ TAKING TURNS
𝒯he sight of Nathan at the sink —
which I saw so often — was
later used in this painting.

It always brings me a sense of joy when someone tells me, as they did with this painting, that I've painted something through their eyes, when they recognize over a garden gate a scene that I've painted and for a moment share it with me.

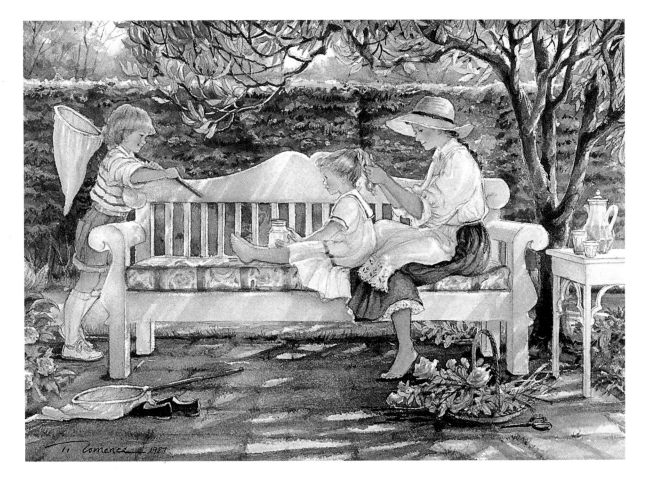

 ▷ GARDEN RETREAT
Persuading children to retreat from play can sometimes be nearly impossible unless they need a cool drink. I can remember how when I was a child my butterfly net was a source of endless delight, and I tried to catch anything that moved in order to get a closer look.

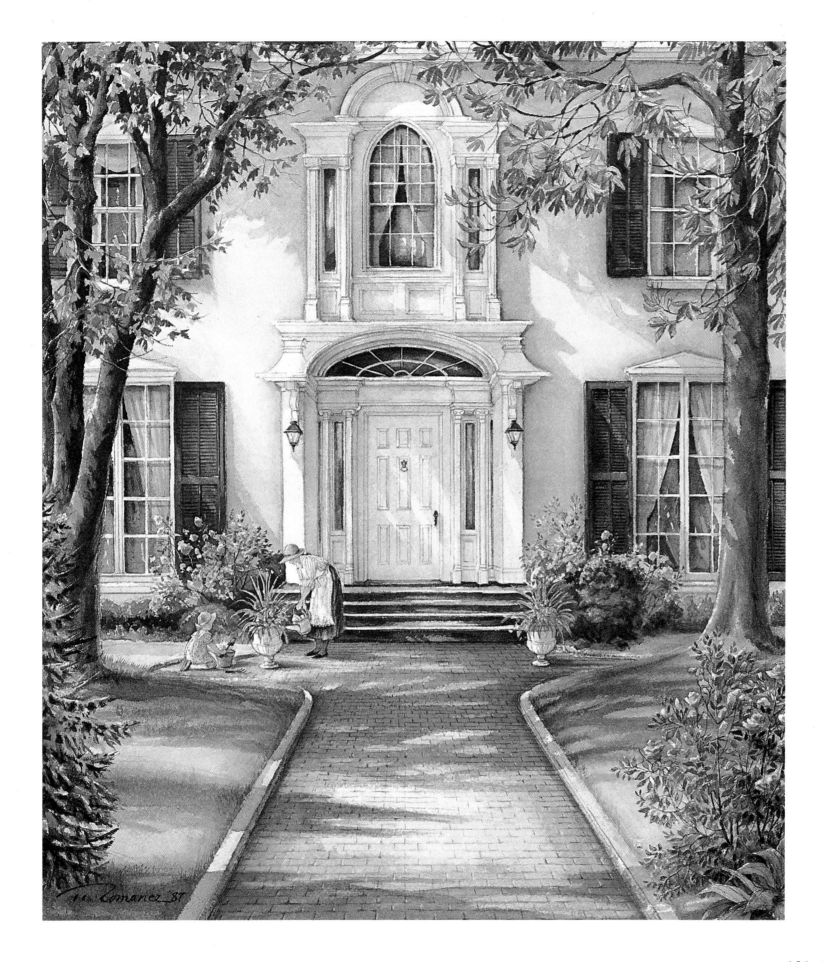

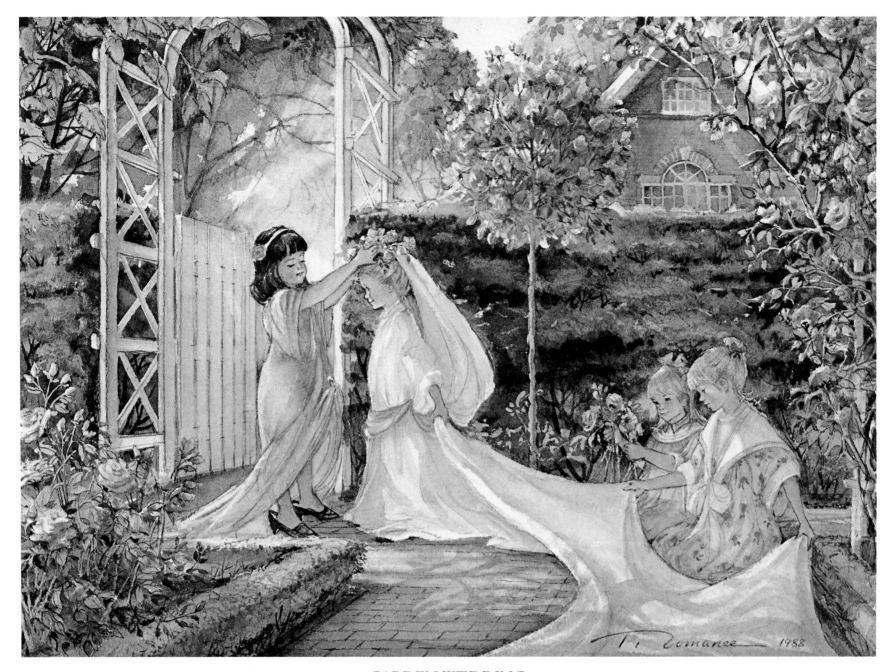

GARDEN WEDDING

*W*hen cousins get together it takes little to amuse them. On one visit they managed to find an unused sheer curtain that made a perfect veil for Tanya. An assortment of my old dresses from the costume drawer provided clothes for the adoring bridesmaids.

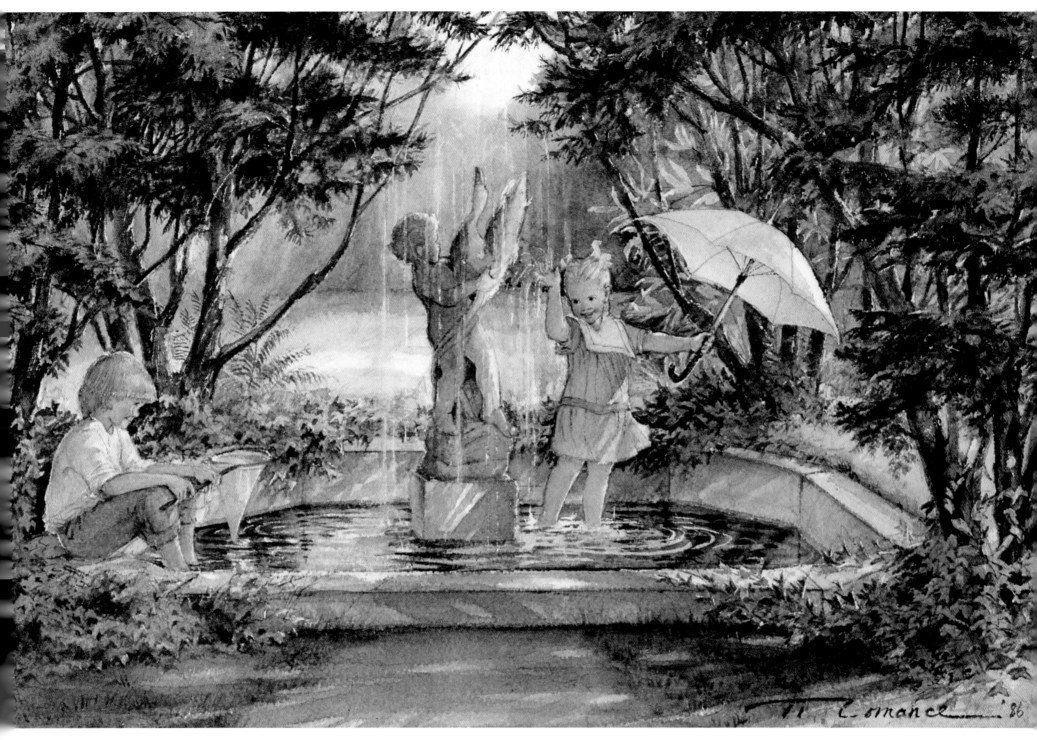

FOUNTAIN OF LOVE

Tanya's mischievous antics always made Nathan an instant audience,
whether he wanted to be or not. Sometimes he just smiled in bewilderment;
other times he couldn't resist the temptation to join in.

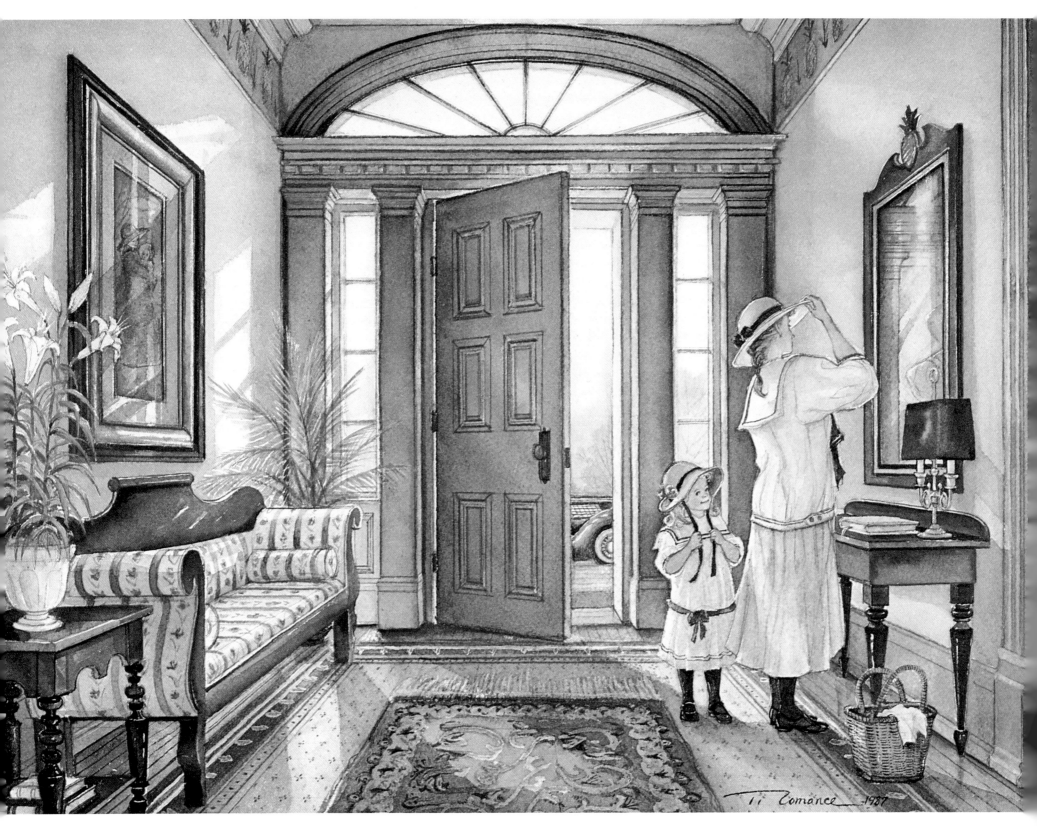

EASTER BONNETS

*A*mong my favourite things to collect are hats, particularly Easter bonnets.
Two of my most prized hats are ones I had as a child. I can't imagine my
childhood without memories of the annual hunt for the perfect Easter bonnet.

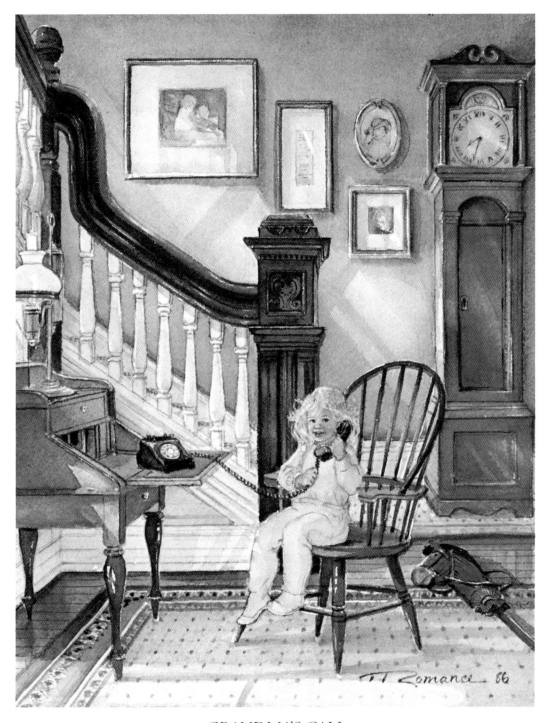

GRANDMA'S CALL

*S*ometimes they only listen to the voice on the other end; other times they are full of wordy news. But there came a time with Tanya when she would race to be the first to answer the ring. You could always tell by the smile on her face when it was a call from Grandma.

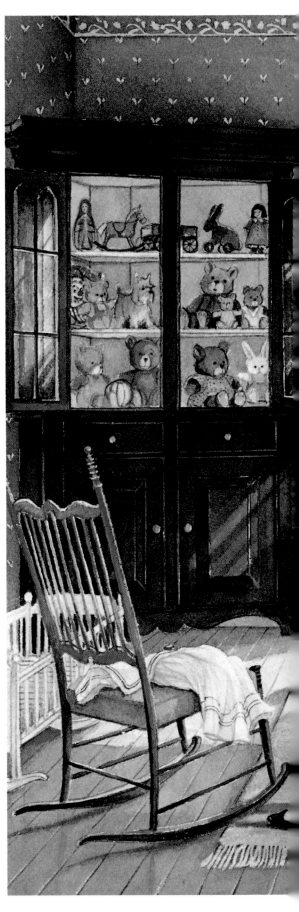

▷ SUNLIT MORNING

*W*hen I painted Tanya's bedroom I wanted to make sure to include her two favourite pairs of shoes — her cowboy boots for when she was feeling boisterous, and her black patents for when she wanted to dress up.

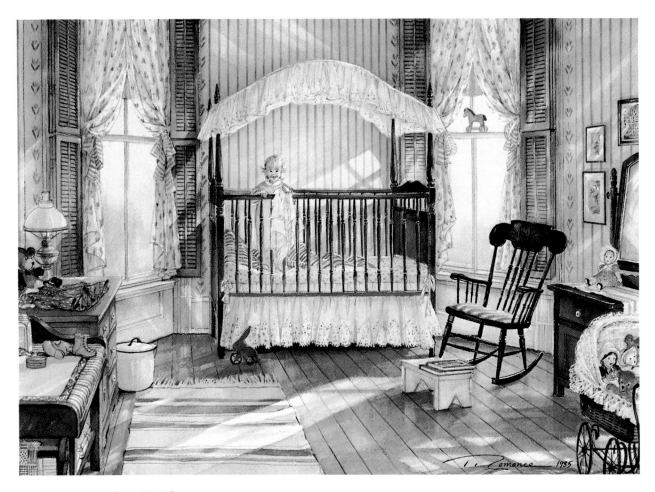

△ GOOD MORNING

*E*very morning that a little one wakes up with a bright-eyed smile is a good morning. Her healthiness, happiness, and excitement at seeing you is a blessing beyond compare.

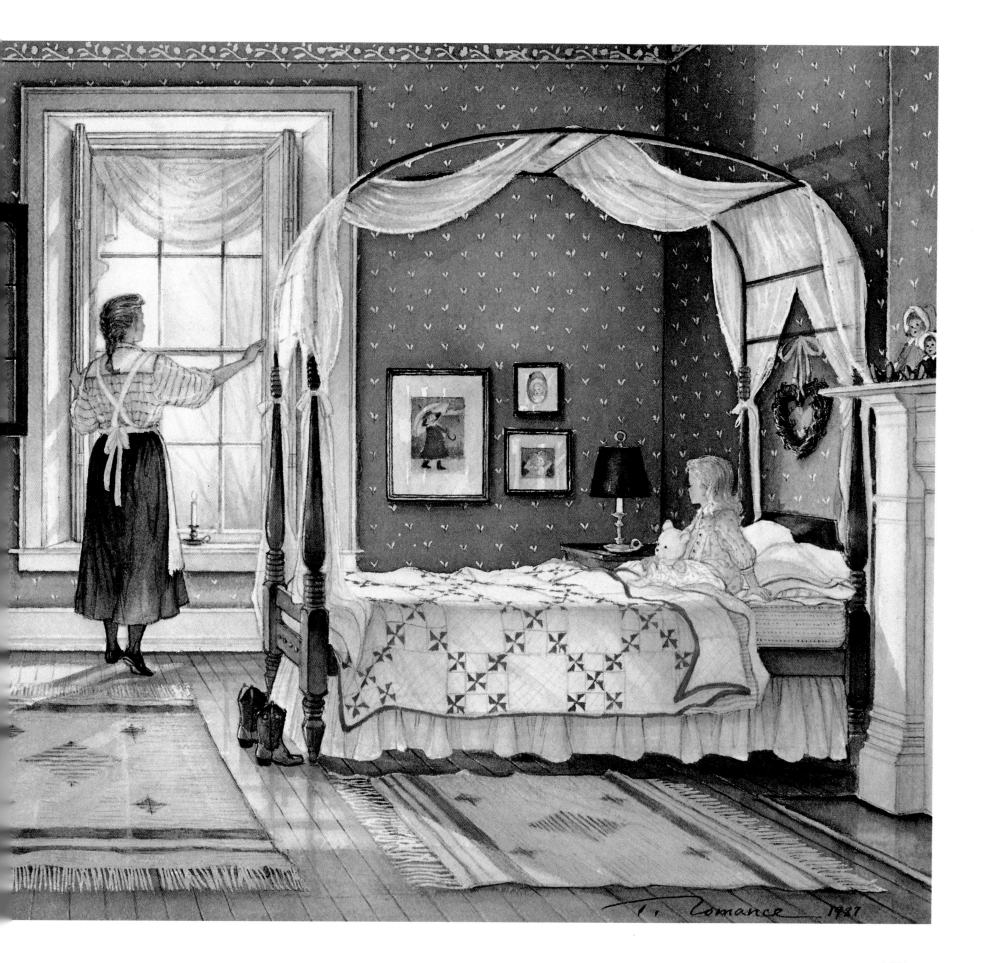

▷ THE ICE CASTLE

Sometimes a home exists in my mind before I actually find it. The idea for this painting was conceived before I saw the real house, so painting it was literally a dream come true.

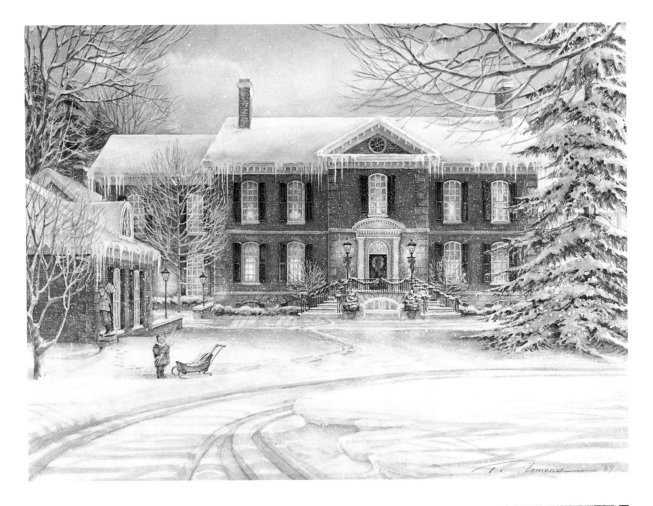

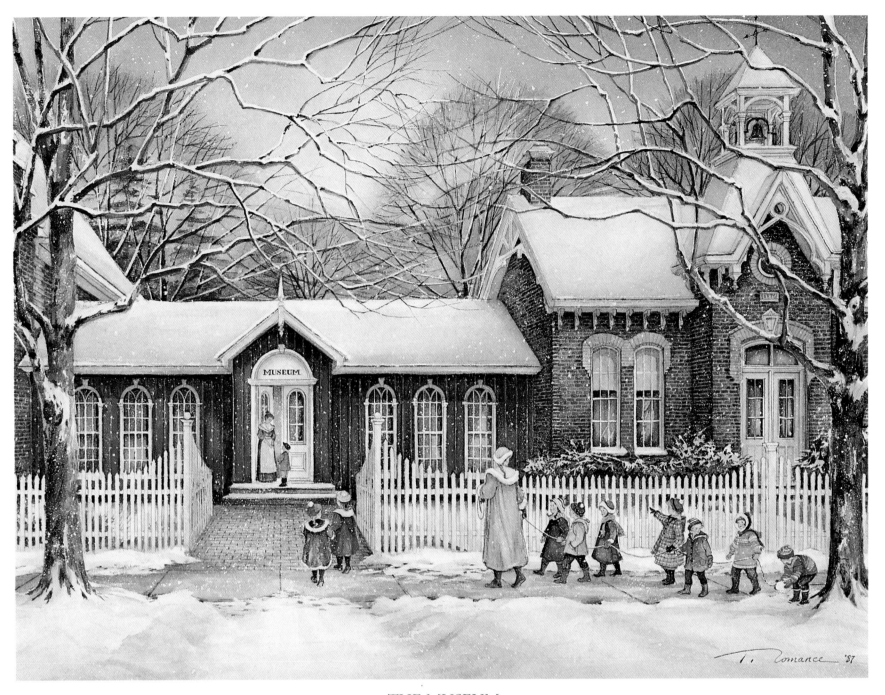

THE MUSEUM

I love our museum in town, and when I saw little ones toddling along in front of it joined by a single rope, I had my inspiration for a painting. A field trip to this special place is always full of excitement and importance.

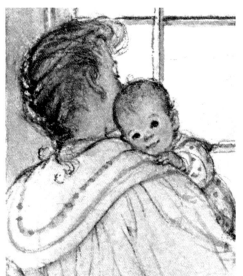

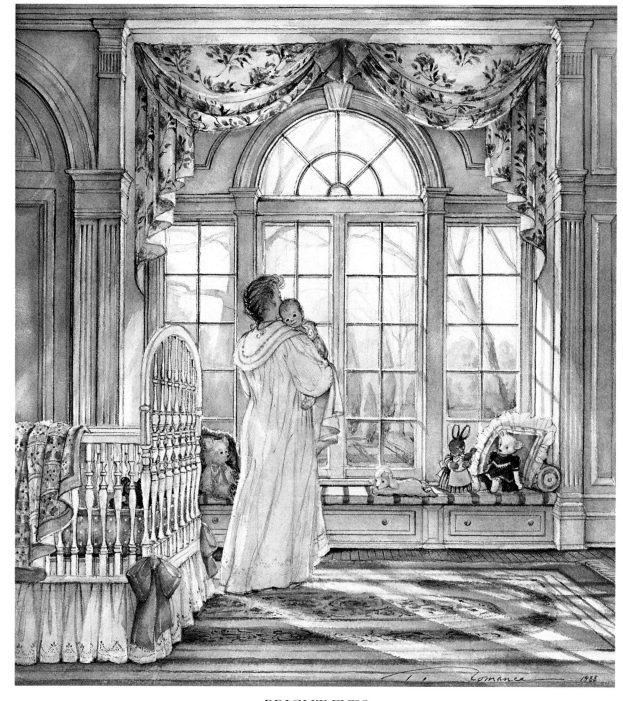

BRIGHT EYES

*C*reating this room had been a labour of love, but the light shining through the brand-new window could never match Whitney's radiance. Her brightness added a special, unbounded love to our family.

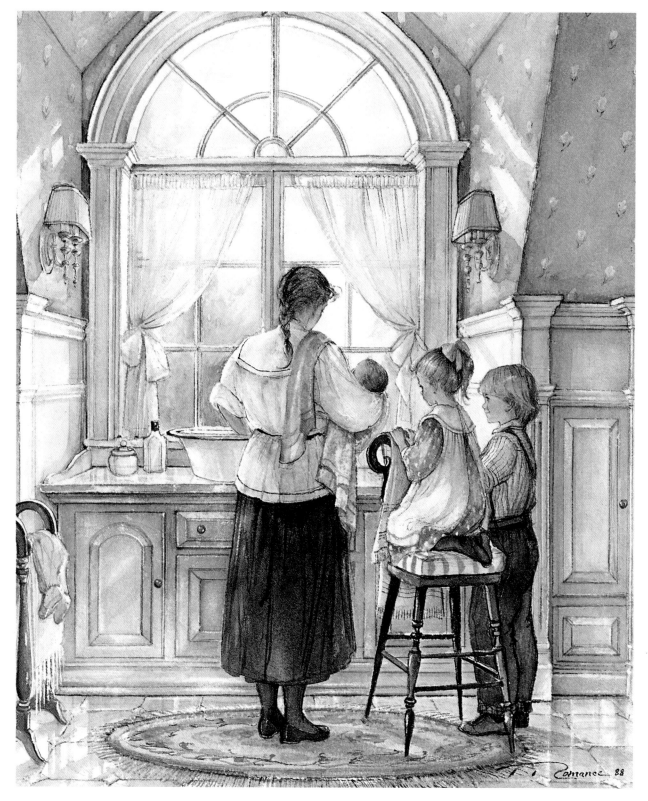

SUN BATH

*B*ringing a new baby home from the hospital is always an important event, and so is the first bath, especially when siblings can watch. To them it seems very ritualistic, and one inevitably asks, "Did you do that to me when I was just born?"

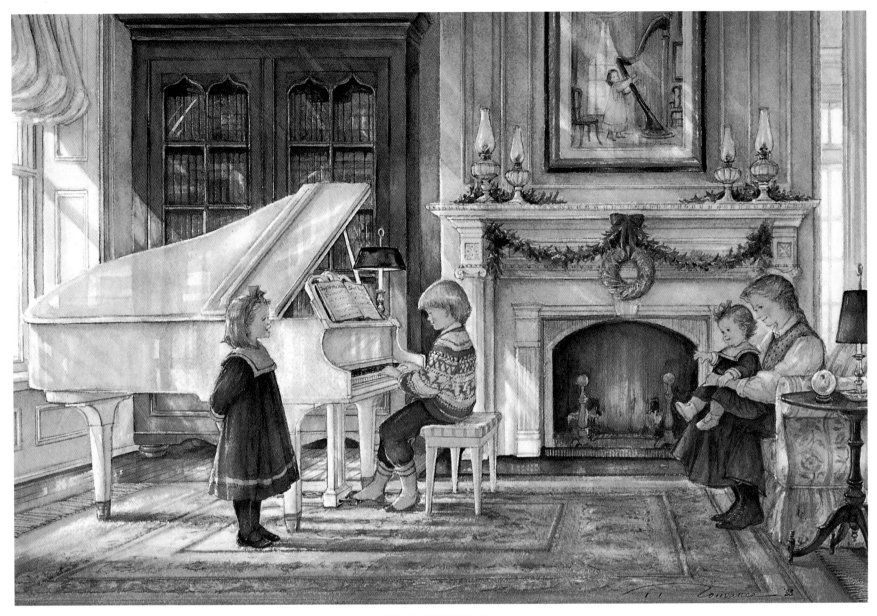

THE RECITAL

*W*e say that Tanya was born singing — nothing recognizable, but she was always bellowing a song from the heart. We sometimes used to play at little recitals, with Whitney being her sister's biggest fan.

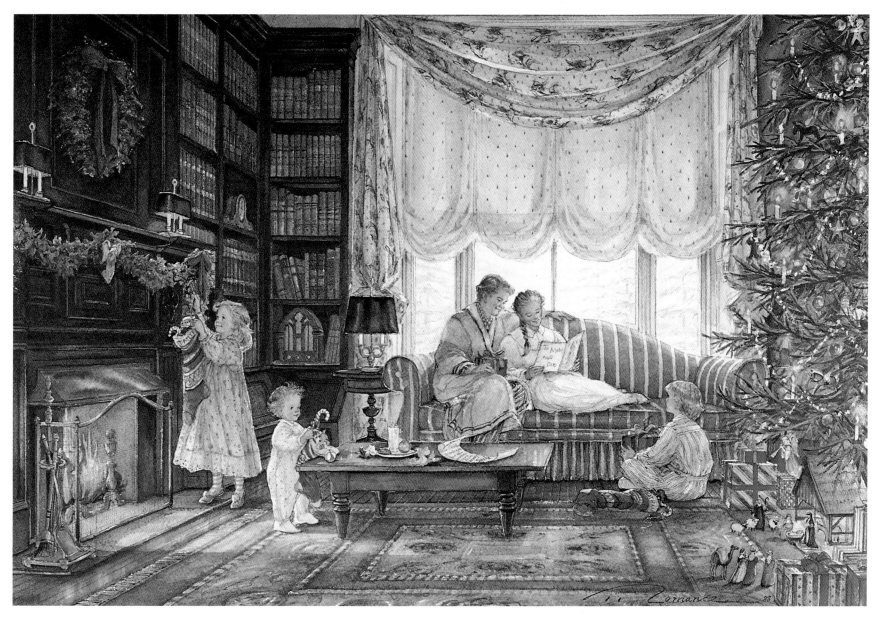

CHRISTMAS MORNING

\mathcal{T}he most sacred and cherished day of our year begins after what seems like
months of anxious preparation. And no matter how extravagant we may be
in our giving, it will always be the handmade cards that we parents will keep
tucked away in our hearts.

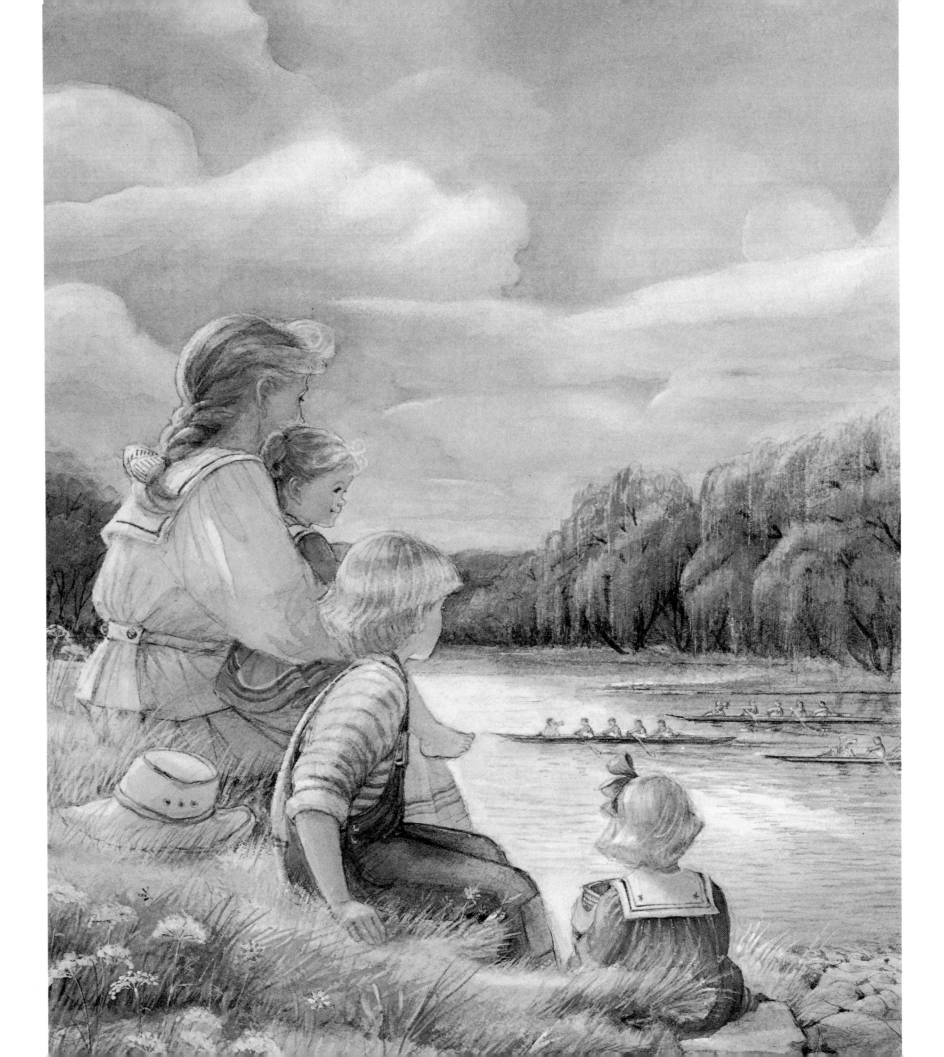

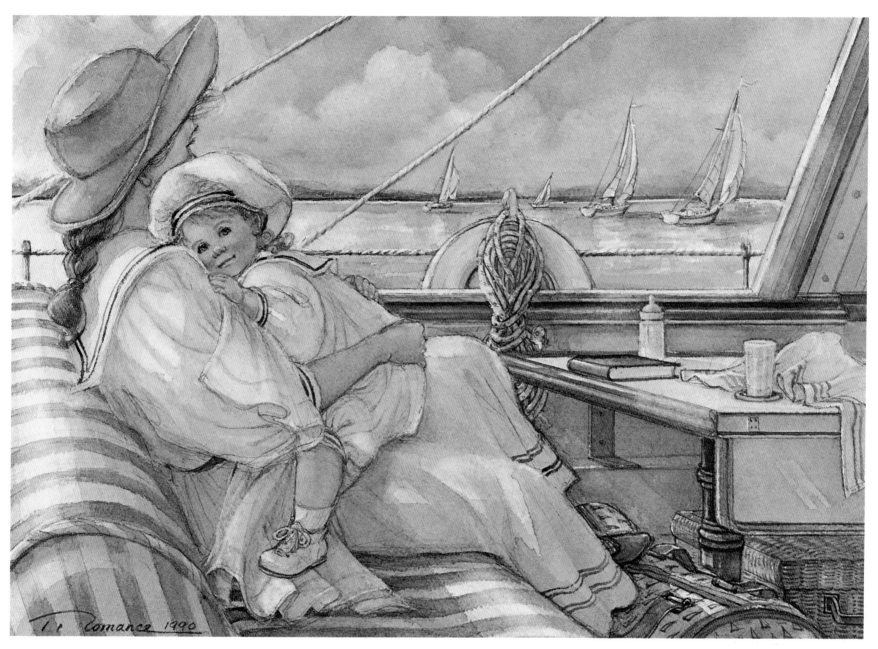

△ LITTLE SAILOR

How comforting the sound of rigging clanging and wake rippling! This was a time I knew Whitney was looking forward to. She snuggled contentedly against me as we got under way for a quiet trip up the Niagara River.

◁ THE REGATTA

I hope that summer days along the inland waterways and rivers of the Niagara Peninsula will become special memories for my children. We are fortunate to be surrounded by such beauty, and I wanted to capture the grace of these scullers in a painting.

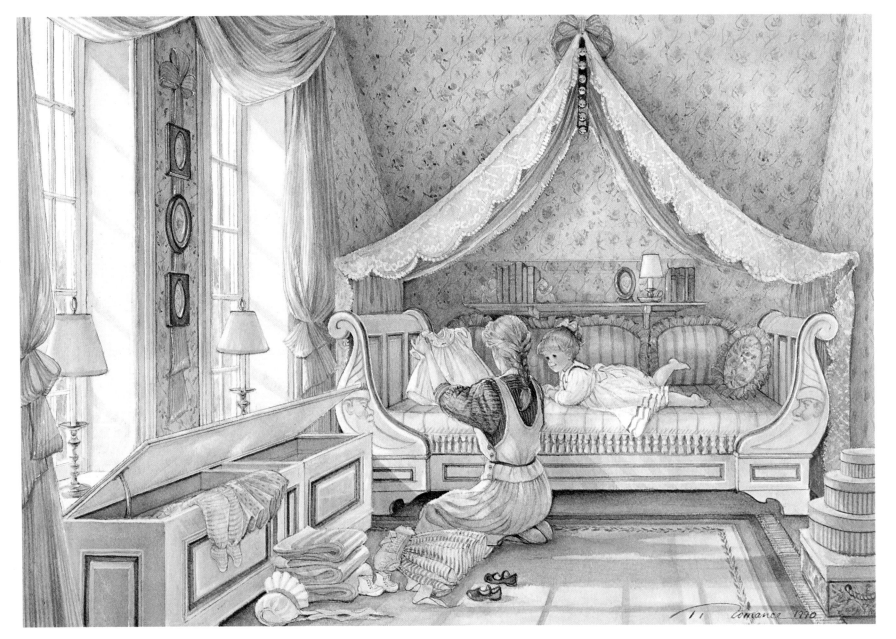

△ TREASURE CHEST

*B*efore we know it our little ones have outgrown their baby clothes, and with mixed feelings I prepare to tuck them away. Unlike Christmas decorations, which I can unpack again next year, I never know when these clothes may be needed again.

▷ HEART TO HEART

*I*t seems like only yesterday that you brought a fragile little baby home from the hospital and gave her a bath. Now, suddenly, here she is having a conversation with you.

Ailing artist faces new health problems

BY ROB ANDRUS
SPECIAL TO THE STAR

NIAGARA-ON-THE-LAKE, Ont. — Despite on-going health problems and now new concerns about her heart, Canadian artist Trisha Romance is signing 10,000 limited edition reproductions of her latest work.

Romance, 43, started the watercolor painting, entitled *Evening Skaters*, two years ago — almost the same time she began experiencing double vision, headaches and numbness in her hands and legs.

Her latest setback, described by her husband Gary Peterson as "skipping heart beats," has left her with chest pains and "feeling really tired."

"We're still waiting for a response from the cardiologist," Peterson said at their gallery here, just hours before a family birthday party for eldest daughter, Tanya, 12.

"We're hoping that there's no disease affecting her heart. She can't do a lot of activities."

Romance, who's best known for her portrayals of family life, continues to take medication for epilepsy acquired as a result of her condition, which has been described by doctors as similar to a large varicose vein near the brain.

"A lot of her problems are hindering her abilities to work," Peterson said, noting that she normally completes two to three paintings every year.

"The most important thing is to make sure that she's getting better and receiving the proper care and medication. Everything else pales in comparison and significance."

Copies of her latest work, which sold out in just one month, are now being delivered to more than 400 galleries across Canada and the United States.

"I wish I could say that we've learned something new," Peterson added. "The frustration is that we don't have any answers yet. Until we do I guess we'll just have to keep striving forward."

TRISHA ROMANCE: Canadian artist took two years to finish latest work.

her daughter's life and lis-
ed to her screams as Bernar-
and his ex-wife Karla Hom-
ka raped her again, and again.

: Now the trial's
over, Debbie's got
to get a life. And I
don't know what
that is.'

When she learned the tapes
existed, Debbie demanded to
see them. She had to see her
daughter one last time. Police
and prosecutors wouldn't let
her. They told her there wasn't
a single frame that wasn't awful.
"I felt like going to the court-
house was like going for sur-
ery every day. It was just rou-
..um. get ready, it was

Niagara artist stricken with ailment in brain

Painter known for portrayals of family life

By Rob Andrus
SPECIAL TO THE STAR

NIAGARA-ON-THE-LAKE — A popular Canadian artist, best known for her portrayals of family life, is battling to regain her health and continue a passion that has consumed 20 years of her career.

Diagnosed as having what doctors say is similar to a large varicose vein near the brain, Trisha Romance, 43, has suffered over the past year from double vision, headaches and numbness in her hands and legs. She is also taking medication for epilepsy acquired as a result of her condition.

ROMANCE

"Doctors who have seen her don't believe it requires an operation at this point," her husband Gary Peterson said at their studio home here.

"What we are concerned about is whether this is putting pressure on parts of her brain and causing some of these symptoms. But we haven't determined if that is the case."

Romance's condition has not improved since she first became ill last January. Although doctors aren't positive about the exact cause of her condition, medication to control her epilepsy and possibly surgery are expected to speed her recovery.

The watercolor artist, born in western New York, is spending more time relaxing with her three children, aged 7, 11 and 14, at the family's home.

Canadians who enjoy Romance's work have closely followed and supported her career.

"It's a very sad time all over Canada and the United States," said Mississauga resident Bernice Antaya, who owns a small collection of her prints. "I love Niagara-on-the-Lake and I love her work."

Romance is best known for depicting life at home, where children are often the focus of family activities.

"She does simple things," said Peterson. "In this day and age, I think her work has become much more significant to people because a lot of families aren't staying together anymore."

t to tell ambulan

ris-
itu-

xed
feel
aid.
bu-
her
has
oth

ways: staff members call collect or managers call them long-distance to give them their upcoming schedules.

The councillor for East Toronto said he spotted the request for the 1-800 line in budget documents submitted to the Metro human services committee.

Upon further investigation, he

learned that about 75 per cent of Metro Ambulance personnel live in areas outside Metro subject to long-distance charges.

A collect call from a staffer costs the ambulance service $3.50 even before long-distance charges are calculated, "so it adds up real quick," Christie said yesterday.

In the letter, he asks Dean to

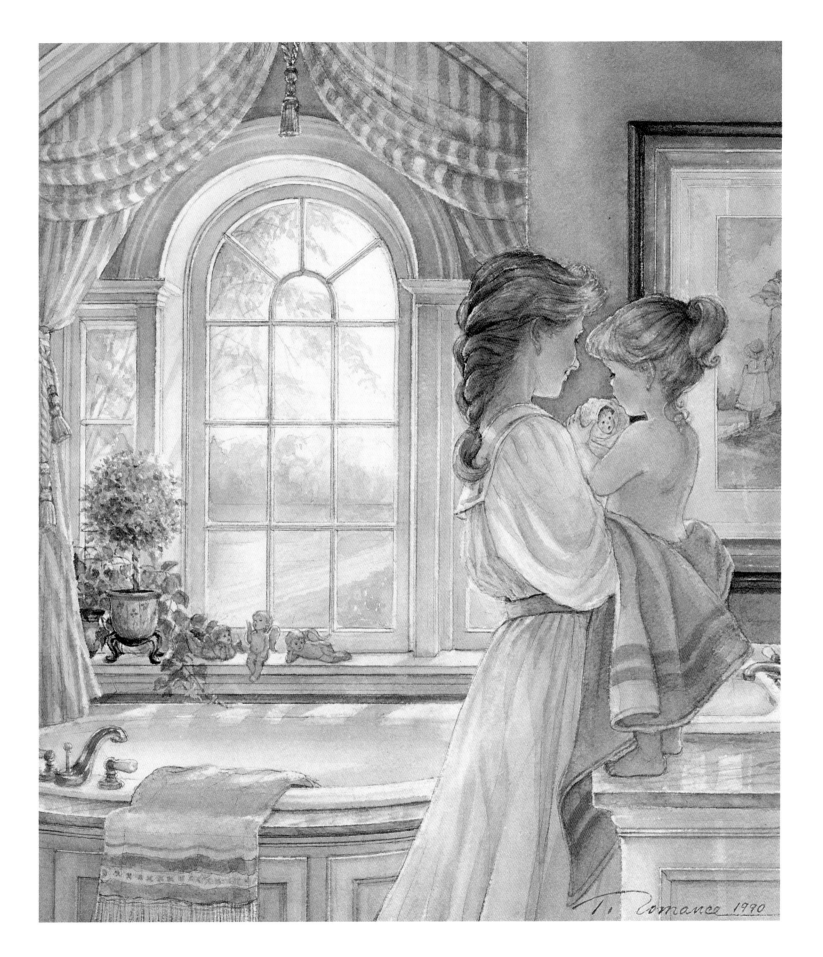

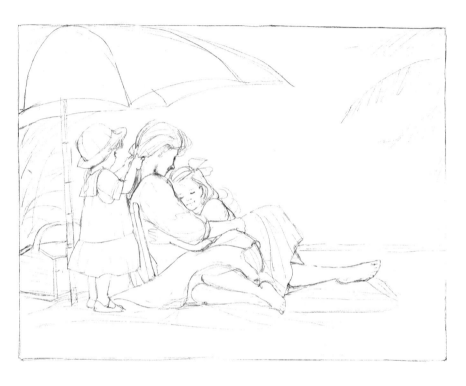

SEA TREASURES

*T*he timelessness of the seashore has an intrigue all its own. I can't think of a single place where I feel so completely relaxed, without a care. It is a time to restore the soul and find the best treasures within.

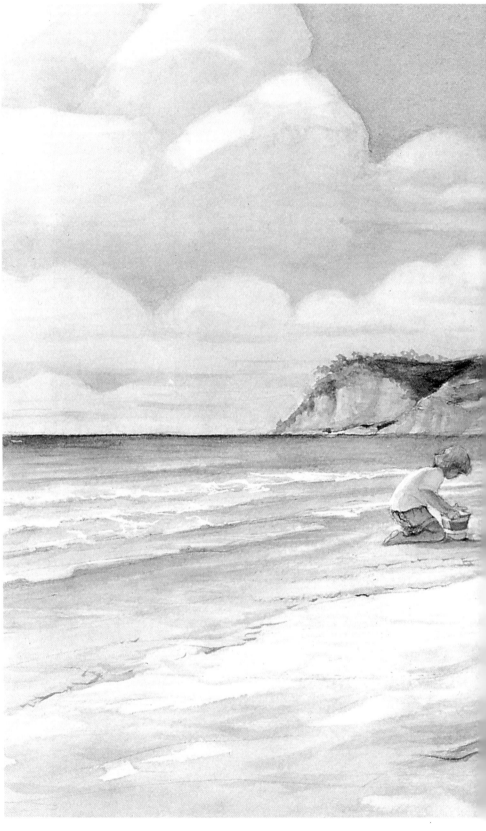

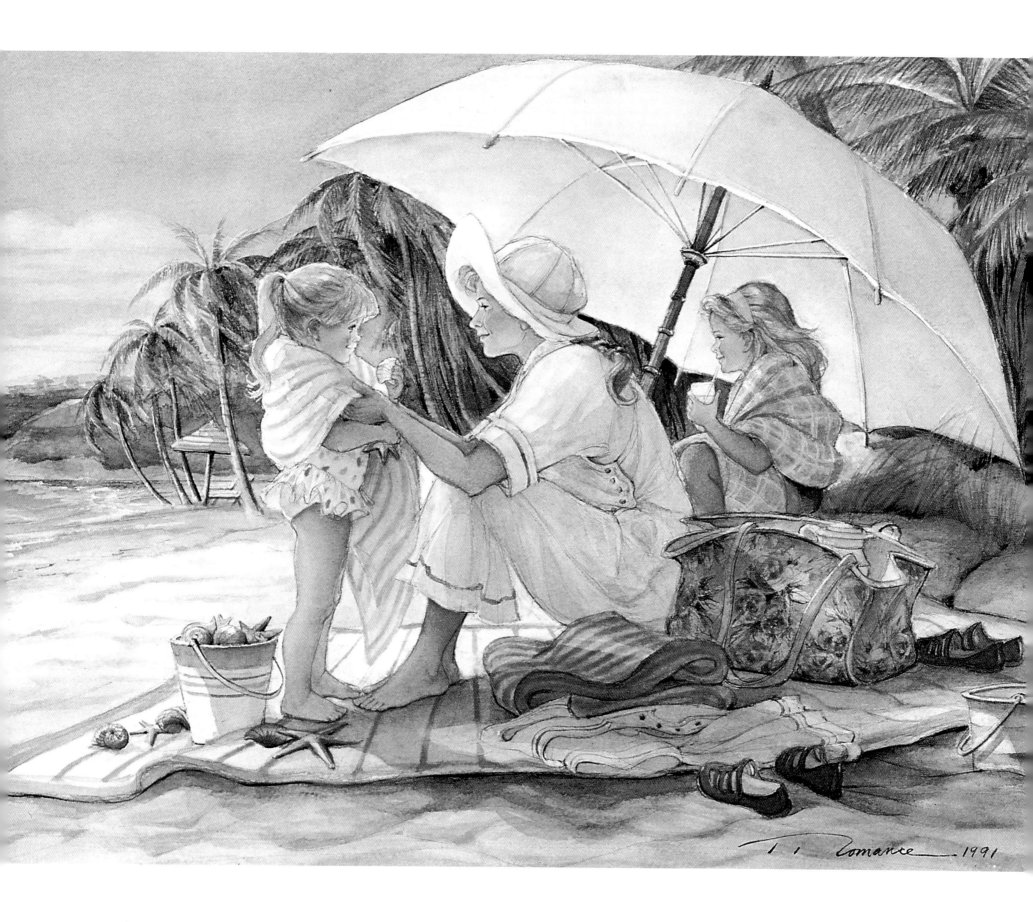

△ FIRST MATE
Nathan is truly a first mate to Gary when we're boating. As I'm totally absorbed in preparing snacks or gathering life jackets, Nathan is learning the ropes.

◁ TO THE BEACH
In Florida we always head for the beach with anxious anticipation. While ocean breezes spur everyone else to a quick pace, I'm content to linger behind, watching moments unfold.

▽ PERFECT GENTLEMAN

*W*e were all there when Whitney met this clown, and my first sketch reflected the actual scene. But in the final painting I decided the centre of attention should be that precious moment when the perfect gentleman took off his hat, bowed down, and kissed her hand ever so graciously.

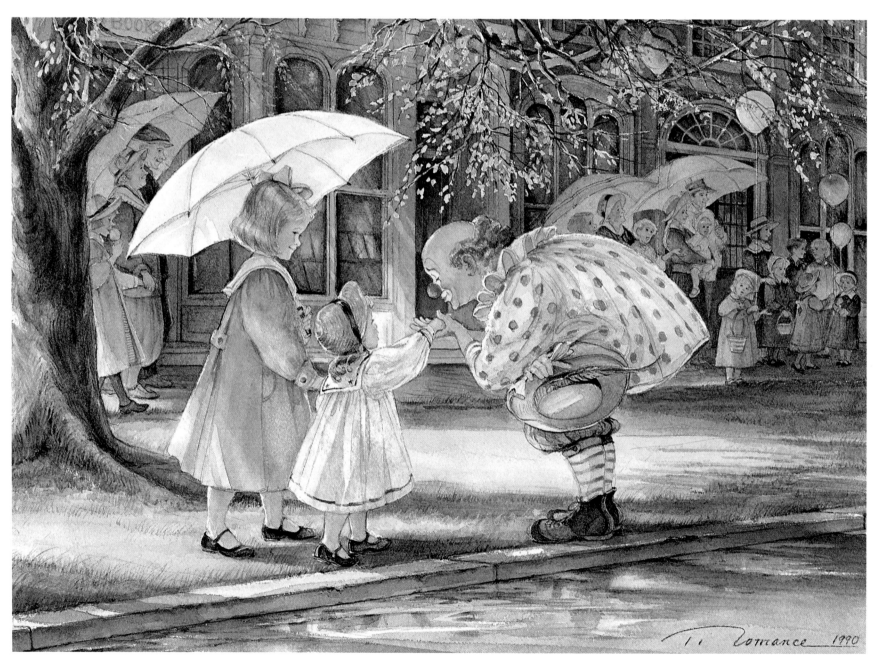

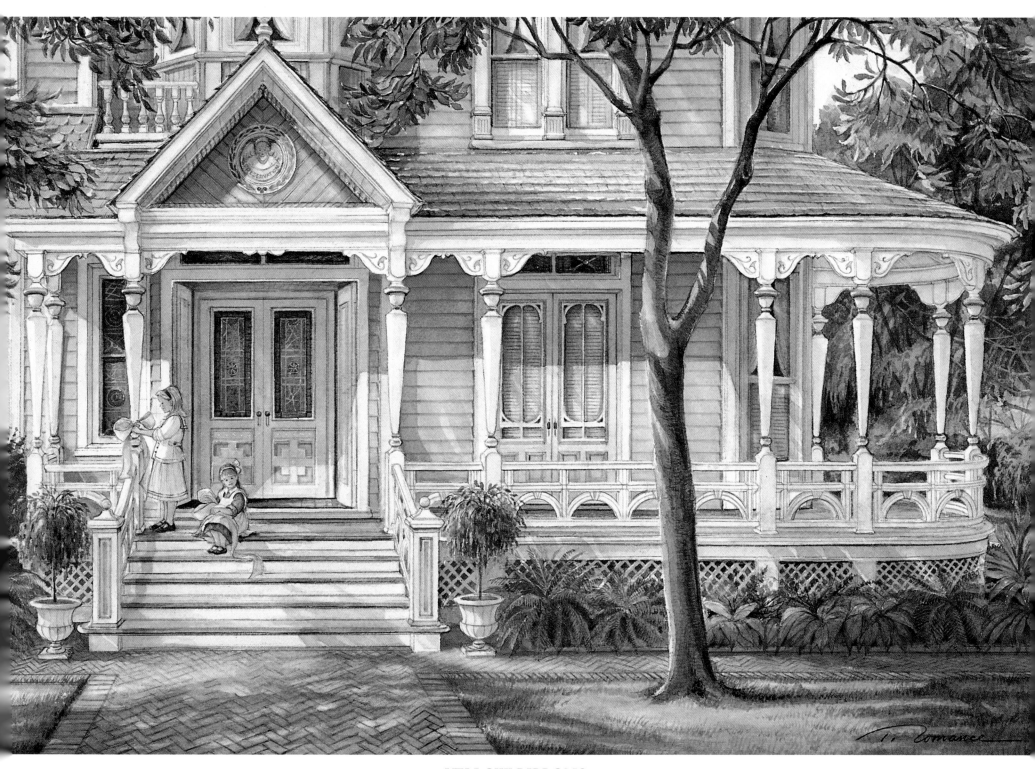

YELLOW RIBBONS

*T*his painting celebrates the return of soldiers from Operation Desert Storm.
What a day of rejoicing, when ribbons that had bound us together in hope
and fear could finally be untied, a symbol of new freedom.

AT HOME
WITH TRISHA ROMANCE

BY DAVID KILGOUR

❖

*T*HE HOUSE — LARGE, IMPOSING — STANDS BACK FROM THE ROAD. TO GET TO IT, you drive through a gate in the picket fence and down a winding lane through a lawn shaded by ancient trees.

You might expect to find Trisha Romance walking in the garden with her children, serving an elegant tea in the sun room, or up in her studio working on a new painting. More often than not, you'd be right. But the day I first met Trisha she was standing by the back door, wearing denim overalls, holding a bag of groceries in one hand, and going over an architectural plan with a carpenter. She had been visiting local farms to get cucumbers for pickling and stopped on her way into the house.

The world that Trisha paints *is* her world — her family, her home, beloved landscapes and buildings — and the serenity in many of her paintings is true to life, but it is distilled from a full, sometimes hectic existence. Trisha is not just an artist: she is also a designer, a businesswoman, a wife, a mother, and a superb cook (not necessarily in that order), and she throws the same passion into every sphere of life that she does into

Reviewing sketches before beginning a painting

painting. Whether at work or at home, it seems that she never stops moving, her mind dancing from task to task — but when it lights, it focuses firmly on the object at hand.

Trisha is nothing if not a perfectionist. In restoring her gallery in Niagara-on-the-Lake, she has overseen the most minute details of woodwork and paint colours; the "midnight dills" she makes late at night are bottled in jars with beautifully handwritten labels; every room in her house has been planned to be a harmonious whole (at the moment she is working on the dining room, which she wants to be "magic"); what appears to be wallpaper in one of the bedrooms is in fact a handmade stencil design — Trisha couldn't find what she wanted in a store.

And yet perfectionism is too cold a word to describe the world Trisha has created for herself and her family and friends. Her home is elegant, but not at all a formal or forbidding place: it is welcoming and lived in. Children come and go, and Trisha will stop anything to spend a few minutes with them. There is a steady stream of visitors, and some have been known to stay for weeks. There are hockey games and piano recitals to attend, tours to go on. And then there is Trisha's involvement in the community, whether through

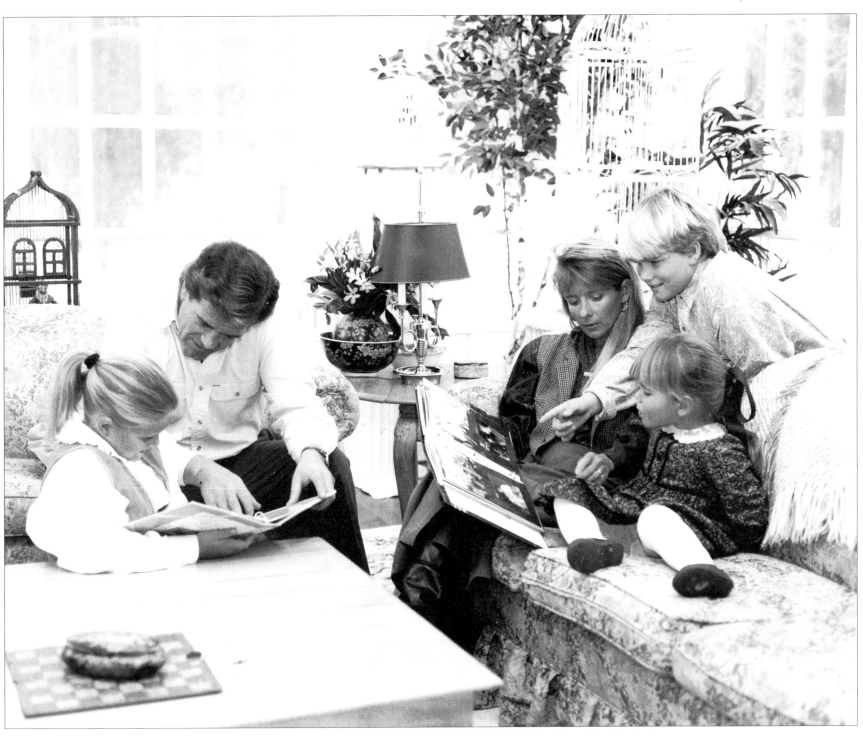

In the sun room with Gary and Tanya, Nathan, and Whitney

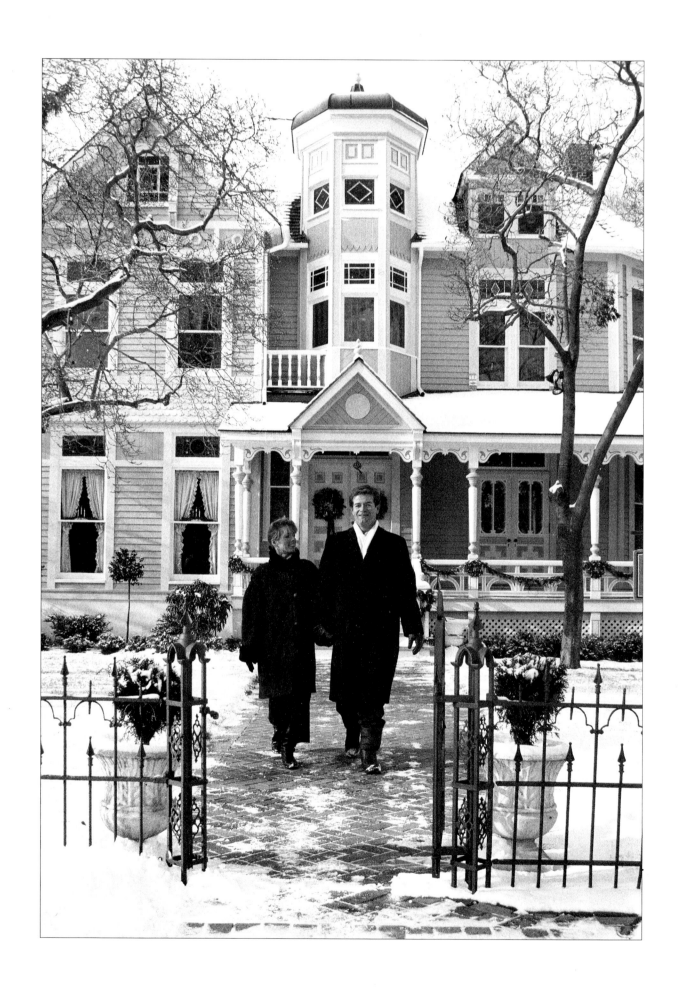

With Gary in front of the gallery in
Niagara-on-the-Lake

Getting ready to bake with Whitney and Tanya

her church or through charity. Over the years she has donated time and work as well as money to such causes as the Epilepsy Research Fund of Canada, the Multiple Sclerosis Society, the Bereaved Families of Ontario, and the Canadian Mental Health Association, as well as many local charities.

In conversation, Trisha is open, frank, and often self-deprecating. What strikes anyone talking to her is the integrity of her vision — noticing, loving, warm, positive, and often very funny. She is as comfortable in her denim overalls as she is in dresses, as at home in the office or kitchen as she is in the drawing room. There isn't an ounce of pretension in anything Trisha does: her art meshes seamlessly with the other threads of her life. But what is perhaps most remarkable about her is the fact that she finds the time and the energy to paint at all. It is in her studio, often late at night, that she sits alone, reflects on the images and feelings in her mind's eye, and creates the magic you see in this book. Whatever it is that enables her to do this is ultimately the secret of the artist, and it eludes explanation.

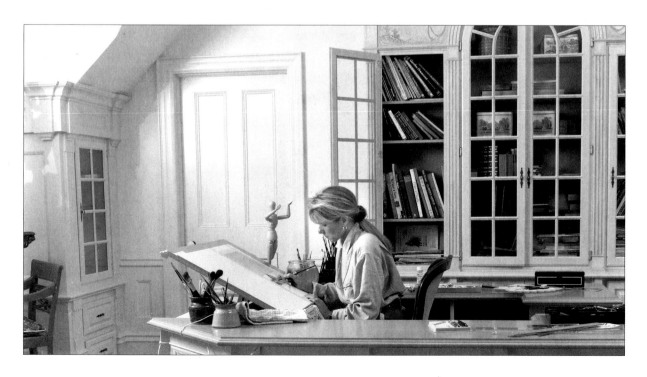

At work in the studio

LIST OF COLOUR PLATES

Unless otherwise specified, all paintings are watercolours.